Identity in Place

POSTCOLONIAL STUDIES

Maria C. Zamora
General Editor

Vol. 12

PETER LANG
New York • Washington, D.C./Baltimore • Bern
Frankfurt • Berlin • Brussels • Vienna • Oxford

Paula Anca Farca

Identity in Place

Contemporary Indigenous Fiction by Women Writers in the United States, Canada, Australia, and New Zealand

PETER LANG
New York • Washington, D.C./Baltimore • Bern
Frankfurt • Berlin • Brussels • Vienna • Oxford

Library of Congress Cataloging-in-Publication Data

Farca, Paula Anca.
Identity in place: contemporary indigenous fiction by women writers
in the United States, Canada, Australia, and New Zealand / Paula Anca Farca.
p. cm. — (Postcolonial studies; v. 12)
Includes bibliographical references and index.
1. English fiction—English-speaking countries—History and criticism.
2. English fiction—Women authors—History and criticism.
3. Ethnicity in literature. 4. Place (Philosophy) in literature. 5. Indigenous
peoples in literature. 6. Ethnic groups in literature. I. Title.
PR9084.F37 823'.92099287—dc22 2011003749
ISBN 978–1-4331–1153–2
ISSN 1942–6100

Bibliographic information published by **Die Deutsche Nationalbibliothek.**
Die Deutsche Nationalbibliothek lists this publication in the "Deutsche
Nationalbibliografie"; detailed bibliographic data is available
on the Internet at http://dnb.d-nb.de/.

Chapter 6 first appeared in the refereed e-journal *The Journal of Australian
Writers and Writing,* Melbourne, Edition One, Autumn 2010
http://www.australianliterarycompendium.com/

The paper in this book meets the guidelines for permanence and durability
of the Committee on Production Guidelines for Book Longevity
of the Council of Library Resources.

To my parents, Angela and Mircea Sârbu, who gave me life and taught me how to live it.

TABLE OF CONTENTS

TABLE OF CONTENTS

ACKNOWLEDGMENTS

My study is dedicated to my parents, Angela and Mircea Sârbu. I thank them for their love, encouragement, support, and memorable advice. I would also like to express my wholehearted appreciation to my wonderful husband, George, for his love, luminous personality, words of encouragement, patience, understanding, and help. I am grateful to my enthusiastic little muses, my sons, Sergiu Patric and Darius Vlad, who offer me much joy and many laughs every day. I would also like to thank my brother, Vlad, for the love and support he has always given me.

I wish to express my special appreciation to Dr. Edward Walkiewicz, for his patient and constructive guidance, his comments on my numerous, tedious drafts, and his kind words of encouragement. I am deeply grateful to Dr. Linda Leavell for her visionary insight, comments, and moral support. To Dr. Walkiewicz and Dr. Leavell, I owe a special debt of gratitude for their consistent and careful guidance and for their endless inspiration. I also would like to thank Dr. Lindsey Claire Smith for her expertise in Indigenous literature, her invaluable suggestions, her enormous patience and dedication, and her constructive criticism.

CHAPTER 1

INTRODUCTION

The Māori saying, *Manaaki Whenua, Manaaki Tangata, Haere whakamua* ("Care for the land, Care for the people, Go forward"), teaches Māori people to value their land, place of birth, and home, take care of one another, and think positively about the present and future. Indigenous people around the world regard their relationship to place as an integral part of their identity and struggle to maintain it despite their losses of lands and homes. *Identity in Place* analyzes the role of place and its cultural significance in the fiction of eight contemporary Indigenous women writers from the United States, Canada, Australia, and New Zealand, four former colonies of the British Empire. More specifically, it addresses the interaction between Indigenous people and the locations they inhabited after colonization.[1] This study addresses how the places Indigenous people go to and imagine reveal the cultural directions toward which Indigenous people are moving and the changes that occurred in their traditions. Places also reveal how Indigenous people survive in a postcolonial world, heal, regain homes and rituals, and subsequently build new homes and create new traditions. I argue that places are social and cultural constructions that regenerate themselves as a result of their inhabitants' active participation; at the same time, the inhabitants' experiences in specific places aid them in renewing their relationships with their tribal and national histories and cultures.

Responding to much postcolonial scholarship, which focuses on the violence of colonialism and on Indigenous people's loss of land and family

[1] Augie Fleras and Jean Leonard Elliott define contemporary Aboriginals as "the existing descendants of those who are commonly thought to be the original inhabitants of a territory, who now occupy an encapsulated status as subordinate members of a larger society, but who continue to identify with a cultural lifestyle at odds with that of the dominant sector." *The Nations Within: Aboriginal-State Relations in Canada, the United States, and New Zealand* (Toronto: Oxford University Press, 1992), 1. Tony Swain discusses the etymology of the word "Aborigine" and claims that "'Aborigine' (Latin 'from the beginning'), which, like *primitivus* ('first of its kind'), conjures the image of a timeless essence, was defined *vis-à-vis* the colonists as unchanging and when they did, undeniably, change, this was ignored." *A Place for Strangers: Towards a History of Australian Aboriginal Being* (New York: Cambridge University Press, 1993), 278-79. Despite the colonists' depictions of Indigenous inferiority, Aboriginal cultures changed like any other culture, so the "image of a timeless essence" does not fit the profile of any culture or country. The places where they resided changed as well.

members, I have found a different approach to place which deals with their losses. I suggest that even the most recent definitions of place can be revised and expanded so that they include an internalized and creative component, one which is shaped by people's imaginations and memories and also by their experiences of places. The Indigenous writers I examine show that places are not only concrete locations but also internalized processes that result from individuals' mental interpretations. In other words, places are not inert pieces of land but textual constructs that are created by those who experience and imagine them.

This new way of thinking about place is relevant to many Indigenous people who lost their land and their family members because it implies an approach to place that involves going beyond one's physical presence in a particular location. For instance, one does not necessarily need to remain on the reservation to maintain certain connections to the reservation; one does not lose a place in its entirety if that place changes radically. The imaginative and internalized responses of Indigenous people to places could also bring them healing and motivate them to go on. Through mental recreations, memories of places, and journeys to specific places, Indigenous people might regain their land and traditions, heal their physical and psychological wounds, and create new places in which their cultures can persist. The various experiences and stories that individuals take from and bring to places shape them both and facilitate dialogues among generations and across time. Emphasizing the fluidity of place as a concept, the Indigenous writers I analyze demonstrate the survival and flourishing of their communities.

The Indigenous authors included in this study are Louise Erdrich, Linda Hogan, Lee Maracle, Jeanette Armstrong, Alexis Wright, Doris Pilkington, Keri Hulme, and Patricia Grace, eight of the most widely read women writers in their own countries and in recent Indigenous literature. As I discuss influential works by women writers along with novels that have not received enough critical consideration, I bring more attention to Indigenous people's relationships to places. My cross-continental and cross-national analysis emphasizes that, despite their tragic colonial pasts and the loss of their lands and even family and community members, Indigenous people are able to create and recreate places in which their cultures and ethnic identities survive and flourish. By negotiating relationships to new places, people, and cultures, reconsidering their old places, and inscribing their stories across

nations, contemporary Indigenous women adapt their community's traditions to new contexts and reinvigorate their ethnic identities and tribal roots. *Love Medicine* (1993) by Louise Erdrich, a contemporary Chippewa tribal storyteller is a novel that revolves around the Turtle Mountain Reservation and its inhabitants, who travel in and out of the reservation, revising its traditions. In *Solar Storms* (1995), Chickasaw author Linda Hogan focuses on five generations of Native American women who tell their stories on the borderlands shared by Canada and Minnesota. In *Daughters Are Forever* (2002), First Nations author Lee Maracle introduces an Indigenous mother who tries to reconnect with her own daughters and the natural world after several years of difficult life on a reservation followed by a disassociated life in the city. Jeannette Armstrong, an Okanagan Indian, has her protagonist explore Indigenous places as she travels from the forests of Canada to Mayan Guatemala to fight for political and environmental justice in *whispering in shadows* (2000). Born in Cloncurry, Queensland and affiliated with the Waanji people of the highlands of the southern Gulf of Carpentaria, Alexis Wright authored *Plains of Promise* in 1997, a debut novel about four generations of women who, under patriarchal and colonial oppression, lost contact with one another. The last descendents of these Aboriginal women try to reconnect with their family members in their birthplace. Doris Pilkington, whose Aboriginal name is Nugi Garimara, brings together the lives of three generations of Mardu women with that of Kate, who revisits the homeland of her ancestors in *Caprice: A Stockman's Daughter* (1991). Patricia Grace, who is of Ngati Raukawa, Ngati Toa, and Te Ati descent, wrote *Cousins* (1998), a novel about three Māori cousins who travel to different places and reunite and find their way home after being assimilated into contemporary New Zealand realities. Each of the three cousins experiences her ancestral home differently and creatively. Finally, in *The Bone People* (1985), Māori writer Keri Hulme tells the story of Kerewin, part Māori, part European, who creates a space by the ocean where Māori, New Zealand, and European cultures clash and merge.

All eight novelists see places as relevant to their characters' development and plights. While these Indigenous writers express common themes, such as the effects of colonialism on their protagonists' homes, cultures, and even bodies, the differences in their approaches to place underscore the diverse ways in which Indigenous characters recreate places. Armstrong's protagonist lives in an urban area but constantly remembers the traditions of

her homeland and the teachings of her family members. Close to their homes but not to their families, Hulme's characters create places in which they coexist. Some of Hogan's and Grace's characters consider their homes and families to be safe and welcoming, while others, such as Maracle's protagonist, remember their homes as places in which violence occurred. Erdrich's characters move back and forth, in and out of their homelands, constantly rewriting the traditions of the reservation. Grace's protagonist, Mata, Pilkington's Kate, and Wright's Ivy are taken to cities, placed in Western schools, and forced to study a predominantly Western and Christian curriculum. Yet Grace's protagonists find their ways back to their homeland and reunite with their families, and Pilkington's Kate recreates the places in which her family members had lived. Wright describes the Christian mission as a violent and oppressive home for Aboriginals and suggests that the natural world provides a place in which lost generations of Aboriginal women can communicate. Grace's Makareta and Armstrong's Penny become political and environmental activists who meet Indigenous people from around the world, while Maracle's Marilyn and Wright's Mary hold government positions that allow them to aid the Indigenous communities in Canada and Australia. The above examples underscore Indigenous people's unyielding attempts to foreground their ethnic identities and inscribe their stories in formerly colonized places.

Throughout their histories, Indigenous people have been trying to affirm their voices and cultures inside and outside of their homelands and the places they visit, and yet, the losses they have suffered remain challenging. Most postcolonial scholarship underscores such losses and challenges. In a study which deals with Indigenous history in Canada, the United States, and New Zealand, authors Augie Fleras and Jean Leonard Elliott write about the significant losses suffered by the Indigenous populations in the former colonies of Britain: "[the] land, culture, and identity were subjected to prolonged pressure, while the loss of control over resources proved lethal in terms of status, economic health, and identity."[2] Underlining the importance of place in postcolonial studies, Jace Weaver claims that the loss of land automatically triggered a loss of culture and identity for Indigenous people: "When Natives are removed from their traditional lands, they are robbed of more than territory; they are deprived of numinous landscapes that are central to their faith and their identity, lands populated by their blood

[2] Fleras and Elliott, 2.

relations, ancestors, animals, and beings both physical and mythological."[3] The loss of the land produced a chain reaction which led to Indigenous people's partial loss of culture, identity, and economic status. Pushed toward the margins of society or placed on reservations, viewed as inferior, and rendered poor, Indigenous people have been struggling to regain their rights, lands, and ethnic identities.

Many well-known scholars in postcolonial studies focus their discussions on place and displacement and view colonization in terms of the conquest of a space. Radhika Mohanram argues that "Colonialism was about the seizing of place, draining it of its resources, its history and the meaning attributed to it by its primary occupants."[4] Deploring the renaming of Indigenous places, Linda Tuhiwai Smith makes a larger point about the loss of Indigenous culture in general as the "newly named land became increasingly disconnected from the songs and chants used by indigenous peoples to trace their histories."[5] Bill Ashcroft, Gareth Griffiths, and Helen Tiffin posit that colonizers destroyed many Indigenous tribes "by imposing a feeling of displacement in those who have moved to the colonies; by physically alienating large populations of colonized people through forced migration, slavery or indenture; by disturbing the representation of place in the colony by imposing the colonial language."[6] Such displacements, dispossessions, and imposed migrations complicate Indigenous people's returns to their communities and lands. Contemporary Indigenous women writers depict their characters' struggles to reconnect with their families, heritage, and land after they and their ancestors had lost land or had been estranged from their families.

Some Indigenous authors write stories of endurance and describe how the characters feel, suffer, act, and behave in times of adversity. Kathleen C. Stewart suggests that the body itself becomes a text on which the history of places can be read, arguing that one may discern "the constant recounting of places on the body where life has left its impact – the scars, the locations of

[3] Jace Weaver, *Other Words: American Indian Literature, Law, and Culture* (Norman: University of Oklahoma Press, 2001), 42-43.

[4] Radhika Mohanram, *Black Body: Women, Colonialism, and Space* (Minneapolis: University of Minnesota Press, 1999), 200-201.

[5] Linda Tuhiwai Smith, *Decolonizing Methodologies: Research and Indigenous Peoples* (Dunedin: University of Otago Press, 1999), 51.

[6] Bill Ashcroft, Gareth Griffiths, and Helen Tiffin, *Key Concepts in Post-Colonial Studies* (London: Routledge, 1998), 177-78.

pain, the disfigurements, the amputations, the muscles and joints and bones
that remember."[7] To underscore the abuse of colonization, the destruction of
the land, and the violence inflicted on Indigenous populations, the eight
women writers whose work I analyze describe scenes of physical suffering
and mental anguish. The physical suffering of the body, which translates into
the authors' insistence on depicting wounds, scars, pain, burns, incisions,
disease, disability, alcohol abuse, rape, and beatings, is oftentimes
accompanied by mental torments resulting from the characters' loss of land
and connections with family. It becomes fairly evident that their journeys
toward habitable places are sometimes journeys toward healing.

By emphasizing places and bodies under siege, the writers portray an
anguished humanity living in a rather diseased environment. It may take
several more generations for some Indigenous people to build new homes; in
the meantime, they search for healthy environments and safe places within
colonized spaces where they can feel comfortable and at home. In some of
the works under consideration, ancestral homes and safe places do not exist
anymore, and therefore the protagonists reinvent, rebuild, remember, and
recreate them. Wright describes the colonial and postcolonial periods in
Australia, when Indigenous children were estranged from their families and
forced into Western schools, where they were taught English and raised as
"good Christians." Since many children grew up without their parents and
families, younger generations face an almost impossible task: to rekindle
meaningful experiences with their family members, homes, and traditions.
The older generations of women Wright describes are victims of rape and
violence, while the younger women are distressed when they cannot find
their mothers and the places in which their families and communities lived.
Pilkington, too, tells the story of a woman who has not met her parents and
grandparents but returns to their home and her birthplace out of a need to
rediscover her cultural and ethnic roots. Hulme's characters are either
disabled or alcoholic but try to create spaces in which people of different
cultures and ethnicities can coexist. One of Grace's characters is motherless
and lost in the foreign space of the city, searching for her ancestral Māori
home. Maracle's alcoholic and abusive protagonist also lives in an unfriendly
city, where she feels disconnected from the home of her great-grandmother
and her daughters. The protagonist of *whispering in shadows* fights against

[7] Kathleen C. Stewart, "An Occupied Place," in *Senses of Place*, ed. Steven Feld and Keith H.
Basso (Santa Fe: School of American Research Press, 1996), 148.

the destruction of the environment in several countries inhabited by Indigenous people but finds out she has developed a rare form of cancer from exposure to toxic pesticides and a poisoned environment. In Hogan's novel, Angel's face is scarred by her mother, whose whole body is an open wound; Angel's mother figures try to heal the girl's body and mental wounds and save their environment from destruction. Erdrich describes a multiethnic and multiracial community which has to come to terms with the changes that occur on the reservation. Her characters, who drink, gamble, or are abusive and suicidal, ultimately have to decide whether or not life on the reservation suits their needs.

The aching bodies, traumatized minds, and poisoned environments described in the novels point to how generations of Indigenous people have been and will continue to be affected by the colonial past. Yet, despite descriptions that reinforce the negative but expected effects of colonization on Indigenous tribes and communities in the United States, Canada, Australia, and New Zealand, the stories that these women writers and others tell are also stories of resistance and hope, and some are even success stories. Thus, the characters' scars also imply healing; their weeping is eventually followed by laughter; their destroyed homes invite the building of new ones; their lost places lead to rediscovered and recreated places; and their forgotten traditions promise recreated ones.

Several Indigenous critics have insisted that Native Americans, First Nations, Māori, and Aboriginal people are not victims but powerful and creative individuals wherever they reside. Weaver contends bluntly that the "colonizers have settled in to stay. To acknowledge this reality, however, is not to acquiesce in it."[8] In the same essay, Weaver posits that Indigenous people are responsible for their own fate because "It is about the ability of Natives and their communities to be self-determining rather than selves determined."[9] "European contact is a given," Craig Womack contends and adds that "what can be innovated and initiated by Native people in analyzing their own cultures rather than deconstructing Native viewpoints and arguing for their European underpinnings or even concentrating on white atrocities

[8] Weaver, "Splitting the Earth: First Utterances and Pluralist Separatism," in *American Literary Nationalism*, ed. Jace Weaver, Craig S. Womack, and Robert Warrior (University of Mexico Press, 2005), 39.
[9] Ibid., 41.

and Indian victims" is definitely more productive.[10] Thus, Weaver and Womack both underscore the futility of reinforcing European supremacy and the victimization of Indigenous people for the simple reason that it limits the future of Indigenous culture. Another interesting point Womack makes concerns the mutual influence between settler and colonized cultures. Womack rejects the "notion that assimilation can go only in one direction, that white culture always overpowers Indian culture, that white is inherently more powerful than red, that Indian resistance has never occurred in such a fashion that things European have been radically subverted by Indians."[11] All the writers under discussion show that exchanges between individuals of different ethnicities, races, and nationalities inform their cultures independent of their skin color. In *The Bone People*, for instance, the strong relationships among a Māori man, a half-Māori-half European woman, and a European boy trigger exchanges between their cultures as well. Together, they form a new kind of family and build a place where their cultures inform one another.

Many of the characters in the novels I examine suffer the consequences of life under oppressive colonial regimes but refuse to be labeled, or to label themselves as victims. In *Solar Storms*, Angel benefits from the guidance, activism, and love of her relatives and succeeds in finding places within the natural world or the community in which she applies the lessons and traditions of her mother figures. Maracle's and Armstrong's protagonists continue to practice the traditions of their elders in cities or communities of Indigenous people around the world. Kate in *Caprice* revisits and recreates the place of her Aboriginal family, where she unlearns the indoctrination taught at boarding schools and learns about her Aboriginal family. In Grace's *Cousins*, three Māori cousins, who are either orphaned or poor, respond differently to the conservative views of their grandparents, who underline the financial and social gains resulting from the ownership of land; in the end, however, their diverse views converge toward a fortunate consensus. Erdrich's characters conclude that the reservation has loose boundaries and have to decide whether they stay at home or live in multiethnic cities. Hulme shows how her characters of different nationalities and ethnicities create spaces in which they can live, communicate, and heal. Wright's novel is

[10] Craig S. Womack, *Red on Red: Native American Literary Separatism* (Minneapolis: University of Minnesota Press, 1999), 12.
[11] Ibid.

perhaps the darkest when it comes to the description of suffering resulting from the violence inflicted on several generations of Aboriginal women. Yet, despite their physical and mental wounds, these women find places where dialogue is possible. The last two descendents of the Koopundi women come to terms with their condition as urban Aboriginal people with almost no connections to their family and community.

Theoretical Places

Historical and sociological studies record the effects of colonization on Indigenous tribes and communities, but literary studies that contextualize these effects in cross-national and cross-continental analyses are still scarce. Although American writers such as Louise Erdrich and Linda Hogan have achieved international fame, and thus received considerable critical attention, I intend to place their works into a larger, multinational context and analyze them next to texts by authors who deserve similar critical attention and have received little so far. While Canadian Indigenous writing is a field being investigated to some extent today, Australian and New Zealand authors such as Alexis Wright and Patricia Grace merit more critical consideration altogether. In addition, the publication of recent cross-national anthologies such as *Skins: Contemporary Indigenous Writing*, edited by Kateri Akiwenzie-Damm and Josie Douglas, and *The Colour of Resistance: A Contemporary Collection of Writing by Aboriginal Women*, compiled by Connie Fife, suggests that the study of contemporary Indigenous writing has become a field which invites cross-national connections. With the emergence of these anthologies and numerous primary works by contemporary Indigenous writers in the first decade of the twenty-first century, there is an increasing need for additional critical studies.

The comparative analysis of contemporary Indigenous fiction by eight women writers from four postcolonial countries opens up a conversation about the losses Indigenous people endured during and after colonization and their various coping mechanisms. All eight novels I discuss center on contemporary female protagonists who find ways to inscribe their stories within places that were the original homes of their families for generations or even within places that belong to or are inhabited by settlers. I underscore their adaptability and flexibility along with their creativity and originality in building or re-creating places, homes, homelands, and safer environments. Indigenous women's relationships to place reveal success stories in which

they learn to heal, adapt, and carry on their traditions and create new ones. Through the creation and invention of places in which their voices and cultures are represented, these women preserve and enrich their ethnic identities and, more important, set an example for future generations of Indigenous people.

Scholars emphasize that place is defined in relation to individuals and communities as a meeting point of culture, economy, nationality, and ethnicity. While place is a common theme in literature, its relationship to its inhabitants is a recent critical correlation. Tadhg O'Keeffe traces the historical development of the landscape-identity nexus and asserts that, until the mid-1980s, scholars treated landscape as a canvas and people as external to it.[12] The Marxist-oriented approaches of the mid-1980s to the early 1990s identified landscape as "inherently social-cultural in its production ... landscape is implicated in relations of power through its ownership, control and manipulation by social élites."[13] Finally, more recent criticism has shown that landscapes are "spaces' or 'places', or both simultaneously, that exist reflexively in our cognitive as well as our corporeal experiences of the material world, shaping and being shaped by our simultaneously multiple identities as humans."[14] This third, and more recent approach to place, interests me because it reinforces the idea that a place is shaped by the minds and bodies of its inhabitants. This new way of thinking about place is especially empowering to Indigenous people because they can still reconnect with their homelands and traditions even after they had lost them.

Twentieth-century cultural geographers moved from the idea of place as palimpsest, where layers are supposedly decipherable, to more open experiences and interpretations of places and landscapes. Hilary Winchester mentions early twentieth-century scholars who thought that the human, natural, and cultural landscape consisted of layers of interpretable artifacts, and she discusses post-World War II approaches to place and landscape, influenced by postmodern theories that "stress the role of human agency, where people are not passive, but actively shape their environment."[15] Paul

[12] Tadhg O'Keeffe, "Landscape and Memory: Historiography, Theory, Methodology," in *Heritage, Memory and the Politics of Identity: New Perspectives on the Cultural Landscape,* ed. Niamh M. Moore and Yvonne Whelan (Aldershot: Ashgate, 2007), 3.

[13] Ibid., 4.

[14] Ibid.

[15] Hilary Winchester, "The Construction and Deconstruction of Women's Roles in the Urban Landscape," in *Inventing Places: Studies in Cultural Geography,* ed. Kay Anderson and Fay Gale (Melbourne: Longman Cheshire, 1992), 140.

Claval shifts the evolution of space and place forward into the twenty-first century and adds that culture, human thought, and experience also shape places. He argues that "contemporary geography explores the way culture is permeating all the forms of spatial organization. In the field of landscape studies, approaches that focus on the meaning conferred on places by the people who inhabit or visit them substitute for the functional approaches imagined during the twentieth century."[16]

Among others, Robert Sack, Miles Richardson, Edward Casey, and J.E. Malpas claim that individuals give meaning to specific places, bring their cultures, histories, and social and behavioral structures into the places they inhabit. However, they do not emphasize enough how places are defined by imagination and memory as well. Sack explains concisely what other theorists have articulated as well: "Places are the primary means by which we are able to use space and turn it into a humanized landscape."[17] Richardson argues that we transform space into place in the same way we turn "stone into tool, behavior into conduct, sound into word, and, in a more sweeping way, nature into culture."[18] Such theorists who explain how people's cultures and their places are interconnected, show that the history, language, and heritage of a certain tribe at a certain moment in time are possible only in a specific location where the community can create them. Notably, Jonathan M. Smith argues that the value of a place is determined by the people who inhabit that place: "No place is naturally valuable simply because its land is productive ... it becomes valuable only once it falls to the hands of a people who desire and know how to make use of [the land] ... The value of any particular place depends on the culture of those who control it."[19] People's cultures influence the physical aspects and the social, moral,

[16] Paul Claval, "Changing Conceptions of Heritage and Landscape," in *Heritage, Memory and the Politics of Identity: New Perspectives on the Cultural Landscape*, ed. Niamh M. Moore and Yvonne Whelan (Aldershot: Ashgate, 2007), 92.

[17] Robert D. Sack, "Place, Power, and the Good," in *Textures of Place: Exploring Humanist Geographies*, ed. Paul C. Adams, Steven Hoelscher, and Karen E. Till (Minneapolis: University of Minnesota Press, 2001), 233.

[18] Miles Richardson, "Place and Culture: Two Disciplines, Two Concepts, Two Images of Christ and a Single Goal," in *The Power of Place: Bringing Together Geographical and Sociological Imaginations*, ed. John A. Agnew and James S. Duncan (Boston: Unwin Hyman, 1989), 142.

[19] Jonathan M. Smith, "The Place of Value," in *American Space/American Place: Geographies of the Contemporary United States*, ed. John A. Agnew and Jonathan M. Smith (New York: Routledge, 2002), 53.

and intellectual dynamics of locations, and, thus, places change when people's lives and cultures evolve.

In discussing how individuals' histories and cultures are reflected in places, Casey perceptively points out that "'place' … is the immediate ambiance of my lived body and its history, including the whole sedimented history of cultural and social influences and personal interests that compose my life-history."[20] Malpas also states that people and places have always mutually shaped one another throughout history and across cultures and elaborates on the link between humanity and location, a link which persists today:

> the basic notion of a tie between place and human identity is quite widespread, not only among pre-modern cultures from Australia to Americas, but also within contemporary culture. Within the latter context it often appears in terms of a preoccupation with genealogy, and so with the tracing of family ties back to particular locations, as well as in the sense of loss and dislocation that is so often noted as a feature of contemporary life.[21]

Malpas alludes here to one's connection to family history, which is usually linked to a particular location. When we say Māori, we immediately think of a place, namely New Zealand. Individuals have a tendency to associate themselves with other individuals who live in the same place, speak the same language, and share the same culture. In *Love Medicine*, Erdrich describes a scene in which Albertine wanders alone in an unfriendly city, looking for someone she can identify with; she finds Henry, who "could have been a Chippewa" and follows him rather than a white man.[22]

The novels under discussions contain abundant scenes that foreground Indigenous people's affinities for their homelands. One of Grace's protagonists returns home after many years and feels an instant connection to her birthplace, one that she has not felt after many years of living in the city. For Mata, home is the place where her ancestors are buried and her family members live. In Wright's novel, Mary and Jessie listen to the legend of a lake full of waterbirds which has dried up and witness how the waterbirds

[20] Edward S. Casey, "Body, Self, and Landscape: A Geophilosophical Inquiry into the Place-World," *Textures of Place: Exploring Humanist Geographies*, ed. Paul C. Adams, Steven Hoelscher, and Karen E. Till (Minneapolis: University of Minnesota Press, 2001), 404.

[21] J. E. Malpas, *Place and Experience: A Philosophical Topography* (Cambridge: Cambridge University Press, 1999), 4.

[22] Louise Erdrich, *Love Medicine* (New York: Henry Holt, 1993), 169.

come back to the lake after many years "as if they had known the waters were returning."[23] Like the birds, Mary and Jessie return to the place where their female relatives lived because they feel an inexplicable connection to it. In *Solar Storms*, Angel perceives her homeland as a combination of old and new, as "going home to a place I'd lived, still inside my mother, returning to people I'd never met."[24] The home Angel has never been to and her people, whom she has never met, seem familiar to her. In *Caprice*, Kate also returns to a familiar place she has never visited. Wright, Hogan, Pilkington, and Grace describe situations in which Indigenous characters feel powerful connections to the places of ancestors they have seldom or never visited because these places promise a familiar past and a safer future.

Other Indigenous characters adjust their needs, dreams, and interests to new places quite different from their initial homes; however, most of them are able to make use of the traditions of their homelands in their new homes. Makareta in *Cousins*, Mary in *Plains of Promise*, Marilyn in *Daughters Are Forever*, and Penny in *whispering in shadows* are advocates for the rights of Indigenous people in New Zealand, Australia, and Canada. Makareta's and Penny's tribal wisdom and knowledge of local customs help them promote Indigenous culture. Mary's and Marilyn's social work for Indigenous organizations, which they perform away from their destructive homes, aids them in healing their own wounds. Hulme's characters also try to heal in places other than their homelands and to create spaces where they can preserve their different traditions. Finally, Erdrich's protagonists decide where they belong by leaving and returning to their reservation.

When they explore the relationship between place and culture, Casey, Basso, Gunn Allen, Malpas, Massey, and others also underscore the importance of communities and collectivities and the idea that culture is seldom produced by individuals in isolation. Authors such as Hogan, Armstrong, and to a lesser extent Wright and Grace, show how ceremonies, dances, and agricultural rites are performed only in specific Indigenous communities and regions. Allen also insists that the spirituality of a place is shaped by the people's culture. The oral culture of Indigenous people in general, and Native Americans in particular, underscores the distinctive features of certain regions, places, and lands inhabited by Indigenous people:

[23] Alexis Wright, *Plains of Promise* (St. Lucia: University of Queensland Press, 1997), 302.
[24] Linda Hogan, *Solar Storms* (New York: Simon & Schuster, 1995), 26.

A region is bounded, characterized by geographical features, but these features take on a human and spiritual dimension when articulated in language. The smells, sounds, and tactile sensations that go with a locale are as central to its human significance as the sights, and it is within the stories that all the dimensions of human sensation, perception, conceptions, and experience come together, providing a clear notion of where we are, who we are, and why.[25]

Allen suggests that the stories the Indigenous people tell, stories that "are as old as the land," offer younger generations a sense of belonging to specific geographical regions and an understanding of their ethnic and geographical identities.[26]

Malpas explains that people invest the places where they live with cultural meaning: "The land around us is a reflection, not only of our practical and technological capacities, but also of our culture and society – of our very needs, our hopes, our preoccupations and dreams."[27] Basso argues that people present "culturally mediated images of where and how they dwell ... that reproduce and express their own sense of place – and also, inextricably, their own understanding of who and what they are."[28] Basso gives examples of people's relationships to places that manifest themselves in the form of "myth, prayer, music, dance, art, architecture, and ... recurrent forms of religious and political ritual."[29] Casey concurs with what Malpas and Basso have written, stating that "place, already cultural as experienced, insinuates itself into a collectivity, altering as well as constituting that collectivity. Place becomes social because it is already cultural."[30] Massey, who has written on place and gender, agrees with Casey when she defines place as a meeting point of cultures and communities: "the very formation of the identity of a place – its social structure, its political character, its 'local' culture – is also a product of interactions."[31] The social and cultural

[25] Paula Gunn Allen, *Off the Reservation: Reflections on Boundary-Busting, Border Crossing, Loose Canons* (Boston: Beacon Press, 1998), 234.

[26] Ibid.

[27] Malpas, 1.

[28] Keith Basso, "Wisdom Sits in Places: Notes on a Western Apache Landscape," in *Senses of Place*, ed. Steven Feld and Keith Basso (Santa Fe: School of American Research Press, 1996), 57.

[29] Ibid.

[30] Edward S. Casey, *Getting Back into Place: Toward a Renewed Understanding of the Place-World* (Bloomington: Indiana University Press, 1993), 31.

[31] Doreen Massey, *Space, Place, and Gender* (Minneapolis: University of Minnesota Press, 1994), 120.

interactions among people have come to represent the identities of specific places, and they also influence the identities of the people who inhabit them. Among other Indigenous critics, Simon Ortiz speaks of the interdependence of land and people in Native cultural philosophy: "without land there is no life, and without a responsible social and cultural outlook by humans, no life-sustaining land is possible."[32] For numerous Indigenous tribes and communities around the world, the land provides nourishment while it represents a historical and cultural reservoir of accumulated knowledge. In her critically acclaimed study, *The Sacred Hoop*, Allen underscores Indigenous people's preoccupation with genealogy and family by identifying them with their lands: "We are the land ... that is the fundamental idea that permeates American Indian life; the land (Mother) and the people (mothers) are the same."[33] Like other critics, Ortiz and Allen provide essentialist views of the land as an unchanging entity and of the relationship between Indigenous people and place, views which are, to a smaller or larger degree, shared by some Indigenous writers. However, while acknowledging essentialist tendencies and nuances in the theory and fiction I examine, I argue that Indigenous characters construct at least partially the places they inhabit and show that places are changed by people's perceptions and actions.

As noted in many examples above, recent critical discussions on place point toward cultural interactions inside communities, ones that are presumed to influence individuals in specific ways. Scholars who write about identity, and Indigenous identity in particular, also posit that, for the most part, identity is constructed within groups, families, tribes, and communities, and so, Indigenous people create their ethnic identities from the wisdom and tribal knowledge of Indigenous groups and communities.[34] Schouls and

[32] Simon J. Ortiz, "Introduction: Wah Nuhtyuh Dyu Neetah Tyahstih (Now It Is My Turn to Stand)," in *Speaking for the Generations*, ed. Simon J. Ortiz (Tucson: University of Arizona Press, 1998), xii.

[33] Paula Gunn Allen, *The Sacred Hoop: Recovering the Feminine in American Indian Traditions* (Boston: Beacon Press, 1992), 119.

[34] K.I.M. van Dam's definitions of ethnic and cultural identities emphasize that identity is derived from the groups and communities to which individuals belong. van Dam defines ethnic identity as "the consciousness which a group whose members are deemed to have the same geographic origins, phenotype, language or way of life has of its economic, political and cultural distinctiveness in relation to other groups" and claims further that "Manifestations of culture such as language, norms and values and worldview are used to constitute cultural

Onsman, who write on Indigenous people in Canada and Finland respectively, argue that Indigenous identity is based on communal ties to a specific territory, culture, and tradition. Onsman states that "identities often grow out of group membership – bonds, relationships, solidarities."[35] Schouls adds that "the well-being of Aboriginal identity is tied directly to the strength and vitality of those community practices linked to distinctive artistic endeavours, economic pursuits, political organizations, and social arrangements."[36]

Malpas elaborates on the relationship between identity and place and concludes that identity depends on the interaction among different subjects in specific locations: "[the] dependence of self-identity on place derives ... from both the general characterisation of subjectivity as a structure that is embedded in a world of other subjects and of multiple objects, and from ... the subject's active engagement with the surrounding environment."[37] Identity, Malpas argues, is seldom formed in isolation but becomes the sum of social, local, and cultural interactions and, I would add, other people's memories and experiences. Hogan shows in *Solar Storms* that Angel's formation of identity as a daughter, a Native American, and an environmental activist is tied to the identities of those relatives who guide her in her journeys. Her mother figures' memories of Hannah help Angel understand who her mother was and who she is. Pilkington describes a similar situation in *Caprice*, in which Kate finds out details about the lives of her grandparents from their lifelong friends. Both Hogan and Pilkington show that identity is embedded in the lives and memories of other subjects. Also, both Pilkington and Hogan describe situations in which their protagonists develop as Indigenous women because they have experienced different locations from those they have become used to, namely places where their family members lived.

Like Schouls, Onsman, and Malpas, who underscore how the cultures of communities flourish in specific locations, Renya Ramirez, a Winnebago/Ojibwe ethnographer, looks at how one diverse group, urban

identity." "A Place Called Nunavut: Building on Inuit Past," in *Senses of Place: Senses of Time*, ed. G.J. Ashworth and Brian Graham (Aldershot: Ashgate, 2005), 107-8.
[35] Andrys Onsman, *Defining Indigeneity in the Twenty-First Century: A Case Study of the Free Frisians* (New York: Edwin Mellen Press, 2004), 69.
[36] Tim Schouls, *Shifting Boundaries: Aboriginal Identity, Pluralist Theory, and the Politics of Self-Government* (Vancouver: UBC Press, 2003), 176.
[37] Malpas, 177.

Native Americans, maintains its traditions and relationships to their lands and tribes. Ramirez develops the concept of the Native hub and "emphasizes the importance of Indians' relationship to *both* homeland and diaspora, thereby supporting a consciousness that crosses large expanses of geographical terrain, which can bridge not only tribal but also national-state boundaries."[38] According to Ramirez, Indigenous people do not have to live on their homelands to stay connected to their tribal roots; on the contrary, tribal cultures flourish and Indigenous people's links to their land become stronger when they live in cities. Ramirez remains optimistic about the cultural future of Indigenous people who travel, relocate, and adapt to an ever-changing world and posits that urban Indians bridge geographic distances, promote their tribal cultures, and rejuvenate Indigenous culture. Ramirez's insightful theory clarifies urban Indigenous people's choices to live in cities and maintain connections to their lands and communities in villages and reservations. Erdrich's protagonists become "Native hubs" as they cross the boundaries of the reservation, live in other places, and return to the reservation. Wright's characters, however, fall into a different category of Indigenous people because they have lost the connections to each other and to their Aboriginal community and cannot preserve and transmit their culture in the same ways Erdrich's Native Americans can. Similarly, Pilkington's protagonist has no connections to her Aboriginal home and family for most of her life, while Maracle's protagonist does not return to her home and community. Wright's, Pilkington's, Maracle's, Hulme's protagonists, and others use their imaginations and inventiveness in their responses to places, and they create, remember, and invent their homes. These characters' responses to places are recreated mostly in their minds. Thus, the protagonists' relationships to places are reflective of specific national, local, and personal contexts.

Each character's experience of place is both unique and cultural because of the creative exchange that transforms both the individual and the place. Physical places shape the identities of individuals, just as those individuals create the cultural aspects of places. Places allow characters to find connections to the past, to make sense of their present, and to open up possibilities for the future. They regenerate people and their cultures and make possible the dialogues among generations of Indigenous people who

[38] Renya R. Ramirez, *Native Hubs: Culture, Community, and Belonging in Silicon Valley and Beyond* (Durham: Duke University Press, 2007), 11.

have inscribed their lives onto those places. Places invite Indigenous characters' imaginative reconstructions that create opportunities for healing and ethnic and cultural rejuvenation.

CHAPTER 2

BORDERLINE INDIANS, PLACES, AND TRADITIONS: LOUISE ERDRICH'S *LOVE MEDICINE*

Alexis Wright, Keri Hulme, Patricia Grace, Lee Maracle, Jeanette Armstrong, and Doris Pilkington portray Indigenous people who leave or return to their birthplaces, and, in doing so, rejuvenate the cultural practices of their homelands. It is through Indigenous people's returns to real or imagined homes that they change, reinterpret their personal and national histories, and establish links with the past, ones which are significant to their presents and futures. Places as meeting points for histories, cultures, races, and ethnicities leave room for individual transformations, and the Indigenous people living in various places in the United States, Canada, Australia, and New Zealand adapt to their changing worlds and in doing so, change the social and cultural features of their homelands and new homes. Like other Native American authors, Louise Erdrich and Linda Hogan also present Indigenous characters who travel back and forth until they come to an understanding about where they belong. For Hogan, a village on the border between the United States and Canada is the place to which her characters come back, while Erdrich chooses the reservation as the focal point of her characters' returns.

A member of the Turtle Mountain Chippewa band, Erdrich draws on her Chippewa, French, and German descent to analyze the identities of characters of full- and mixed-blood, their relationships with their reservation and tribal culture, and their understanding of "being Indian." Rather than examining one Indigenous character who epitomizes a group, tribe, or community, Erdrich creates sketches of Native Americans of different ages, social classes, professions, and religions, with differing aspirations, who choose to live on their homeland or outside it. In *Love Medicine* (1993), the protagonists' various responses to the same place suggest not only that the reservation has fluid borders, but that they are also presented with more choices because of this fluidity. Viewing the reservation as an ancestral homeland, many of Erdrich's full-blood Indian characters preserve their tribal traditions, such as hunting and healing practices. On the other hand, the younger, mixed-blood characters do not necessarily see the reservation as a stable and perennial entity, and they travel in and out of the reservation, continuously revising the traditions of the place. Amelia V. Katanski argues

that Erdrich proposes a mechanism through which revisions of traditions lead not only to the survival of these traditions, but also to significant connections and dialogues between younger and older generations of Native Americans. Katanski states that "as each branch grows, develops, and tells its story, we see the Ojibwe roots of these characters flourish and continue, changed, but still powerful, adapting traditional ceremonies to heal in the contemporary world."[1] For Katanski, new branches represent some young tribal members who still perform ceremonies and traditions on a reservation with open borders with the contemporary world. Through their recreations and revisions, Erdrich's characters do not perform old traditions in the same manner in which their ancestors did, but they preserve traditions in some form and celebrate them.

Some critics view outside influences on Indigenous traditions as damaging to tribal cultures. Joel Waters believes that reservations are the only places where Native American traditions are kept alive: "Even though the reservations are dirty and in bad shape, it's still the only place where Native Americans are allowed to be themselves, and our culture is best preserved there because that's where most traditions and elders are."[2] Waters implies that Native Americans lose some of their cultural practices when they leave their reservations or when they change the traditions of their elders. Michael Wilson posits that the interaction between Indigenous people and nonindigenous populations brings fragmentation to the unity of tribal communities and claims that "Louise Erdrich's *Love Medicine* enacts a dynamic tension of an indigenous community that simultaneously moves both inward toward its traditions, and outward toward fragmentation and loss."[3] The United Stated government policies that led to the Native Americans' loss of tribal land and the conflicts between younger and older generations, full-blood and mixed-blood Native Americans, supporters of tribal traditions and innovators, and Amer-Europeans and Indians have contributed to the fragmentation of older traditions over the years. Yet,

[1] Amelia V. Katanski, "Tracking Fleur: The Ojibwe Roots of Erdrich's Novels." in *Approaches to Teaching the Works of Louise Erdrich*, ed. Greg Sarris, Connie A. Jacobs, and James R. Giles (New York: Modern Language Association, 2004), 73.
[2] Joel Waters, "Indians in the Attic," in *Genocide of the Mind: New Native American Writing*, ed. MariJo Moore (New York: Thunder's Mouth Press, 2003), 91.
[3] Michael D. Wilson, *Writing Home: Indigenous Narratives of Resistance* (East Lansing: Michigan State University Press, 2008), 111.

political and cultural fragmentation does not necessarily lead to a complete loss of traditions. Erdrich does show that in an ethnically dynamic place such as the Turtle Mountain Reservation, a unified and pure Chippewa tradition is less likely to exist or be preserved because outside influences have defined and revised that tradition. Erdrich also focuses on the ways her characters manage to preserve tribal traditions by recreating them and adapting them in a contemporary context. The reservation shelters Indigenous people who do not completely lose the traditions of the elders but adapt them to a world undergoing a continuous transformation.

The inhabitants of the Turtle Mountain Reservation cross its boundaries or other types of borders between cultures, religions, and ethnicities, and these "crossings" bring about numerous rewritings of traditions. Helen Jaskoski argues that Native American writers are interested in borders, boundaries, and cultural borderlands "where lines between ethnic groups are drawn, denied, defied, and proudly distinguished."[4] Through the crossing of territorial, biological, and psychological borders, Erdrich's characters establish rapports with various people and cultures, revise their Chippewa traditions, and adapt these traditions on the reservation. The history of the Turtle Mountain Reservation underscores the ethnic and cultural diversity of its inhabitants, which causes Indian identity to change continuously and be recreated. The French and English fur traders, who traveled to get furs from the tribesmen, and the Catholic missionaries, who promoted their religion, changed Indian family dynamics as well. "The Chippewa and the traders maintained considerably friendly contact."[5] The initial contact between fur traders and Indians and First Nations peoples, which was economically oriented, was followed by the marriages of the fur traders with Native American women. Hogan, who also describes the influence of the fur traders in places inhabited by Native Americans in *Solar Storms*, views their migration in a negative light. Hogan comments on how the fur traders returned to Canada when fur companies no longer needed their services and

[4] Helen Jaskoski, "From the Time Immemorial: Native American Traditions in Contemporary Short Fiction," in *Louise Erdrich's Love Medicine: A Casebook*, ed. Hertha D. Sweet Wong (New York: Oxford University Press, 2000), 27.

[5] Julie Maristuen-Rodakowski, "The Turtle Mountain Reservation in North Dakota: Its History as Depicted in Louise Erdrich's *Love Medicine* and *The Beet Queen*," in *Louise Erdrich's Love Medicine: A Casebook*, ed. Hertha D. Sweet Wong (New York: Oxford University Press, 2000), 15.

abandoned the Native American women they had married and left them to raise their children by themselves.

In Erdrich's novel, however, contact with the fur traders and the Catholic Amer-Europeans has led to the ethnic diversity of the reservation. The Turtle Mountain Reservation families include the Kashpaws, who are the tribal leaders, the mixed-blood Lazarres and the Lamartines, and the Morrisseys, a mixed-blood family who have lost their land. Over the course of six decades and four generations, these family members' relationships with each other and with their ancestral land change. The marriage between Nector Kashpaw, Rushes Bear's and Kashpaw's son, and Marie Lazarre is a union between a Native American and a descendant of the French fur traders. Marie, the daughter of Pauline Puyat and Napoleon Morrissey, is proud of her Catholic faith, which she tries to instill in her children and grandchildren.

Maristuen-Rodakowski argues that the influence of Roman Catholicism on the Turtle Mountain Reservation started in around 1817, when Catholics "felt a moral obligation to 'save' the Indians, and they established schools that educated the children and convents that ministered to the needs of the people."[6] Wright, Grace, and Pilkington also describe how Christian missionaries "educated" Indigenous children, who were estranged from their families and forced to attend Christian schools. Erdrich points out that exposure to other religions and lifestyles is inevitable, and many of her mixed-blood characters struggle to balance more Western influences with their Native American traditions. Marie's and Nector's daughter, Zelda, for instance, marries European men, and their granddaughter, Albertine, leaves the reservation at fifteen and chooses to live in the city. The history of the Turtle Mountain Reservation entails Native Americans' negotiations of borders between themselves and different peoples, ethnicities, and religions and their development after these interactions. The social and cultural influences point to how the reservation has not been an enclosed space but a transformative place which reinvents itself and its people.

Political and social changes that revolve mainly around the loss of land, assimilation to mainstream culture, and exposure to ethnic and cultural influences coming from outside and inside the reservation lead to Erdrich's characters choosing to stay or leave their home. Like Wright, Pilkington, Grace, and Maracle, whose Indigenous characters leave their communities to live in big cities, Erdrich focuses on characters who often exchange life on

[6] Ibid., 19.

the reservation for a different experience elsewhere. She also shows the evolution of Native American families living on the reservation over the course of several generations. While older characters, who are often full-blood Indians, are more reluctant to absorb outside influences and therefore remain on the reservation, the younger generations of Native Americans are more eager to leave home and experience other places. Lyman becomes the administrator of the Bureau of Indian Affairs in Aberdeen, moves back to the reservation to run the souvenir factory that his father had started, and opens a casino, an endeavor which upsets many full-blood Native Americans. Other characters are faced with identity crises and personal ambitions that involve crossing the borders of the reservation or continuing the Ojibwe traditions on the reservation. Albertine leaves home and studies to become a nurse and, later on, a doctor, but she attends ceremonies and other familial and cultural events on the reservation. Lipsha, a present-day Indian bricoleur, recreates some of his ancestors' Ojibwe practices, including concocting a love medicine for his grandparents. Gordie and Eli adapt a traditional activity such as hunting to their world – one with no skilled hunters.

With such a plethora of characters, who have quite different answers for how they define home and traditions, readers often ponder Erdrich's overall message about the reservation sheltering such diversity. *Love Medicine* starts with the story of June Kashpaw, who intends to return to the reservation but never makes it because she freezes to death on her way home. The narrator comments that June knows exactly where she is going and after she crosses the fields of snow, June already feels at home, "as if she were walking back from a fiddle dance or a friend's house to Uncle Eli's warm, man-smelling kitchen."[7] The fantasy of her uncle's kitchen, which she sees before she dies, underscores what June values. She honors the place of her childhood and her uncle, who raised her like his own daughter, and she dies with this image in her mind. The brevity of the episode prevents critics from drawing conclusions about the reasons behind June's death, yet it is clear that her intention was to come home. Despite her premature death under unclear circumstances, June is brought to life through the characters' memories of her and her son's, Lipsha's, search for his identity. Like his dead mother, who "walked over it [snow] like water and came home" (7), Lipsha manages to "cross the water, and bring her home" (367) at the end of the novel. Here,

[7] Louise Erdrich, *Love Medicine* (New York: Henry Holt, 1993), 6. Further page references are in the main text.

"her" could allude to his mother, which would make his return home also hers. John Purdy claims that with these two lines "Erdrich has established a circular structure, but more importantly an implication of continuance and endurance, tied to home, that provide a precarious counterbalance to the images of loss, disintegration, and assimilation that some readers may initially discern."[8] Despite the characters' turmoil and identity crises, Erdrich's overall message could be interpreted as optimistic. The novel begins and ends with June and Lipsha returning to the reservation, which is regarded as a stable and meaningful home by some characters.

Another return home, in the chapter entitled "The World's Greatest Fishermen," is Albertine's. Albertine, a nursing student who lives in the city, runs away from her mother's house, but she often returns home. In the first chapter of *The Bingo Palace*, Albertine, who studies to become a doctor, dances at the winter powwow with her friend, Shawnee Ray Toose, whom Lipsha falls in love with. In chapter three of *The Bingo Palace*, Albertine attends a naming ceremony conducted by Xavier Albert Toose, her own namesake and Zelda's suitor, and receives the name Four Soul, which originally belonged to a Pillager healer four generations earlier. Known for their healing practices and the preservation of old traditions, the Pillager family members hold on to their land, which is considered to have power and a special sanctity. The naming ceremony on the reservation constitutes one of Erdrich's happy coincidences because it suggests a fruitful continuation of Albertine's past, along with her family's in the present. Albertine built a successful career in the city and fulfilled the destiny of the family when she became a doctor, thus continuing the family's old healing traditions in a new context.

Other characters leave home in search of adventures and various dreams that they do not necessarily fulfill somewhere else, and, when they return to the reservation, some cannot adapt to their old lives. Lulu's son, Henry, fights in Vietnam, and when he comes home, he presumably suffers from post-traumatic stress disorder and ultimately commits suicide. From bits and pieces of information, readers gather that Albertine's life in the city is lonely and discomforting at first. The sex scene with a Chippewa, who proves to be Henry Lamartine, reveals Albertine's disorientation in an unfriendly city

[8] John Purdy, "Building Bridges: Crossing the Waters to a *Love Medicine*," in *Teaching American Ethnic Literatures: Nineteen Essays*, ed. John R. Maitino and David R. Peck (Albuquerque: University of Mexico Press, 1996), 86-87.

rather than her adaptability to the new environment. The narrator comments that Albertine is frustrated and disappointed after she leaves home: "Now that she was in the city, all the daydreams she'd had were useless. She had not foreseen the blind crowd or the fierce activity of the lights outside the station" (168). Barbara Helen Hill describes Native Americans' experience in the city as disastrous: "What the Indians found [in the city] were poorly paying jobs, if there were any jobs; ghettos to live in with heartbreak, loneliness, confusion; and homesickness that led to alcoholism, death, and dishonor, not necessarily in that order."[9] Hill's description points to the discrimination against Native Americans, who were ultimately denied the possibility of a home outside of the enclosed space of the reservation. While Albertine, Henry, and Gordie are in a state of exile on the reservation, other characters, such as June, Lipsha, Uncle Eli, Lulu, and Moses Pillager, feel at home on the reservation and value its old traditions.

Erdrich's characters who crossed the borders of the reservation, including Albertine, June, Lulu's boys, and Lipsha, share mixed feelings of joy, melancholy, and anxiety when they return home. June is glad to return home, and she dies with the image of home in her mind, while Henry Lamartine comes home to die. Albertine worries about seeing her mother, who announced her aunt's death only after two months and suspects that Zelda is still upset that her daughter had fled from the reservation. As she is driving home, Albertine admires the beautiful land close to the reservation and describes her home as a landscape which stands out. Although Albertine is reminded of the impoverished state of the reservation when she sees the highway turn to gravel with holes, dust, and ruts, she feels that the reservation is a distinctive place set in opposition to everything else.

Albertine complains that the politics of allotment, which mistakenly sought to transform Indians into farmers, contributed to the loss of the reservation land, which was sold to Amer-Europeans. Unlike many Native Americans, including Albertine's great-grandparents and grandparents, who had little interest in farming, people of European descent such as Zelda's husbands, bought or were allotted land on the reservation. The location of the house of Zelda and her new husband, Bjornson, built right on the edge of the reservation, underscores the borderline identity of its inhabitants. Zelda, who married men of European descent, teeters between her Indian identity and

[9] Barbara Helen Hill, "Home: Urban and Reservation," in *Genocide of the Mind: New Native American Writing*, ed. MariJo Moore (New York: Thunder's Mouth Press, 2003), 22.

her European education, which inspires a different attitude toward the land. Hill comments on how the Relocation Act and the allotment policies denied Native Americans a better life rather than promised them one: "After the government took their land and put them on reservations, it then took their livelihood of hunting and fishing and harvesting. Placing the Native people on land that would not grow a blade of grass, never mind crops, was just another way to assimilate, annihilate, and decimate."[10] Since reservations started to look similar to regular towns and the people did not have the means to preserve their traditions as they used to, many Native Americans felt the need to leave the reservations altogether and live in cities. In addition, the city promised a more attractive and financially secure, life, which it did not necessarily deliver.

In *Tracks*, Erdrich details how the United States government's extreme policies led to the loss of the land on the Turtle Mountain Reservation. Although Erdrich does not mention the Dawes Allotment Act of 1887 directly, critics believe that the consequences of the act are seen in Erdrich's novels. Circe Sturm contends that, through the Dawes Act, the United States government used the Indian blood quantum to control Native Americans' access to economic resources. Sturm posits that "Native Americans living on reservations who were documentably of one-half or more Indian blood received allotments, while those who did not meet this standard were simply excluded."[11] The consequences of the Dawes Act, however, were far more dramatic because many Native Americans, including full-bloods, lost their land altogether. Lorena Stookey argues that the Dawes Allotment Act, which encouraged Native Americans to give up their traditional hunting and gathering practices, "allowed tracts of arable land that had been communal reservation property to be allotted to individual tribal members."[12] Margaret Rushes Bear Kashpaw, for instance, was allotted land on what was once the Ojibwa reservation, but her children were allotted land in Montana, so Rushes Bear divided her time between Montana and the reservation. *Tracks* covers the difficult years after the period of grace promised by the Dawes Allotment Act, which provided that no property taxes had to be paid for

[10] Ibid.

[11] Circe Sturm, *Blood Politics: Race, Culture, and Identity in the Cherokee Nation of Oklahoma* (Berkeley: University of California Press, 2002), 78.

[12] Lorena L. Stookey, *Louise Erdrich: A Critical Companion* (Westport: Greenwood Press, 1999), 72.

twenty five years. After this period of grace, some landowners sold their allotments, while others borrowed against their allotments and, when they could not repay the loans, lost their allotments altogether. Unlike the Morrisseys, who profit from the Dawes Allotment Act and acquire more land, Fleur Pillager and Nanapush lose their family land and lament the destruction of the values and traditions connected to it. Fleur manages to avoid facing the invading loggers, who want to move to her land, and sabotages their equipment many times, but she eventually loses her land and is forced to send her own daughter, Lulu, to a boarding school – a regrettable choice which causes Lulu to distrust her mother.

The family reunion following Albertine's return to the reservation at the beginning of *Love Medicine*, in which several family members participate, reveals conflicts between generations, struggles about the characters' Indian mixed-blood identities, and offers commentary on religion, race, and ethnicity. Many of the tensions seen in the characters' conversations are the direct result of past government policies and allotment acts that created division, envy, and hatred among tribe and family members. Whenever the discussions veer toward ethnicity, race, religion, land, and tradition, the characters argue because some of them are sensitive about and, to some extent, confused about their mixed-blood identities. Devon Mihesuah comments on the status of mixed-blood Indians within reservations and states that "usually, but not always, mixed-bloods had more money and material goods than fullbloods, and they maneuvered themselves into tribal leadership positions ... Their 'white blood' also contributed to their feelings of importance. From their point of view, they were in the superior 'class.'"[13] On the other hand, Mihesuah views full-blood Indians as people "who valued tribal traditions and resisted acculturation [and who] believed themselves to be 'more Indian' than the 'sell outs.' Many biracial Indians may have been more wealthy and educated than fullbloods, but among traditionalists, these were not enviable social traits."[14] It is no surprise, then, that many of Erdrich's full-blood characters, including Fleur Pillager, lose their land, while the mixed-blood characters or the Indian characters married to whites keep their land and even prosper. Other critics, however, underline the

[13] Devon A. Mihesuah, "Commonality of Difference: American Indian Women and History," in *American Indians in American History, 1870-2001: A Companion Reader*, ed. Sterling Evans (Westport: Praeger, 2002), 169.

[14] Ibid.

challenging existence and continuous struggle of mixed-blood Indians, who are torn between at least two cultures. Nancy Mayborn Peterson analyzes life stories narrated by mixed-blood Indian women and argues that many of them "earned their places as leaders in both white and Indian societies"[15] despite their concerns that they did not fully belong in either culture. Claiming that "blood, race, culture, language, religion, national politics ... can both unite and divide Cherokee citizens," Sturm urges Cherokee and other Native Americans of mixed descent to perceive these blood differences "not as a source of social and political factionalism but as one of strength."[16] Erdrich's Albertine, for instance, manages to be successful both in the city and on the reservation. However, many Native Americans, as Erdrich shows, still have to come to terms with their mixed-blood identities.

The biting dialogue among Zelda, her sister, Aurelia, and Albertine uncovers some hidden layers of the anxiety these mixed-blood Native Americans feel about their identities and their relationships to the traditions of the elders. When Zelda asks her daughter whether she met any marriageable boys in the city, she alludes to Catholic boys, the only ones who are deemed honorable and suitable for her daughter. Zelda values her mother's religion, and she tries to impose it on her daughter as well. She also looks down on King's wife, Lynette, a woman of Norwegian descent, and complains about her. Forgetting that her own situation is similar, Zelda probably considers that marriage between a Native American man and a white woman of European descent is unnatural: "'That white girl ... she's built like a truck driver. She won't keep King long'" (24). Instead of blaming King's violent temper for most of the couple's arguments, Zelda criticizes Lynette's physical appearance and implicitly blames her ethnicity for their possible divorce. In her mind, "whiteness" equates with discord and bad genes. Zelda does not like to be reminded that Albertine's father is Swedish and white, and, when she is cornered by Aurelia, she uses her Indian identity as a way out of a difficult situation. Aurelia scolds her: "'*Jeez*, Zelda! ... Why can't you just leave it be? So she's white. What about the Swede? How do you think Albertine feels hearing you talk like this when her Dad was white?'" (24). Aurelia obviously suggests that Albertine is light-skinned, thus more prone to embrace Amer-European values, so Zelda's criticism of

[15] Nancy Mayborn Peterson, *Walking in Two Worlds: Mixed-Blood Indian Women Seeking Their Path* (Caldwell: Caxton Press, 2006), xiv.

[16] Sturm, 210.

white and light-skinned people implies a belittlement of her own daughter. Zelda answers Aurelia promptly, saying: "'My girl's an *Indian* ... I raised her an Indian, and that's what she is'" (24). Zelda makes the argument that despite genetics, her daughter is "Indian" because she educated her in Native American traditions. Aurelia's comment that Albertine is more beautiful than the Kashpaws is again ironic because Aurelia implies that her niece got her slim figure and good looks from her white father and not from her Indian genes.

The verbal exchange between the two Kashpaw sisters is humorous, but it raises several issues about identity on the reservation and outside it. Erdrich's protagonists have problems identifying themselves as mixed-blood Native Americans and recognizing that their identities are the result of the historical, social, and political changes the reservation underwent. Their self-characterizations betray friction, tension, and a certain degree of confusion about their identity. Both Zelda and Aurelia are the children of a Catholic mother who does not necessarily describe herself as Indian and an Indian father who, unlike his brother, leads a more Western-oriented life. Although Zelda treasures her Indian heritage and her Catholic religion, she sometimes turns against them without realizing that she is turning against herself. Even though some of Erdrich's characters are Christian Native Americans and involved in inter-faith and interracial relationships and marriages, they find it difficult to come to terms with their hybrid identities and reconcile the racial, ethnic, and religious components of their self-conceptions.

The dialogues between Eli and the other family members are not as sarcastic as Zelda's and Aurelia's because Eli's opinions are respected and taken into consideration. Kashpaw's and Rushes Bear's son and Nector's twin brother, Eli lives a more traditional life in which he at least tries to imitate his ancestors. In a disappearing traditional world torn by policies that work to destroy Native American thought and culture, Eli is among the few on the reservation who preserves his heritage. Applying the old ways to his modern life and world, Eli stayed on the reservation, lived closer to nature, and continued to hunt, cook, and speak occasionally in the old language. Rushes Bear allowed government officials to take Nector and educate him in American schools and hid Eli from them so that "Nector came home from boarding school knowing white reading and writing, while Eli knew the woods" (19). The places where they grew up and were educated influenced Eli's and Nector's lives and alternatives. By choosing different types of

education for her sons in two different places, Rushes Bear exposed them to two cultures and lifestyles. Nector becomes the chairman of the tribe, flirts with a possible Hollywood career as an Indian extra, marries Marie, a Catholic woman, and has a lifelong affair with Lulu. His love interests almost mirror his divided life, which turns toward both the white and the Native American cultures. Marie is the ambitious wife who pushes her husband to succeed both on the reservation and outside it; she encourages Nector to go to Washington and invite senators and governors for dinner and hunting in the woods. Lulu, Fleur's daughter and Nanapush's granddaughter, satisfies Nector's need for freedom and adventure outside his marriage. Eli, on the other hand, remains a bachelor who leads a solitary life, and, he tries to adapt the lifestyle of his ancestors to a modern-day world. In the end, Eli's life, which emphasized his love for his place of birth and his interest in the language of his ancestors, then hunting techniques, and traditional cooking, proves healthier and richer than his brother's. Albertine concludes that at the end of their lives, "Eli was still sharp, while Grandpa's mind had left us, gone wary and wild" (19). Eli seems to have found more meaningful resources to draw on in order to insure a spiritual and healthy existence, one which celebrates the traditions of his ancestors.

At the family reunion, Eli prides himself in speaking the old language once in a while as he is among the few old-time Indians who know the right words. He also likes to show his relatives that his taste in cooking sets him apart from the young Native Americans on the reservation. Eli teaches Gordie, King, Lipsha, and Albertine how to skin and cook a skunk and criticizes Zelda and her first husband, Swede Johnson, because they find skunk disgusting. He implies that Zelda and the younger generation are influenced by Western cuisine and veer away from traditional dishes. Yet Eli's language and taste in cooking do not necessarily make him what he calls an old-time Indian. He speaks English for the most part and eats the food cooked by Zelda. The same goes for his hunting methods, which continue the hunting of his ancestors in some fashion, but do not imitate them exactly. Eli delights in the variety of Western cuisine or profits from new tools, such as bullets, when he hunts. Although he takes advantage of the opportunities of a faster and more developed society, he makes use of the old traditions of his ancestors in this new world.

Gordie characterizes Eli as the last man on the reservation that could capture a deer. King refers to him as the world's greatest hunter and adds

fisherman as well. Although these compliments come from people who hunt and fish more poorly and seldom than Eli, they indicate that both men regard Eli as the authority on old traditions such as fishing and hunting. However, Eli talks about how he has to save his shells because "they was dear" a detail which suggests that he is not hunting with a bow and arrow (30). Robert Gish concludes that "Eli is a semi-modern hunter who relies on a gun and shells, albeit sparingly, he is still the nearest link to the old ways."[17] Eli is indeed practicing an improvised and modern type of hunting, but he can function as a teacher for King and Gordie, offering them an example they can follow. In fact, the name "Eli" from the Old Testament refers to the priest of Israel and the teacher of Samuel who did not hear the word of God but who knew God's way. Similarly, Eli could potentially be viewed as a teacher of traditions for the younger generations of reservation Indians. His knowledge of words in the old language, his familiarity with the traditional ways of hunting and cooking do not result in his exact reproduction of old traditions but still represent a continuation of these past traditions in the present. Although Eli adapted what he learned from his ancestors to an ever-changing life on the reservation, he still manages to perform a different version of the old traditions. Thus, the heritage will not be lost completely, but it will be preserved and adapted in new ways.

The tradition of hunting has been transformed and adapted in more drastic ways by other characters as well. In "Crown of Thorns," a chapter which describes Gordie's inner turmoil after June's death, Gordie hits a deer accidentally and imagines it is June. Torn by his own association of woman with animal, Gordie smashes the deer's head, a gesture which functions as his symbolic murder of June. Here, the hunting of animals and women stands for death, guilt, and violence. In such chapters as "Wild Geese" and "Love Medicine," hunting becomes a metaphor for courtship, sex, and love. "Wild Geese" depicts the meeting on the hill and the infatuation of Marie and Nector who, until that moment, planned to marry Lulu. Eli and Nector hunt for wild geese and sell them for alcohol and money, which Nector uses to take girls out. Hunting, thus, has lost its primary function, that of providing food, and has come to represent lust. Nector, who has dead geese hanging from his wrists and prepares to complete his transactions, sees Marie coming

[17] Robert Gish, "Life into Death, Death into Life: Hunting as Metaphor and Motive in *Love Medicine*," in *The Chippewa Landscape of Louise Erdrich*, ed. Allan Chavkin (Tuscaloosa: University of Alabama Press, 1999), 71.

down the hill from the convent and hunts her down until he realizes he is the one who is hunted. Erdrich reverses the traditional roles of the male hunter in search of prey and the female victim and suggests that hunting is empowering for women as well.

Marie counteracts Nector's intentions to steal from her and victimize her. Continuing the hunting he did with Eli in the woods, Nector hunts women as well, describing them in hunting terms and comparing them to animals: "I never move her [Marie]. She is planted solid as a tree. She begins to struggle to get loose ... But it is just to take aim. Her brown eyes glaze over like a wounded mink, but still fighting vicious" (63). Nector even feels compassion for the wounded Marie and thinks of all the wounded animals in the woods that he had to put out of their misery and of how he touched "the[ir] suffering bodies like they were killed saints I should handle with gentle reverence" (67). Yet Marie refuses to allow Nector to assume the traditional role of the hunter and does not permit him to treat her as a wounded animal who needs to be either saved or put out of her misery. Addressing the association between women and animals in women's fiction, Marian Scholtmeijer posits that "instead of reproducing the conventions of conquest, and using those conventions to compose the narrative of the animal ... [many] women writers ... expose and subvert the assumptions underlying victimization."[18] Instead of being a victim and easy prey, Marie is the one who laughs at Nector and beats him at his own game. In the end, Nector is forced to admit that Marie is not a thief but a brave, stoic, and attractive young woman.

The exchange of racial insults between Marie and Nector, while exposing the ethnic tensions on the reservation, also suggests that Marie is determined to resist Nector's physical and verbal attacks. Both Marie and Nector are judgmental and prejudiced against what the other represents. Marie says: "'Lemme go, you damn Indian ... You stink like hell ... you ugly sonofabitch'", while Nector calls her a "skinny white girl, dirty Lazarre!'" (63-64). In the end, Nector feels so ashamed that he thought Marie had stolen goods from the convent that he is willing to offer the dead geese to Marie as a gift. She refuses the gift but accepts Nector's company. Although Nector stops Marie from going down the hill, it is Marie who puts a stop to Nector's plans to marry Lulu, and she becomes his bride instead.

[18] Marian Scholtmeijer, "The Power of Otherness: Animals in Women's Fiction," in *Animals and Women: Feminist Theoretical Explorations*, ed. Carol J. Adams and Josephine Donovan (Durham: Duke University Press, 1995), 241.

Erdrich expands on the traditional activity of hunting and turns it into a courting ritual and into a vehicle empowering women. This transformation of the techniques and purpose of hunting shows again that old customs and traditions are constantly reinvented on the reservation, which is a place in a continuous state of change.

In "Love Medicine," Lipsha Morrissey practices a different kind of hunting and becomes a well-intentioned Cupid who wants to shoot his bow and hit Marie and Nector to rekindle their love. The dead pair of geese hanging from Nector's wrist foreshadows the ending of Marie's and Nector's relationship and marriage and suggests unfulfilled promises. Lipsha's elaborate plan involves two main elements of traditional Ojibwe culture, namely a love medicine and hunting. Lipsha, who believes he inherited his ancestors' healing powers, explains that the love medicine he intends to use on his grandparents is "something of an old Chippewa specialty. No other tribe had got them down so well" (241). Lipsha also seeks his great-grandmother's advice, and Fleur speaks with him in the old language about love and the value of the land, an episode which is narrated in *The Bingo Palace*. Lipsha wants to shoot a pair of geese and feed their hearts to his grandparents so that they stay in love for eternity. Following this plan, he thinks, will involve honoring Chippewa tradition, helping his grandparents, and demonstrating his potential. Repeating the actions of the mediocre hunters in his family, Lipsha delivers two shots, but misses them both. Lacking adequate hunting and shooting skills, Lipsha alters his plan and Chippewa tradition and uses frozen turkey hearts. To elevate his cheap substitution, Lipsha takes the frozen hearts to church to be blessed with holy water. In bringing together Ojibwe and Catholic rituals, Lipsha changes both traditions and adapts them to the present milieu of the reservation.

Analyzing the significance of Lipsha's love medicine, Katanski states that Lipsha proved himself to be a "budding successor to Fleur, improvising an appropriate ceremony by drawing on all his cultural influences."[19] Despite Marie's belief that the love medicine worked because Nector's presence is still felt after his death, Lipsha's love potion was not successful. However, whether Lipsha's love medicine worked or not is beside the point. What matters is that he found a way to carry on what the elders taught him. Since the boundaries between Catholic and Chippewa rituals are not clearly delineated anymore, it is not surprising that Lipsha and other characters bring

[19] Katanski, 73.

them together to create a contemporary ritual and salvage a Chippewa tradition. Lipsha's practices result from his early exposure to the cultural influences that he, along with other reservation Indians, absorbed. Emphasizing the survival of traditions over time and generations, Erdrich also creates situations that echo one another in ironic fashion, constantly reminding her characters and readers what these traditions are. When Lulu asks Nanapush what his love medicine is, he answers that Indian time, which runs without clocks and outside white time, heals him. Several years later, Lulu's grandson invents a crazy scenario which changes the symbolism and connotations of love medicines and parodies them.

Hunting and love medicines are not the only recreations of traditions that lead to their survival. The reservation shelters different individuals (close family members and those who are remotely related) whose completely different lifestyles make it a dynamic place. Moses Pillager lives a more traditional life than Eli himself; alone on his island, Moses is "talking only in the old language, arguing the medicine ways, throwing painted bones" (73). Even if they sometimes fail, people such as Moses, Lulu, Nanapush, and Eli try to keep Native American traditions alive on the reservation. Lipsha, Albertine, Gordie, King, and Eli adapt the old traditions to make them fit their changing world. Lyman Lamartine, one of Lulu's numerous sons, wants to change the face of the reservation altogether and transform traditional objects and customs into marketable commodities.

"The Tomahawk Factory" and "Lyman's Luck" focus on the economic realities of the reservation and on the debate among the tribe's members about maintaining versus exploiting heritage. As the home and lives of the reservation Indians change, so do their expectations and needs. While some of them are more reluctant to change, others welcome it. Lulu, Marie, and Lipsha, whom Lyman humorously calls traditionalists and "back-to-the-buffalo types" value their heritage and resist the commercialization of their culture (303). Lyman, on the other hand, sees no problem with exploiting his Chippewa culture and selling it. He wants to continue his father's legacy and "set into motion a tribal souvenir factory, a facility that would produce fake arrows and plastic bows, dyed-chicken-feather headdresses for children, dress-up stuff" (303). Native American art is reduced to cheap and kitschy objects that degrade the culture and its presentation to the world. Marie, Lipsha, and Lulu work at Lyman's factory out of economic necessity but

"are hostile to the idea of the mass production of the fraudulent Indian artifacts, which makes a mockery of Chippewa heritage."[20] In the brief, penultimate chapter of the novel, "Lyman's Luck," Lyman rethinks his business, anticipates the Indian gaming regulatory act, and plans to open up a casino on Fleur's land. Instead of exploiting Indians, he will create employment opportunities for them; in addition, he plans to exploit members of the white culture which oppressed Native Americans. This new scenario which Lyman envisions is "going to be an Indian thing ... based on greed and luck" (326-28). Lyman wrongly thinks that casinos constitute an honorable way for Native Americans to maintain their tradition, earn decent money, and find political justice. Several of Erdrich's characters oppose Lyman's project and believe that casinos pose serious threats to the preservation of traditional values and of the people's connections to their lands.

Numerous scholars in countless studies deplore the existence of casinos on Native American lands and argue quite adamantly that casinos bring insignificant financial gain and serve no cultural purpose. They also discuss the disorderly conduct, drug violations, and even crimes such as robbery, rape, and murder that are still prevalent in casinos. Nicolas Rosenthal frames his analysis of casinos in California around Native Americans' struggles against European and American colonialism, underscoring the commercialization and loss of their traditions along with other unresolved controversies surrounding "the legal status of casinos, tribal and economic diversification, and competition among gaming tribes."[21] Other critics concur with the general view, but try to consider some economic and social aspects of gaming. Underlining how Seminoles' commercial enterprises promoted cultural expression, Jessica Cattelino invites readers to move away from "what casinos have 'done' to native peoples' cultural and social life to instead show how tribal casinos are cultural and social practices worked out

[20] Allan Chavkin, "Vision and Revision in Louise Erdrich's *Love Medicine*," in *The Chippewa Landscape of Louise Erdrich*, ed. Allan Chavkin (Tuscaloosa: University of Alabama Press, 1999), 109.

[21] Nicolas G. Rosenthal, "The Dawn of a New Day?: Notes on Indian Gaming in Southern California," in *Native Pathways: American Indian Culture and Economic Development in the Twentieth Century*, ed. Brian Hosmer and Colleen O'Neill (Boulder: University Press of Colorado, 2004), 99.

at the interface of economy and cultural production."[22] Cattelino's ideas could be applied to Erdrich's novel because this critic invites us to think about the economic and cultural context that made possible and even facilitated the existence of casinos. Erdrich herself shows how gambling has been an old Ojibwa tradition and an avenue through which some of Erdrich's protagonists defined themselves. Lipsha, the orphan of the novel and the most worthy successor of his ancestors, recognizes his father at a poker game from the way Gerry Nanapush holds his cards. Ironically, Lipsha is the winner of the game and of June's car, an unlikely situation in which Lipsha's dead mother and his convict father are involved.

Critics argue that Erdrich's images of gambling and luck are related to Ojibwa traditions and make the case for the survival of these traditions. Lyman's casino, with all its downfalls, could keep some of these traditions alive. Stookey reminds us that gambling "is itself an ancient Ojibwa tradition and might prove to be the means by which the culture ensures its own continuing survival."[23] Purdy, in an article on images of luck in Erdrich's fiction, argues that gambling entails "the engagement of two societies [Euro- and Native American] and the juxtaposition of two conflicting views of the future" and he believes that "This confrontation is a recurring motif, another locus of colonial tension, but also transformation."[24]

Lyman's casino project, while a source of tension between the Native American and Amer-European cultures and peoples, constitutes a space in which the characters' fascination with luck and gambling can continue. Katanski makes the point that "there is more going on at the casino than Vegas-style gambling."[25] Erdrich shows that the characters' gambling is part of their tribal culture, and, thus, scenes in which characters gamble, play poker, win, and lose abound in her novels. At the beginning of *Tracks*, Nanapush tells his granddaughter, Lulu, that "the earth is limitless and so is

[22] Jessica R. Cattelino, "Casino Roots: The Cultural Production of Twentieth-Century Seminole Economic Development," in *Native Pathways: American Indian Culture and Economic Development in the Twentieth Century*, ed. Brian Hosmer and Colleen O'Neill (Boulder: University Press of Colorado, 2004), 85.

[23] Stookey, 92.

[24] John Purdy, "Against All Odds: Games of Chance in the Novels of Louise Erdrich," in *The Chippewa Landscape of Louise Erdrich*, ed. Allan Chavkin (Tuscaloosa: University of Alabama Press, 1999), 10.

[25] Katanski, 74.

luck and so were our people once."[26] Nanapush, a man who is deeply rooted in traditional Indian culture, speaks about the direct connections among Native American people, their land, and luck. The reverse is also true, and Native Americans' luck could be seen as bad, especially when it involves the loss of their land. Fleur, for instance, gambles for her children's lives and loses one child, just like she loses her land. Yet loss and gain are part of the characters' resistance and struggle against government policies. Katanski remains optimistic about the survival of the Ojibwe culture, even in the final scene of *The Bingo Palace*, in which Fleur dies on Matchimanito Lake after she has lost her land. She posits that "as her [Fleur's] cabin becomes a casino, the Ojibwe's contemporary gamble for cultural and economic survival, Fleur, who frequently gambled to save her land, will live on."[27] Fleur's legacy and the tribal tradition of gambling will persist through Lyman's casino, which assures economic gain and the preservation of land from generation to generation.

Love Medicine does not end with Lyman's idea that the future of Native Americans will be based on greed but with Lipsha's return home after he has met his father, Gordie, and learned who his mother is. Exposed to various ethnic and cultural influences inside and outside of the reservation, the characters try to figure out where they belong, follow different paths in life, both literally and figuratively, and, then, come back to the reservation, which functions as a cultural nexus which constantly attracts them. The Turtle Mountain Reservation is not an enclosed place which preserves Indian identity and tribal traditions intact but a transformative place in which traditions such as gambling, hunting, and healing practices are constantly under revision. Erdrich's Indians, who cross the boundaries of the reservation, orbit around its borders, travel, and return home, constantly absorb new experiences and influences that inform their traditions, values, and lifestyles. In their attempts to answer who they are and where they belong, Erdrich's protagonists change, adapt to changes, and resist change.

[26] Erdrich, *Tracks* (New York: Perennial, 1988), 1.
[27] Katanski, 74.

CHAPTER 3

STORYTELLING IN MULTIETHNIC PLACES: LINDA HOGAN'S *SOLAR STORMS*

Louise Erdrich explores how younger and older members of a Chippewa community respond to the changes that occur on their reservation. The loss of tribal land has triggered the loss of the traditions of the place, so Erdrich's characters adapt their traditions to reflect their new context. In *Solar Storms* (1995), Linda Hogan, a Chickasaw novelist, poet, and essayist, does not focus on the government policies that led to the loss of tribal land; rather, she is concerned with how Indigenous women of different tribes have made Adam's Rib, a village in the wilderness, their home and shaped its identity with their stories of survival and the narratives of their ancestors. Hogan's protagonists adapt to the harsh natural environment of the Boundary Waters between Minnesota and Canada and instruct one another with their stories. Hogan portrays a place situated at the intersection of two nations, several tribes, and numerous ethnicities, one in which tribal stories flourish.

While Erdrich follows some Chippewa families over the course of several generations, in *Solar Storms*, Hogan tells the story of five generations of Native Americans who try to hold on to their heritage and their natural surroundings in the face of corporate and governmental threats. The construction of the James-Bay-Great Whale hydroelectric project in Quebec upsets the community of Cree Inuit and mixed-blood Indians and throws their life upside down. Like Alexis Wright, Hogan follows the evolution of a matriarchal family of female survivors and preservers of Indigenous culture. In *Plains of Promise* and *Solar Storms*, the natural world, while dangerous and vindictive, offers a space in which relationships between Indigenous characters can take place and even grow. Angela Jensen returns to her birthplace, a small village in the Boundary Waters, a region of the Minnesota-Canada border inhabited by Crees, Anishnabeg, and the descendants of European and Native immigrants involved in the fur trade. After she has taken her birth name, Angel, the mixed-blood Cree-Inuit is told stories about the history of her people, their heritage, tribal lands, and natural surroundings, stories that aid her transition into maturity and development as a Native American woman. Angel opposes the dam construction in the area and learns from her relatives to decipher the rhythms of nature and the maps made by animals and birds; her growing respect for ecology and her interest

in tribal stories help this scarred young woman regain her self-confidence. The education she receives at Adam's Rib teaches Angel to preserve her family's traditions and transmit them to future generations of Indians.

In presenting her protagonists' response to place, Hogan foregrounds the connection between her female characters and nature, an association which ecofeminists explain in depth. Throughout the novel, Angel, Dora-Rouge, Bush, and Agnes try to preserve nature and protect the waters and ecosystems of the area from what they consider an intrusive industrialization. Yet Hogan complicates the relationship between woman and nature by placing it in a geographical area which poses challenges to its inhabitants and against an Indigenous context which is multiethnic. Thus, ecofeminist readings do not necessarily explain the relationship with place of Hogan's Indigenous female protagonists. Rather, an approach which considers place in terms of Indigenous people's adaptability and their expression of their oral culture is more relevant to the multiethnic environment Hogan portrays. The protagonists learn to survive in a harsh wilderness on the border between two nations and in the midst of several tribal cultures because they come together and share their stories. In doing so, they carry on their tribal traditions in a multiethnic place and inspire younger people to create their own narratives.

Keith Basso focuses on the ways Western Apache construct their landscape to reflect their cultural practices and argues for a close cultural tie between places and stories. The names of places inhabited by Western Apache are meaningful to their communities because each name is connected to a story they told. Basso claims that Western Apache storytelling "holds that oral narratives have the power to establish enduring bonds between individuals and features of the natural landscape."[1] Basso adds that "a native model of how stories work to shape Apaches' conceptions of the landscape … is also a model of how stories work to shape Apaches' conceptions of themselves."[2] Through storytelling, Apaches teach moral values and social behavior, and these teachings are also inscribed on their landscape. The stories about Indigenous people's survival at Adam's Rib and about the history of tribes and family members, stories told by Hogan's protagonists, have defined the culture of Adam's Rib and taught Indigenous women how to confront adversity.

[1] Keith H. Basso, *Wisdom Sits in Places: Landscape and Language Among the Western Apache* (Albuquerque: University of Mexico Press, 1996), 40.
[2] Ibid., 40-41.

Scholars, including Malpas, Casey, and Basso, argue that places reflect the aspirations and cultures of their inhabitants. Adam's Rib, for instance, is transformed continuously as it welcomes and shelters fur traders, women left alone to raise their children, the elderly, and people of different ethnical descent. Hogan's protagonists resist the possible changes that would affect their surroundings, but they are powerless in the face of inevitable industrial progress. The outcome of their endeavors suggests defeat, but it also reveals the characters' adaptation to their environment, a situation which reinforces their own history and the history of their frontier village. Since several Indigenous tribes and white inhabitants had to adapt to each other and to the wilderness at Adam's Rib, Hogan's Indigenous protagonists had negotiated their relationships with a changing natural world all along. They also told the stories of their ancestors and learned from their lessons on survival and, thus, adapted their traditions to make them fit their natural and multicultural environment.

Ecofeminist critics emphasize the harmonious relationship between nature and women, one which Hogan does not dismiss in totality but rather analyzes critically. Beate Littig posits that, according to an ecofeminist position, "women have a closer relationship than men to nature. This is seen as positive."[3] Littig adds that ecofeminist and feminist critics believe that "the female body in itself – women's ability to bear children, to bring forth life – is the reason for this closeness to nature."[4] Women's relationships to nature and their advantage over men's relationships are difficult to quantify and prove. So are the so-called "maternal" qualities of both women and nature. As Hogan shows, motherhood does not necessarily presuppose love and care, and nature does not imply safety and comfort. Hannah, for instance, abandons and almost kills her own daughter by letting her die in the snow, while the angry river kills Agnes during the women's trip to save the waters of the area. Dora-Rouge, Agnes, and Bush live in an area in which the weather sometimes does not cooperate and the resources are scarce. Their relationships to the natural world are a result of their adaptation to their surroundings and the difficult climate at Adam's Rib and not necessarily of a predetermined harmonious synergy with nature.

[3] Beate Littig, *Feminist Perspectives on Environment and Society* (Harlow: Prentice Hall, 2001), 13-14.

[4] Ibid., 14.

Several critics offer ecofeminist readings of Hogan's novel in which they link the state of the female body and the natural world and suggest that healing involves a return to the pristine world before colonization, which leads to the healing of the body as well. Silvia Schultermandl, for instance, describes such a pre-colonial world as ideal and whole:

> In the depiction of the geographical Boundary Lands between the United States and Canada, Hogan indicates the integrity of an ecosystem before Euro-American intervention. Abiding the laws of nature, water and land are united in a contract that ensures the organic equilibrium of the natural world. The implication of this natural boundlessness, recognized by Angel's tribe, refers to the cosmogonic balance within the biosphere cherished in cultures that define themselves in close relation to their native lands. By contrast, cultures that rely on hierarchical structures of social organization with the white man in the top position disrespect such natural laws within the ecosystem.[5]

Schultermandl's assumptions that an organic balance and a non-hierarchal social structure existed in the natural world and that human healing implies a return to a pre-colonial state are difficult to prove and sustain. While I agree with Schultermandl that Angel needs healing, I suggest that she heals because of her exposure to the tribal cultures at Adam's Rib and her relatives' stories and teachings and because she adapts to her new environment and participates in environmental activism. Angel becomes a confident Native American woman when she returns to her homeland, finds her own place in the family's dynamics and its history, hears her relatives' stories, learns to survive in a harsh natural environment, and supports the preservation of the rivers. When the dam is built, the inhabitants in the area, including Angel and her mother figures, have to adapt their lifestyles to this new situation. Hogan's protagonists persevere as they tell their stories, continually enriching their oral tradition and instructing one another despite the destruction of the natural world around them. While industrial progress changes the look of the natural environment looks on the frontier, it does not significantly change the traditions of the Indigenous inhabitants who continue to create and tell stories.

Angel starts her initiation into the cultural past of her tribe in a unique place called Adam's Rib, a name with biblical overtones suggesting new

[5] Silvia Schultermandl, "Fighting for the Mother/Land: An Ecofeminist Reading of Linda Hogan's *Solar Storms*," *Studies in American Indian Literatures* 17, no. 3 (2005): 70-71.

beginnings. The home of Angel's mother figures shelters a community of white and Indigenous women from different tribes who, through interaction with one another, have reinvented themselves and their culture at Adam's Rib. Jim Tarter argues convincingly that Hogan leaves categories such as race and ethnicity undefined to draw attention to "other factors that people have in common, especially the languages of other living things and the land or biotic community of their place."[6] Agnes has lived all her life among the Cree, Anishnabe, and French Metis, while her mother came from the land of the Fat-Eaters, also called the Beautiful People, in the James Bay region of Canada. Bush, a Chickasaw from Oklahoma, is the only inhabitant of Fur Island, which is surrounded by waters and wilderness; some Indigenous women have Cree or Anglo-European ancestors; and other women have white ancestors. The cultural diversity of the community stimulates the women to interact with one another, hear each others' stories, and recreate an identity specific to Adam's Rib. What results from this interaction is a unique amalgamation and assimilation of races and ethnicities that informs the identities of Indigenous people living there. A return to a pre-colonial state, as some critics propose, is not only impossible but also undesirable given the alternative, fruitful exchange among the inhabitants of Adam's Rib. The identity of this location depends on the multiethnic identities of its inhabitants. Thus, Angel, like the women who came to Adam's Rib before her, absorbs the multiethnic influences that created this place and contributed to the formation of Angel's ethnic identity.

The name of the town also alludes to Eve's creation through Adam's wounding and indirectly to the subordination of women. Yet the women who lived at Adam's Rib reversed this type of subordination and took control of their own lives and culture. The French fur trappers, who searched for better land and healthier animals, had deserted the women: "The first women at Adam's Rib had called themselves the Abandoned Ones ... When the land was worn out, the beaver and wolf gone, mostly dead, the men moved on to what hadn't yet been destroyed, leaving their women and children behind, as if they too were used-up animals."[7] These powerful women of different

[6] Jim Tarter, "'Dreams of Earth:' Place, Multiethnicity, and Environmental Justice in Linda Hogan's *Solar Storms*," in *Reading under the Sign of Nature: New Essays in Ecocriticism*, ed. John Tallmadge and Henry Harrington (Salt Lake City: University of Utah Press, 2000), 130.

[7] Linda Hogan, *Solar Storms* (New York: Simon & Schuster, 1995), 28. Further page references are in the main text.

ethnicities struggled by themselves to survive and form a community while they took care of their children, of the elderly, and of their animals. This town represented freedom for many white, Indigenous, and mixed-blood women, who created a flourishing community and culture that reflected their own struggles and aspirations. Angel, who returns home to piece her life together after her mother's abandonment, confesses that Adam's Rib "held my life" (23) mainly because in this place she had to face her painful past, make sense of the present situation of her family and people, and apply her relatives' life teachings to her future.

Angel feels she has come back home and compares her return to "traveling toward myself like rain falling into a lake, going home to a place I'd lived, still inside my mother, retuning to people I'd never met" (26). Referring to herself as rain falling in a lake, which is personified as her mother and mother figures, Angel creates an oxymoronic combination of familiarity and newness, two concepts that eventually inform each other. Although her journey is new and unexpected, and Angel visits Adam's Rib for the first time, she perceives it as a return to familial and familiar places like her mother's womb, the home of her ancestors, and their natural world. The allusions to her heritage and motherhood underscore the focus of this journey, which becomes an amalgamation of acquired knowledge and novelty for Angel. The bond she feels with her homeland will help Angel absorb more easily the family's stories told by her mother figures. In fact, Angel confesses that Adam's Rib sheltered "an old world in which I began to bloom. Their stories called me home" (48). She uses the word *bloom* to refer to her spiritual development and recognizes that her family's stories form a cultural space in which she can grow into a young adult. By listening to the stories, Angel inherits the culture and experiences of past generations, understands her own place within the family history, and tries to heal from her mother's abandonment.

Critics have written extensively on the significance of oral traditions in Native American culture and on the strengthening of tribal communities through storytelling. Karl Kroeber believes that for "Indians, storytelling was their most important cultural activity. Every one of their most sacred rituals was rooted in a narrative."[8] In *Solar Storms*, Hogan shows how tribal stories constitute the protagonists' primary means of continuing their cultural

[8] Karl Kroeber, "To the Reader," in *Native American Storytelling: A Reader of Myths and Legends*, ed. Karl Kroeber (Malden: Blackwell Publishing, 2004), 6.

traditions and educating younger people. Pointing out that storytelling deliberately prompts instruction, Joseph Bruchac explains the nature of this type of education and adds that "Native people tend *not* to tell others what they should and shouldn't do. Instead, other indirect mechanisms were used and continue to be used to inform individuals."[9] Through storytelling, Bush, Agnes, and Dora-Rouge offer Angel a past, a place in the family history, and a beginning for her life as an Indigenous woman. Angel's mother figures instruct Angel on her tribal heritage by telling stories that help this estranged and scarred young woman make sense of her past and heal from her wounds. They do not impose rules about what Angel should or should not do but create a safe place in which Angel learns and heals while she participates in the daily activities of the community. Shortly, Angel, who, unlike her mother, returned to rather than left her homeland, understands that her return home saved her.

On several occasions, Angel and her relatives characterize storytelling as a transformative process which has the power to create and bring to life certain worldviews and values. Dora-Rouge rewrites Genesis from a tribal viewpoint when she adds that "on the ninth day was the creation of stories, and these had many uses. They taught a thing or two about doing work, about kindness and love" (181). Dora-Rouge implies here that the educational purposes of stories include the transformation of the listeners into kinder and more hard-working individuals. Angel, too, recognizes the importance of the spoken word and storytelling when she compares Agnes' first story with "Genesis [because] the first word shaped what would follow ... It determined the kind of world that would be created" (37). Storytelling empowers Angel's mother figures to create a safe world that facilitates learning, transformation, and healing. By confessing further that their family stories come from "the milk of mothers," Agnes reinforces the values of community and family and explains that the family stories are as foundational and vital to Angel as breastmilk is to a newborn (40). A young person needs these stories of the past to build a present and a future and feed his or her spiritual life. Deprived of her mother's breastmilk when she was a baby, Angel feeds herself with her mother figures' stories instead and allows their regenerative powers to heal her.

[9] Joseph Bruchac, *Roots of Survival: Native American Storytelling and the Sacred* (Golden: Fulcrum Publishing, 1996), 54.

Angel's healing also implies her active participation in what she listens to and her creation of her own narrative. Susan Berry Brill de Ramírez points out that Native American storytelling requires a common effort when she states that "the story is not a monologue whose storyteller wields total semiotic control, with listeners as passive audience members whose responsibilities are relegated to discerning the significance placed by the storyteller."[10] Since "within a storytelling venue, there is no one story, for each listener brings her or his co-creative powers to the developing story," Angel does not listen to her mother figures' stories passively but starts telling her own stories as well.[11] Hogan's novel starts with a statement which shows how Angel had already absorbed and applied her mother figures' teachings and had created her own narrative: "Sometimes, now I hear the voice of my great-grandmother, Agnes. It floats to be like a soft breeze through an open window"(11). After reading the first sentences of the novel, readers understand that the adult Angel remembers the stories of her family and modifies them by adding her own experiences to the original stories.

The women's stories reflect the social and environmental realities at Adam's Rib as well as the history of the family and serve as life lessons for young Angel. Dora-Rouge's story about Agnes' compassion for the bear hunted by white men teaches Angel to confront adversity and to respect the beliefs of the elders, who think that animals should be protected for the wisdom and power they can convey. While Agnes takes care of the captive bear and protects it from the men's mockery and derision, she also starts singing the old bear songs of her ancestors, who revered bears. Joseph Epes Brown, an expert on the Oglala Sioux, contends that the bear "represented knowledge and exploitation of underground earth forces (the roots and herbs) … and lack of fear for either human or animal."[12] Dora-Rouge explains to Angel that Indian tribes protected the bears and that they have been around for a long time. Agnes kills the bear to save it from an agonizing death, and she fights for its fur, which she considers sacred. By wearing the bear's fur from then on, Agnes thinks she has received the bear's strength. When Angel arrives at Adam's Rib for the first time, Agnes emerges in her old bear coat,

[10] Susan Berry Brill de Ramírez, *Native American Life-History Narratives: Colonial and Postcolonial Navajo Ethnography* (Albuquerque: University of Mexico Press, 2007), 27.

[11] Ibid., 27-28.

[12] Joseph Epes Brown, *Animals of the Soul: Sacred Animals of the Oglala Sioux* (Rockport: Element, 1992), 21.

which makes her look like "a hungry animal just stepped out of a cave of winter" (23). Dressed in an animal coat with leaves coming off of it, Agnes belongs more to the deep wilderness than on that deck waiting for Angel. Yet Angel has a strong physical reaction to Agnes' apparition, a reaction which includes again familiarity and strangeness, and, when her heart pounds in her chest, Angel knows that it has recognized its own blood.

Agnes's and Angel's reunion on the deck differs from the final separation of Agnes from her son and his family. In a story about Angel's estranged relatives, Agnes tells how she sees her son, Harold, Angel's grandfather, her daughter-in-law, Loretta, Angel's blood grandmother, and Hannah, Angel's mother, for the last time on the deck as they are running to catch the ferry and realizes that Angel's beginnings were related to human suffering and familial disintegration. Loretta was born and raised in a toxic natural environment and in an impoverished community whose members were so hungry they ate the poisoned carcasses of deer white hunters had left to the wolves, which caused their bodies to smell of cyanide. Agnes deplores the fate of Loretta, who was abused by white men after she had watched her tribe members die. Loretta and Hannah fled from Adam's Rib, and they were incapable of settling down and adapting to any natural environment. Hannah, too, lost her ties to nature, her family, homeland, and tribal community, became the victim of the violent world she lived in, and lost herself altogether. By sharing this disturbing story with Angel, Agnes teaches Angel at least two lessons. Since Angel is hungry for stories about her mother, Agnes fills in the gaps of the girl's family history. Agnes also tells Angel that, unlike her mother, Angel returned to the tribal home to piece her life together and that she is more willing to learn from the stories she hears.

Angel's life has been difficult because she grew up in foster homes far removed from her tribal home and disconnected from her heritage. Prior to her return to Adam's Rib, Angel's existence had been defined by the wounds her mother Hannah had given her when she was an infant: "Scars had shaped my life. I was marked and I knew the marks had something to do with my mother ... While I never knew how I got the scars, I knew they were the reason I'd been taken from my mother so many years before" (25). Angel's insecurity and suffering come from her mother's violent inscription on her body and her inability to come to terms with this violence. She feels she has to navigate the map of scars written on her body by her mother, and she does this with the help of her great-great-grandmother, great-grandmother, and

grandmother, who all contribute to her healing. Agnes and Dora-Rouge share their stories with Angel and then send the girl to Fur Island, where she continues her initiation with her step-grandmother. Bush, "a person of the land," contributes to her step-granddaughter's healing and spiritual growth (71). At first, Angel is dazzled by the old woman with radically different ways of living than anybody she has known, and she is angry with Bush's silence and bizarre customs. By involving Angel in the physical work and daily chores necessary for survival on the island, Bush makes her granddaughter earn the stories she tells about Hannah and the lessons she gives about nature.

While disturbing, the stories Bush tells about Hannah help Angel understand her mother's abandonment and her violent behavior. Like Agnes, Dora-Rouge, and later on, Angel, Bush describes her family members using comparisons to the natural world, not only because this is the best way she can understand people, but also because nature constitutes her immediate reality. The comparisons with familiar natural elements and phenomena are supposed to alleviate the pain caused by Angel's mother's behavior. Thus, Bush tells Angel that Hannah's personality resembles bad weather forecasts: "'Your mother was like the wind. Sometimes she was the winter wind and she chilled our bones and snapped frozen branches off the trees ... [she was] a storm looking for a place to rage ... when Hannah was a warmer wind ... we'd let her near and then she changed into ice and turned against us'" (76). Hannah's destructive nature stifles any growth and perpetuates further destruction. Bush finds explanations for Hannah's misplaced feelings and disturbing behavior and believes that Hannah has been the victim of constant abuse. When Agnes and Bush bathe her, they see that Hannah's scarred body preserves the signs of the violence done to her: "*her skin was a garment of scars. There were burns and incisions. Like someone had written on her. The signatures of torturers*" (99). Her signifying body becomes a space which allows violence to happen. At the same time, it records the suffering of generations of Native Americans. Bush and the Old Man on the Hundred-Year-Old Road, who claim that Hannah suffers for her people and brings upon herself their fate, describe her body as a meeting place where violent acts are recorded, a place "*to where time and history and genocide gather and move like a cloud above the spilled oceans of blood ...An inescapable place with no map for it. Inside were the ruins of humans. Burned children were in there, as well as fire*" (101-03). Barbara Cook argues that Angel's

wounds, left by her mother, are reminiscent of the suffering of Native Americans, while her "battered and scarred body stands for the people and the land ravaged by Anglo-European practices ... Angel's body is a result of generations of abuse and only heals slowly."[13] Hannah, like Loretta before her, cannot save herself and remains a victim who perpetuates the evil done to her and endangers her daughter's life.

Bush ends her stories about Hannah with one about Hannah's appalling behavior on the day Angel was born, a scene which indicates that Hannah has no devotion to her family. The images of cold weather that suggest an unfriendly and harsh natural world culminate in Hannah's failed filicide, which takes place outside in the snow. The weather conditions are averse during Hannah's labor in an unheated house, from where mother and midwife can hear roofs and trees collapsing under the weight of snow. Hogan juxtaposes the cutting of the birth cord to the breaking of the heavy branches from the tree. Both scenes suggest violent and irreversible rupture. The midwife, frightened by Hannah's madness and odd behavior, has the strange but accurate feeling that by cutting the cord which connects mother and daughter, the two of them will be separated permanently. Bush saves Angel and concludes that fate decided in her favor: "*I found you tucked into the branches of a birch tree. You were still and blue ... You were alert, alive, and cold as ice ... You searched out warmth ... You were tiny, you were cold, and you wanted to live*" (112-13). Hogan describes a place in which violence, ice, and death also leave room for life, regeneration, and hope. The icy nest, where Angel awaits salvation, differs from the house of snow, where the birth takes place, because it gives Angel a chance of survival and promises her a future.

Young Angel needs time to absorb the stories about Hannah, accept the truth, heal the physical and mental wounds left by her mother, and find a way to move forward. Ellen Arnold comments on Angel's metamorphosis and transition to maturity and claims that "Having traced this narrative line to its origins, Angel has finished with piecing fragments together and can begin

[13] Barbara J. Cook, "Hogan's Historical Narratives: Bringing to Visibility the Interrelationship of Humanity and the Natural World," in *From the Center of Tradition: Critical Perspectives on Linda Hogan*, ed. Barbara J. Cook (Boulder: University Press of Colorado, 2003), 44.

the process of making a new identity."[14] Arnold underscores Angel's new identity formation at Adam's Rib, but this process does not necessarily imply the girl's return to her origins to make herself whole. Agnes herself has difficulties tracing the origins of the family, so she refers to the disappearance of the beavers or to the logging of the pine forests in the area instead of assigning exact dates to the beginning of their stories. Angel would prefer to identify herself as a reborn woman with no history and consciousness but her fantasy represents an unattainable ideal: "'Wouldn't it be wonderful to piece together a new human, a new kind of woman ... Start with the bones, put a little meat on them, skin, and set them to breathing" (86). Angel experiences a different kind of rebirth, which is not a return to origins but one similar to these experienced by the abandoned women who had recreated their identities at Adam's Rib. The stories of her relatives and her growing interest in and respect for nature define Angel's new life and identity. Gradually, she becomes a more confident young woman who appreciates the advice and teachings she receives. She sleeps better after she takes Dora-Rouge's potion for sleeplessness, eats the moose meat given by the hunters and the fish caught by Bush, and becomes concerned about the construction of the dam in the area.

To show Angel's process of absorbing the stories about Hannah and the girl's handling of this difficult information, Hogan juxtaposes her protagonists' stories, narrated in italics, with Angel's own comments about her training and transformation at Adam's Rib. Her education by Bush and her other relatives entails various lessons about living in the wilderness. Hogan does not show Angel's direct reaction to what Bush says about Hannah. Angel's response to these terrible stories is missing because she has learned to channel the darker episodes of her existence toward something positive: her daily life at Adam's Rib. Thus, Bush's stories are followed by descriptions of the natural environment and Angel's explanations about her surroundings, which indicate her growing understanding of the whims and rhythms of nature.

Because Bush lives on an island, water is among the first elements that Angel tries to comprehend and befriend. Not surprisingly, water becomes important to the entire family, especially when the rivers in the area are

[14] Ellen L. Arnold, "Beginnings Are Everything: The Quest for Origins in Linda Hogan's *Solar Storms*," in *Things of the Spirit: Women Writers Constructing Spirituality*, ed. Kristina K. Groover (Notre Dame: University of Notre Dame Press, 2004), 288.

threatened by the hydroelectric corporation's plan to build a dam. Angel, who confesses that she learned about water from Bush, paddles and steers faster in time and appreciates accurately the distances between islands. She also learns how to fish, hunt, and use water to become a better fisher and hunter: "I began to see inside water, until one day my vision shifted and I could even see the fish on the bottom, as if I was a heron, standing in the shallows with a sharp, hungry eye" (85). Bush praises Angel for her vision, which resembles that of the animals and birds, and she teaches her how to transfer this new gift to her everyday life and "see to the bottom of things" (86). Angel considers the functions of water and understands how water contributed to the survival of many Indigenous tribes, constituted the source for many of their stories, and bridged the gaps between generations: "It [water] was the sweetness of milk and corn and it had journeyed through human lives. It was blood spilled on the ground. Some of it was the blood of my ancestors" (78). To Hogan's protagonists, water is not a simple element but stands for perseverance and survival and becomes an overflowing inspiration for tribal stories. Agnes', Dora-Rouge's, and Bush's stories about water trigger Angel's more in-depth analyses and aid her in her decision to save and fight for the rivers.

The reasons behind the four women's journey to Canada are political, personal, and spiritual. Angel and her relatives share a common desire to oppose industrialization and preserve the waters in the region, but each of them has her own reason for making the journey north. Bush wants to check the damage done to the waters and oppose the dam project; Dora-Rouge wants to gather healing plants for her people and, more important, to die in the area inhabited by her ancestors, the Fat-Eaters; Agnes accompanies her mother and prepares for mourning; and Angel heard that her mother Hannah lives in the north and decides to find her. Angel's education continues during this journey, which ends tragically but teaches the girl to take a stand for her beliefs and the values of her community.

During their journey north, Angel and her mother figures also learn to adapt to the wilderness by giving up Western orientation and official maps in favor of maps made by animals, birds, and plants that mark the land as accurately as people. That the women let themselves be guided by alternative maps is not surprising because many Native American people mark the land much differently than Westerners. Martin Brückner, who wrote a study of the historical and geographic maps in the United States, argues that Native

American maps represent sacred sites, tribal histories and "the experience of land and landscape."[15] They "were conceived in the oral tradition; stored in the memories of chiefs and elders they were only supplements to an orally performed 'picture'." [16] Thus, Native American maps reinforce the natural and cultural landscapes of tribes and Indigenous people. Angel learns a version of history, which has little to do with colonialism, one in which the land has its own a voice, which utters tribal stories, and its own will, stubbornness, and passion that function independent of political decisions. In the wilderness, which slowly disappears, the four women become emotionally invested in this mythic place and feel that the natural world is in harmony with itself and its people. Angel is "singing, talking the old language;" Dora-Rouge "sang low songs that sounded as wind;" and Angel feels the presence of deities and ancestors (177). Angel observes how the wilderness draws elements toward it and encompasses them: "Everything merged and united. There were no sharp distinctions left between darkness and light. Water and air became the same thing … It was all one thing" (177). The women, too, feel they comprise a single entity: "The four of us became like one animal. We heard inside each other in a tribal way … Now we, the four of us, all had the same eyes" (177).

The merging of the four women into one organism and their integration into the natural world provide only a temporary comfort since the wilderness and wildlife they encounter will be changed. In addition, Agnes' death, caused by the natural world, suggests that such merging is not feasible. Dora-Rouge, Agnes, Bush, and Angel encounter an angry river which "roar[s] … so loud it sounded like earth breaking open and raging" (192). The women avoid a hasty return home and manage to cross the river after strenuous efforts, but Dora-Rouge's deal with the angry water does not protect Agnes. Analyzing the water imagery in *Solar Storms*, Birgit Hans concludes that there is a "relationship of mutual respect [between water and people] if both sides live up to their commitments."[17] For instance, Angel and her relatives recognize the power of water and respect it; in turn, water protects the women on their journey north and accepts Dora- Rouge's bargain, which

[15] Martin Brückner, *The Geographic Revolution in Early America: Maps, Literacy, and National Identity* (Williamsburg: University of North Carolina Press, 2006), 224.

[16] Ibid.

[17] Brigit Hans, "Water and Ice: Restoring Balance to the World in Linda Hogan's *Solar Storms*," *The North Dakota Quarterly* 70, no. 3 (2003): 94.

involves their commitment to the fight against industrialization for their safe passage through the troubled rivers. Cook argues that the art of negotiation is crucial to Hogan's characters, who "attempt negotiation not only with the rivers but … with the developers who threaten their land."[18] Despite Hans' and Cook's arguments about the benefits of bargains and negotiations, Agnes' death represents a gratuitous human sacrifice for a cause the four women had lost before they left Adam's Rib. Their peaceful methods, such as petitions, community meetings, and blockage of the roads buy them time and temporary control over the industrial development; however, such nonviolent methods cannot stop the construction that affects the towns, the landscape, the natural habitat, and the waters in the region and result only in a postponement of the construction.

The women's involvement in the fight for waters in the region reveals an older conflict between traditional lifestyles that seek to preserve the environment and an expansive industrialization which uses natural resources. Wendell Berry does not specifically address the conflict between Amer-Europeans and Indigenous people, but he does touch on the debate between the preservation of the environment and technological development: "We have never known what we were doing because we have never known what we were *un*doing … And that is why we need small native wilderness widely dispersed over the countryside as well as large ones in spectacular places."[19] Berry advocates a more prudent approach to the human impact on the natural world and to the use of natural resources. Analyzing the historical and economic conflict in *Solar Storms*, Christa Grewe-Volpp explains that "European immigrants have taken whatever their economic interests demanded: French trappers harvested beaver and fox until both were gone, Norwegian and Swedish loggers deforested the land, contemporary Canadians and US Americans covet water power."[20] In the novel, Dora-Rouge sees the actions of the Amer-Europeans as destructive: "[The European] legacy … had been the removal of spirit from everything, from animals, trees, fishhooks, and hammers, all things the Indians had as allies" (180).

[18] Cook, 48.

[19] Wendell Berry, *Home Economics* (New York: North Point Press, 1987), 147.

[20] Christa Grewe-Volpp, "The Ecological Indian vs. Spiritually Corrupt White Man: The Functions of Ethnocentric Notions in Linda Hogan's *Solar Storms*," *Amerikastudien/American Studies* 47, no. 2 (2002): 273.

Hogan underscores the complexity of the economic, political, ethnic, and cultural conflict caused by such driving forces as progress, development, and preservation and she presents multiple sides of this conflict. Her protagonists obviously fight for the preservation of the environment and against the industrialization of the area; their beliefs need not label them as "ultimate ecologists" or "ecofeminists," though. When Angel's relatives and the community at Adam's Rib cannot influence the course of industrial progress, they adapt to the changes brought by it. Hogan foregrounds characters whose adaptability to their environments and to change constituted the main reasons for their survival and prosperity. She also shows the turmoil of those nostalgic characters who cannot adapt to change. Dora-Rouge, for instance, finally arrives at her homeland, the territory inhabited by the Fat-Eaters or the Beautiful People, only to discover that the place is radically different than how she imagined it. While she lived at Adam's Rib, Dora-Rouge has created in her mind an image of her homeland as a pristine space preserved by her ancestors and inherited as such by future generations. This image helped her survive, dream, and hope that one day she could return to this place.

Dora-Rouge returned home "to die in a place that existed in her mind as one thing; in reality it was something altogether different. The animals were no longer there, nor were the people or clans, the landmarks ... and not the water they once swam in" (225). The construction and technological advancements in the area changed the land of her ancestors. The people "lived in little, fast-made shacks, with candy and Coca-Cola machines every so often between them ... The younger children drank alcohol and sniffed glue and paint" (226). The replacement of healing plants with Coca-Cola, which once allegedly contained the extract of a medicinal plant, but which now represents consumerism, confirms the losses suffered by Native Americans, losses that Dora-Rouge calls "murder[s] of the soul ... with no consequences to the killers" (226). Dora-Rouge believes that the future of the next generations remains dismal unless young people learn to preserve their environment and culture.

Other Indigenous people disagree with Dora-Rouge's nostalgic view of the past and welcome technological advancements. While Hogan's Indigenous protagonists and many people living along the Minnesota-Canada border oppose the construction of the dam, other communities believe they would benefit from the advantages of electricity. Angel observes that "We

became divided ... the hardest part, [was] not having the people united" (311). The inhabitants of the Holy String Town want electricity; some of the Fat-Eaters confess that they could easily get used to it; and the Inuits prefer toilets and warm buildings. Confident that the dam could provide work for Indian people, some participants at the demonstrations start to see the construction as advantageous. The Indigenous people in the area are not a mass of people who share the same ideas, and their division underscores their willingness or reluctance to accept a world which is changing. Basso acknowledges the social and technological changes that occur in Native American communities and points out that their older members "are concerned that as younger people learn more and more of the 'whiteman's ways' they will also lose sight of portions of their own."[21] Basso suggests that the landscape "is not merely a physical presence but an omniscient moral force" which instructs people through its stories.[22] The stories that community members tell about the landscape function as preservers of traditions independent of the technological progress in certain areas.

Toward the end of the novel, Hogan addresses changes in the dynamics of the protagonists' matriarchal family. Agnes and Hannah die during the women's trip north, but the hopeful reunion between Angel and Aurora, Hannah's baby-daughter and Angel's half-sister, suggests that the future of the family lies in the hands of younger generations. The baby's name, Aurora, which means "dawn," also points to hope and new beginnings for the matriarchal family. Angel becomes a mentor and a guide to Aurora in the same way her mother figures were to her. Applying a life philosophy learned from Dora-Rouge, Agnes, and Bush, Angel believes that every individual can be successful in the present when connected to past generations and her heritage: "Older creatures are remembered in the blood. Inside ourselves we are not yet upright walkers. We are tree. We are frog in amber. Maybe earth itself is just now starting to form" (351). New blood and new stories will feed the rebirth of Indigenous people and their communities. Despite her hardships, Angel remains hopeful and looks toward the future while she underlines the need for regeneration, dialogue among generations, and continuation of traditions.

Although Hogan's characters suffer and the natural world is changed, the characters heal, preserve their traditions, adapt them to their environments.

[21] Basso, *Wisdom*, 63.
[22] Ibid.

The future of Indian communities lies in the hands of young women like Angel who love the homeland of past generations, tell their stories, and respect the environment. In addition to the author's insistence on the moral duty of younger Native Americans to carry on the knowledge they have received, Hogan also underscores the necessity of people's adaptability to places. As the natural world is changing, contemporary Indigenous people consider these changes and think of ways to preserve their oral culture.

CHAPTER 4

TRAVELING THROUGH MEMORY AND IMAGINATION IN *DAUGHTERS ARE FOREVER* BY LEE MARACLE

Unlike the two novels by Louise Erdrich and Linda Hogan, which describe Indigenous people's struggles to carry on their tribal traditions on reservations and remote villages, Lee Maracle's 2002 novel, *Daughters Are Forever* focuses on a Salish woman who is alienated from her culture, family, and self in a Western city in Canada. As a divorcée and single-mother, Marilyn struggles to raise her daughters while she overcomes her alcohol addiction. Although her academic and social work center on helping, speaking for, and fighting for the rights of First Nations, middle-aged Marilyn feels she has failed as an Indigenous woman, wife, and mother. To heal her damaged self, Marilyn allows her memory to take her to uncomfortable places she had inhabited so she can reevaluate her life and decisions. Erdrich and Hogan also present Indigenous women who remember places they visited in the past. For instance, Dora-Rouge in *Solar Storms* and June in *Love Medicine* look nostalgically at their past and recreate images with their homelands in their minds. However, demonstrating that mental places are as powerful as real ones, Maracle bases her whole novel on mental recreations of places and makes the case that the analysis of these memories can be healing. Since many Indigenous family and community members around the world had lost their lands, the memories of their homelands replace their experiences with their real homes and assuage their longing for their lost homes. By examining mental recreations of places, Maracle shows that places are not only fixed geographical locations, but also textual concepts.

In revisiting the places she inhabited at different moments of her young and adult life, Marilyn recreates scenes involving her family members and their hardships. Marilyn's memories of her village, her parents' house, her great-grandmother's home, her own house, where she had lived with her husband and daughters, and of other households belonging to First Nations women convey the poverty and violence of Indigenous families. While Marilyn confronts many painful episodes of her past, she also starts to listen to the winds in the city, recalls soothing scenes with her great-grandmother, and tries to reconcile with her two grown daughters. Finally, Maracle provides a somewhat optimistic, open-ended conclusion to the novel which

implies that Marilyn has neither solved all her problems and inner conflicts nor completed her healing process but, rather, will continue the struggle of reconciliation with her daughters and herself. Maracle, thus, sends the message that the condition of many Native women is not fixed and their conflicts not easily resolved. The Native women Maracle describes still feel out-of-place and at odds with the world they live in. Yet the reader is led to believe that their endless struggles and perseverance are commendable.

Maracle addresses the First Nations' alienation from their culture and land and looks at the everyday life of an Aboriginal woman in a fairly new location for Native people: the city. Many First Nations people left or were forced to leave their communities, villages, and reservations to migrate to cities, where the connections to their culture and heritage become tenuous endeavors. Like Erdrich, Armstrong, Hogan, and Grace, Maracle describes several scenes in which solitary First Nations do not find their place in the city and drink in public establishments. Erdrich's Albertine and Grace's Mata wander purposelessly in the city in search of meaningful human interactions.

Scholars who write about geography and gender agree that the city is a masculine space which favors men and marks their achievements. In a study which focuses on women and the places they inhabit, authors Mary Ellen Mazey and David R. Lee argue that: "The cities were considered to be masculine: active, powerful, assertive. Important matters were decided here."[1] They also claim that, although women constitute more than half of the population, they do not significantly alter the landscape of the city because "agriculture, industry, and urban design are dominated by men, and the landscapes associated with these activities owe their overall composition to the decisions made by men."[2] Janice Monk also sees the urban landscape as masculine and believes that "conveyed to us in the urban landscapes of Western societies is a heritage of masculine power, accomplishment, and heroism; women are largely invisible, present occasionally if they enter the male sphere of politics and militarism."[3] Contemporary Indigenous women

[1] Mary Ellen Mazey and David R. Lee, *Her Space, Her Place: A Geography for Women* (Washington: Resource Publications in Geography, 1983), 63.

[2] Ibid., 71.

[3] Janice Monk, "Gender in the Landscape: Expressions of Power and Meaning," in *Inventing Places: Studies in Cultural Geography*, ed. Kay Anderson and Fay Gale (Melbourne: Longman Cheshire, 1992), 126.

writers occasionally place their female characters in the city, where they struggle to find openings in the masculine space that could have the potential to become their homes. Grace's Makareta, Armstrong's Penny, and Maracle's Marilyn eventually find these openings, inscribe their own discourses in the space of the city, become successful advocates for the rights of Indigenous people, and build new homes away from their families' homelands.

Marilyn revisits scenes of her life and travels to different locations through her imagination and memory. Her dreams about the natural world, her childhood memories of her violent home, her memories of her two daughters, and her dialogue with herself and with her great-grandmother take place in her mind, the only private space in a loud city. Marilyn travels to different places in her mind and embarks on an oxymoronic static yet mobile journey to redefine her status as an Indigenous woman, daughter, and mother. She examines several places where she had lived as a child, adolescent, and young wife and mother and analyzes them to understand what she has done wrong. Unlike Dora-Rouge in Hogan's *Solar Storms*, who recreates an imaginary homeland in her mind and is disappointed when she sees it, Marilyn recreates several episodes and places from her childhood and adulthood to adjust her present reality. Marilyn confronts her past memories about uncomfortable places, tries to heal herself and find closure, and create safe homes and places in the city.

Edward Casey, a philosopher who has written extensively on place, believes that time, memory, imagination, mind, and body are all related to place. Casey describes our bodies and minds in relation to places and posits that "we feel the presence of places by and in our bodies even more than we see or think or recollect them. Places are not so much the direct objects of sight or thought or recollection as what we feel *with* and *around*, *under* and *above*, *before* and *behind* our lived bodies."[4] Here, Casey uses spatial prepositions to reinforce the concept that our bodies and minds cannot even make sense of our reality outside of a place. Casey also links memory and imagination to place and explains that imagination takes us to the realm of *might be* while memory takes us to *what has been*; place positions people into what *already is*. Thus, memory and imagination should be understood in terms of places as well: "If imagination projects us out *beyond* ourselves while memory takes us back *behind* ourselves, place subtends and enfolds us,

[4] Edward S. Casey, *Getting Back*, 313 (see chap. 1, n. 30).

lying perpetually *under* and *around* us."[5] The narrator of *Daughters Are Forever* insists that Marilyn's memories are linked to certain places. When Marilyn remembers episodes from her past, she actually "searched about for a way to locate herself somewhere in time."[6] Both the verb "locate" and the adverb "somewhere" reinforce that her memories take her to certain places in time. More than that, her memories of these places in time become a combination of reality and imagination as "today, yesterday, tomorrow all melded into one another … Yesterday's images pushed up today's emotions … she was not sure what was real and what was not" (64). Through her memory and imagination, Marilyn sees the places of her past, those places she had left behind herself, where she has been, lived, and inhabited. Away from the ancestral homeland, disconnected from the natural world, and alienated from her daughters, Marilyn begins her journey via her memories because she needs to confront her past and heal in the present. She realizes that she repeated the mistakes of her mother and created a similar, unsafe environment for her daughters. Marilyn's memories take her to uncomfortable places, but once she analyzes these places and confesses her inconvenient truths, she improves her rapport with her daughters and the natural world.

Marilyn's journey is difficult at the beginning because she is not ready to remember and return to the places of her past. The narrator explains that memory "arises from the sum of our perception of reality. It is tempered by the emotional angle from which we are looking at reality. The stretch we apply to significant memory is funneled through our emotional filters" (93). Marilyn's filters remain clogged because she has not been prepared to clear these filters and face her painful past. At first, Marilyn remembers only those episodes that reinforce her emotional apathy and the inertia of everyday life. The results are unfavorable because they underscore her blindness and disorientation. Refusing to remember certain scenes, Marilyn gets literally lost in the city, which is neither a safe place nor a home for her: "She sometimes got lost on days when the grey was so intense that she could not recognize the markers that located her in the city. Today, she missed her street. She missed it by a long way" (93). Because she fails to recognize the markers that should position and locate her in what is supposedly her home,

[5] Ibid., xvii.

[6] Lee Maracle, *Daughters Are Forever* (Vancouver: Polestar, 2002), 64. Further page references are in the main text.

Marilyn needs to find other places in which to reside. Memory offers her this opportunity and takes her to different places (some of them safer, others disturbing). Since her immediate reality, that is her social and academic work, focuses on the problems of Indigenous mothers, she starts to reflect on her own status as an Indigenous mother. Marilyn's new feelings, emotions, and actions in the present trigger the unfolding of certain memories. Gradually, she clears her grey filters of memory and becomes more prepared to face her past and admit that she had neglected, mistreated, and abused her daughters because of her alcohol addiction.

Marilyn's process of remembering starts with a memory that she receives in her sleep. This first memory, which refers to the historic destiny of the First Nations, triggers her memories about her own family. Her dream in the first section, seemingly unconnected to the rest of the novel, introduces Maracle's critique of colonialism, explains some of the causes of the failures of Indigenous women, and frames Marilyn's imperative need to confront her painful memories and restore her relationship to her daughters. Maracle does not suggest that the pre-colonial model described in Part One of the novel should be copied and reproduced in the present, but she underscores that Indigenous women should heal themselves and build safe and welcoming homes for their families. The alternative version of Genesis and the ecological inauguration of the world that Maracle envisions, one in which the masculine Westwind and the female sky's daughter created an Indigenous nation out of the breath of the wind and the star dust in the sky, suggest a promising beginning for Indigenous people. Nancy Hathaway reports that myths about Sky Woman, who gives birth to the Earth Daughter, who, in turn, gets impregnated by the wind, abound in Native American and First Nation creation mythology.[7]

Maracle's vision, while purposefully exaggerated and unrealistic, establishes an important contrast between the pre-colonial period, when many First Nations lived a more peaceful life, undisturbed by the colonizers, and the postcolonial period, when both their natural surroundings and their cultures were under attack. The author describes an Indigenous community on Turtle Island, now located in Lake Erie, near the Michigan/Ohio state line, which is attacked by colonizers. As citizens of this promising nation, Indigenous people sang songs, recited their ancestors' stories, danced their

[7] Nancy Hathaway, *The Friendly Guide to Mythology: A Mortal's Companion to the Fantastical Realm of Gods, Goddesses, Monsters, and Heroes* (New York: Viking, 2001), 14.

ancestors' dances, and transmitted their traditions to future generations. The colonizers, who arrived on Turtle Island by sea, killed many Indigenous people and destroyed the islanders' community and their chance of rebuilding their previous lives. The women who escaped the slaughter and went into hiding blocked their feelings and became still. Throughout the novel, Maracle associates *stillness*, a feeling which Marilyn and her mother also experience, with a numbness of spirit. When Indigenous women remain still, they stagnate and renounce any spiritual growth. Their stillness translates into their disinterest in what their ancestors believed in, that is a respect for the environment, family, motherhood, and heritage. Marilyn's life goals are to fight her stillness and the anger that plagued Indigenous women, admit that her alcoholism led to the estrangement of her daughters, become a better mother, and regain her daughters' trust.

In a tragic scene, which renders the death of Marilyn's father and the disintegration of a First Nations family, Maracle makes the transition from the violence of colonization in Part One to the turbulent saga of modern-day life. By moving the focus from a community that lived in harmony with the environment to a household and family on the reservation which literally fall to pieces, Maracle underlines the antithesis between life on Turtle Island before colonization and existence after the devastation caused by colonization, which affected the future and culture of First Nations. Under the eyes of a shocked young daughter, an inebriated father has an argument with his wife, knocks her out with a lamp, runs from the house, and collides with a transport truck. Maracle does not link Eddy's death directly to the effects of colonization, but her placement of this tragic scene right after the metaphorical vision of the colonization of Turtle Island forces readers to connect the two scenes in some fashion.

Marilyn does not convey numerous details about the marital situation of her parents and the nature of their argument. The details are not even relevant because the chaos in the house points to the problems and frustrations of the family members: "Blood still gushed from her mother's nose. Around her mother's body ... [there was] the tangled mass of beer, blood and lamp glass ... Broken bottles and supper leavings ... dishes from the night before stood upright untouched" (33). Judging by this gloomy picture, Marilyn's parents lack interest in their house and family. Marilyn's father drinks and abuses his wife, and her mother neglects her household and possibly her children. Marilyn's own marriage falls apart, along with her

relationship with her daughters, as a result of her drinking and abuse. While working with First Nations mothers, Marilyn more fully remembers her own experiences and witnesses similar episodes involving broken families and abandoned children. Maracle establishes a pattern for many First Nations families, independent of their social class, which is marked by ongoing problems such as alcohol abuse, poverty, and desolation.

During her parents' fight, little Marilyn's orchestrated reactions prove that she is not unfamiliar with the disputes in her family. Shortly after she sees her father die, Marilyn imitates her mother's gestures and stays still and quiet: "Marilyn mimicked her mother's silence. She shuffled about quietly, practicing Anne's stillness ... Stillness filled both mother and daughter. It became their governess" (34). Whenever she finds herself in a crisis, Anne commands her daughter not to move. Like the hunted women in Maracle's inaugural story, who hid from the colonizers, mother and daughter express their shock by freezing their gestures and feelings. In Part One, the women's stillness hinders their ability to nurture their children and educate them. To make things worse, Anne says aloud the words that will haunt Marilyn forever: "'That is just like Eddy, to leave me to raise his child alone'" (34). Anne does not even identify herself as her daughter's mother and regards Marilyn as a burden she has to take care of by herself now that her husband is gone. The narrator comments that Anne's words will rob Marilyn of the love, nurturing, and guidance she would have needed to become a happy daughter and a good mother herself.

Although Westwind whispers to Anne that children require parental attention, which inspires the courage needed to transform them into adults, Anne is too numb to hear the voice of the natural world. Most of her life, Marilyn pays no attention to nature and to the voice of the wind, but Westwind never leaves her side. Marilyn slowly develops a relationship to Westwind in the city, a place which usually limits Indigenous people's connections to nature. Westwind, whose name appears capitalized in the text, represents a reliable masculine presence in Marilyn's life. Since her father died when Marilyn was a child, her stepfather beat her and her brothers, her husband left her, and most of her relationships with men never materialized, Marilyn finds in Westwind a father figure, a partner, and a guide for her journey. The narrator explains Marilyn's relationship to the wind at the beginning of the novel: "Westwind follows Marilyn. He whispers old story as he tugs and nags at her coattails. He is always beside her. He pleads with

her to listen" (38). Westwind, which was present at the birth of the nation, accompanies Marilyn and whispers the ancestors' stories into her ear, hoping that one day she will hear its message. The wind travels to several places inhabited by First Nations, carries with it the cultural heritage of past generations, and inspires future generations of First Nations.

Marilyn learns gradually how to listen to the voice of the wind and follow its guidance. There are moments when she does not feel its positive influence and moments when she is receptive to its message. When she goes to the ocean to watch the children play, Marilyn is inspired by the natural setting, where she and the children are integrated so well. Westwind makes the necessary arrangements for good weather and "pulls up clouds from the massive breast of the sea ...Wind, sun and cloud enter into a triangular relationship ... In the passionate play, they can create all manner of weather conditions in a matter of hours" (87). Marilyn watches how the children are enjoying the glorious day by the ocean. The presence of children suggests hope for Marilyn's future as a mother and her feeling at ease within the natural world promises a better relationship with her environment.

Until she lets Westwind guide her existence and inspire her relationship to the natural world, Marilyn struggles with her everyday responsibilities as a single mother and social worker. The first adjective the author uses when she opens the scene with middle-aged Marilyn working at her desk is "still." Marilyn is "still" because her connection to the natural world is almost nonexistent in the city, her relationship with her daughters is difficult, and her childhood memories are painful. Marilyn has reached the point in her life when her aspirations and vocations stagnate. To overcome her numbness and avoid further mistakes, Marilyn revisits other places from her past and reconsiders key moments of her existence so that she can understand what she has done wrong. Her academic and social work devoted to First Nations' problems allows Marilyn to remember and analyze troublesome moments in her life as an Indigenous woman and mother. Marilyn eventually finds the strength to redirect her life when she attends conferences on Indigenous themes and matters, works for First Nations families, and struggles to understand her daughters. In this way, her stillness turns gradually into effective action.

A more mature and responsible Marilyn analyzes herself and, based on what happened to her in the past and what she caused to happen, she decides what actions to take. J.E. Malpas links memories of childhood or youth to

self-identity and place and argues that "such memories and places often become more important to us as we age, and the strong feelings (whether of fondness or, sometimes, of revulsion) that are typically associated with the places of our growing up and of early life, can be seen as indicative of the founding role of those places in ... the establishing of our sense of self-identity."[8] David Lowenthal also believes that people's memories accumulate with age: "Although some [memories] are always being lost and others altered, the total shock of things recallable and recalled grows as life lengthens and as experiences multiply."[9]

Marilyn's journey into her past via memory takes her to dark places and difficult moments that stir her feelings of revulsion. As Malpas and Lowenthal suggest, memories become more important as people become older. Now that she is wiser and more experienced, middle-aged Marilyn analyzes "memories of her own ... from some angle she dared not think existed" (59). Her mental journey to uncomfortable places allows her to confront her demons and heal her diseased heart.

Lowenthal argues that our recollection of memories depends on our activities and behaviors in the present. Thus, the "past as we know it is partly a product of the present; we continually reshape memory, rewrite history, refashion relics."[10] Since the past is important to us and influences our present continuously, our need to "forget as well as recall, forces us to select, distil, distort, and transform the past, accommodating things remembered to the needs of the present."[11] Marilyn's social work with First Nations in the present stimulates her memory process and helps her to refocus her attention on her past. While assisting other Indigenous mothers, she starts to evaluate her own performance as a mother to Catherine and Lindy. Marilyn admires another Indigenous mother's honesty and her effort to get her two children back after her daughter's death. Elsie admits that her drinking problem contributed to the loss of her children to the authorities. Marilyn avoided a thorough self-evaluation for years because the process of remembering the mistakes in her past was too painful. Many times, Marilyn blocked a memory by saying *"Don't go there"* because the outcome would have been

[8] Malpas, *Place and Experience,* 182 (see chap. 1, n. 21).

[9] David Lowenthal, *The Past Is a Foreign Country* (Cambridge: Cambridge University Press, 1985), 194.

[10] Lowenthal, 26.

[11] Ibid., 194.

devastating for her (47). However, Marilyn reaches a point in her life when her memories become too important to her present and future, so she is willing to return to the places of her past.

The source of Marilyn's dissatisfaction is related to her behavior toward her two daughters. Like Anne and Elsie, young Marilyn drank heavily and neglected her children. "She had drunk away her lonely hours and been unable to wake up in the morning and motivate herself to carry out the simple chore of feeding her two daughters … Drunk, she opened the window slightly so the scent of the wine aged by her own breath would leave the tiny, dingy apartment before her girls awoke" (58). When she finally admits the truth to herself, Marilyn allows her painful memories to pour into her mind and heart.

In developing his philosophy on psychoanalysis, Sigmund Freud explains his theory of repression as a psychological defense mechanism against traumatic experiences. Describing the unconscious system with a spatial metaphor, Freud posits that it resembles an ante-room "in which various mental excitations are crowding upon one another" and a "second smaller apartment … in which consciousness resides."[12] Between these two rooms, Freud continues, "there stands a personage … who examines the various mental excitations, censors them, and denies them admittance to the reception-room when he disapproves of them."[13] In other words, an individual's emotionally painful events are consciously blocked out so that their effects are not experienced. Freud believes that the patient's and therapist's uncovering of the patient's repressed memories is part of the healing process.

Marilyn, who repressed her unpleasant memories for many years, realizes that the only way she can heal is to remember and deal with her past and the events she repressed. She remembers several episodes when she was drunk and terrorized her girls, who were scared of her reactions. When Marilyn awakened to the smell of smoke and discovered that Cat and her three-years-old cousin, Alfred, were making toast in the middle of the night, she tried to overcome her anger. Because Alfred mumbled an excuse, Marilyn did not beat them, but she confessed that it was the last time she spoke to them nicely after they did something they were not supposed to do.

[12] Sigmund Freud, *A General Introduction to Psycho-analysis*, trans. Joan Riviere (New York: Clarion Book, 1969), 260.
[13] Ibid.

Other times, she remembered herself looming over the girls with a wooden spoon and threatening them. When she drank and beat them, the girls cried out: "'Mommy, we'll be good'" (61). They whimpered and asked for forgiveness each time they upset their mother, whose attacks and rage increased as the years went by. Helpless and afraid, Catherine and Lindy are the victims of Marilyn's frustrations and anger. Although the "begging, pleading, loving, eager, worried, terrorized little voice[s] begged Marilyn not to hit [them]," the opposite happened (102). At some point, Marilyn decides she would rather die than hit her daughters again. Whenever she drinks and wants to punish her girls, she retreats into her bedroom and fights her anger, loneliness, and frustration by herself.

Marilyn does not reveal the reasons behind the social workers' decision to remove her ten-month-old daughter, Catherine, from her mother and family. She remembers only a disagreement with a Chinese social worker over her girls' food, which looked like grass. Marilyn explained that the other children made derogatory comments about Indigenous food that does not look like theirs. The Chinese social worker, who probably dealt with similar issues herself, understood Marilyn's explanation. Interestingly, there is a mutual understanding among non-Westerners; perhaps the outcome would have been different had the school social worker been Canadian. This short episode, which took place at the girls' school, reveals the precarious status of many First Nations in contemporary Canada, where the cultural practices of Indigenous people are repudiated by Western society and viewed as inferior. If the appearance of a particular food item is reason enough to estrange two daughters from their family, then the system clearly discriminates against Indigenous mothers.

Marilyn remembers another episode when she lost Cat for ten days. The fight to regain her daughter rekindled Marilyn's old passions and energies. She was so adamant in her pursuit of her children that she hired a lawyer, bought a gun, tore apart the house, hit her husband, and screamed: "'They aren't going to steal my children … I will die if I do not see her [Cat] from birth to maturity'" (48). With her spirit awakened, Marilyn succeeded in bringing Cat back home. She keeps the memory of her victory over the authorities dear to her heart because it brings her closer to her daughter. Marilyn's wonderful "memory was ensconced in a specially lit altar separate from the clouded place old memories usually live" (49). Unlike most of

Marilyn's memories, which remind her of painful moments in her life, this one is comforting.

During Marilyn's painful process of recovering unpleasant memories of her interactions with her daughters and parents, the natural world participates in her struggle and guides her toward a positive outcome. The winds try to convince Marilyn that she has to confront these memories to heal her injured self and move on with her life. When Marilyn wonders about her behavior toward her daughters, Northwind makes sure the sounds outside do not interrupt her train of thought. Northwind "knew she had plenty of ideas about how she arrived to where she was, but no single one of them seemed big enough to justify it. Further, he knew there was no justification; but there could be redemption if she actively accepted what she has done" (115). Although the winds cannot intervene directly in her decision making, they send her signs and guide her healing process. Marilyn also feels that "the passionate wind of her western breath had burnt the stillness from her body" (48).

Marilyn experiences this closeness to nature and her heritage years later when she looks at Elsie's photographs. Marilyn collapses at her desk after she realizes that the social worker did not pay attention to the dying Marsha. It is Southwind that "had hold of her. He continued to carry her through the moving picture of Marsha's last moments" (44). Here, Southwind acts as a friend and consoler. The winds, whether it is Northwind, Southwind, Eastwind, or Northwind, intensify Marilyn's feelings and reactions when she is involved in any issue connected to Indigenous identity. Immersed in Elsie's family tragedy and concerned about Marsha's fate, Marilyn hears the words of the Indigenous song, "I carry these bones," sung by the women who attend Marsha's funeral and whispered by Eastwind and Northwind in her ear. The winds mediate Marilyn's connection to the Indigenous women in the photo and aid Marilyn in participating in their moment of grief.

After she confesses the truth to herself and confronts her terrible memories, Marilyn realizes that not all her memories are painful. A conversation with Elsie about grandmothers makes Elsie laugh and Marilyn think of Cat's smile. As a young mother, Marilyn did not appreciate Catherine's smile, but "now, in memory, Cat's face was so clear. Marilyn savored the innocent image of Catherine's small mouth opening up, eyes turned up, head cocked to one side" (70). Marilyn's current image of young Cat reveals the mechanism behind her memory process. A comforting event

in the present, such as a conversation about her family in a hair salon, triggers a happy moment from the past. More important, Marilyn attributes her knowledge and wisdom to this memory and is capable of enjoying it completely in the present. She can remember it by applying her experience to this memory and by looking at it from a different angle, one she dared not think existed.

As surprising as this may sound, Marilyn is not necessarily a bad mother. After her drunken husband leaves her, twenty-three-year-old Marilyn struggles to keep the family together and build a career. She tries to battle her addiction and promises she will stop drinking. She constantly teeters between hysteria and sanity and spends her time in and out of courts fighting to keep her daughters. When social workers come to inspect her house, she wakes up from her drunkenness and sweeps the house clean until her whole body aches. Marilyn understands that love is crucial to her children's development, and she dreads the thought that she may lose her children to the authorities. She worries that her failures and mistakes have already affected her daughters and scarred them for life. Remembering episodes with her mother, who also drank and did not offer her children affection and care, and with her stepfather, who mistreated her brothers and sisters, Marilyn realizes she is not much different. Given the conditions in which Indigenous mothers raise their children, Marilyn's drinking constitutes a way of escaping a harsh reality. With no role model, no husband, and no help, single-mother Marilyn does the best she can. Harassed by social workers, removed from the environment of her ancestors, and disassociated from her heritage, Marilyn fights the Western system in her personal and social life. Unlike her mother, Marilyn has the capacity to accept her mistakes, change, and heal.

The scenes with Indigenous mothers who lost their children to the authorities uncover the indifference and violence of the Western system in postcolonial years and trigger Marilyn's painful memories. Marilyn, whose own bad memories of social workers still haunt her, wonders about the solutions and options for Indigenous mothers. If social workers determine that an Indian mother is negligent or unfit to raise her own children, they place the children in foster families; their actions suggest that Indigenous parents have limited control and power of decision over their children. The "children were continuously robbed of their mothers' love, such as it was, and taken to some strange place where strange people 'integrated' them into their family life" (56). Wright, Pilkington, and Grace also describe the

abduction of Indigenous children from their mothers and families and condemn the devastating effects this act has on Indigenous children and the future of Indigenous culture.

Elsie's case is complicated because one of her daughters died of pneumonia after a social worker had decided to take away the child. The social worker and the photographer acted in accordance with a preordained procedure, applied rules without assessing the situation at hand, and analyzed the poor conditions in which the family lived. They were indifferent to the needs of the children and decided that Elsie was negligent. Instead of realizing that Marsha was dying and calling an ambulance to save her, they gathered evidence for the file. The location of this tragedy is recreated by Marilyn through her interpretation of the photos of Elsie's house. One photo shows Elsie with a beer bottle in her hand in a dirty room with a spilled ashtray and cigarette butts on the floor. Marilyn, who is familiar with the social and economic situation of First Nations, is not particularly impressed by what she sees because her parents' household, and possibly her own, looked similar to Elsie's. This incident shows again that the Western system is insensitive to the real needs of First Nations and goes so far as to exploit parents and their children. Although the social worker and the photographer are culpable, the judiciary system declares them "not guilty." During the trial, Ms. Madison is held blameless, and Marilyn almost loses her job because she was too outspoken at the press conference.

Marilyn's statement that "Elsie's condition had taken over one hundred years to create" uncovers several issues that lie beneath the surface (55). The Amer-Europeans took the land of the First Nations, changed their ways of living, and deprived them of a civilized and humane existence. Indigenous parents became too poor to take proper care of their children. The blame also belongs to Canadian social workers and judges who dictated the fate of First Nations children and influenced the future of Indigenous families. In time, the children become strangers to their own families, culture, and roots. Marilyn, who writes her masters thesis on the situation of Native children, points to the apathy which plagued the First Nations' spirits. After "one hundred years of siege and prohibition, no one had the energy to fight another political battle against the various forms that prohibition took" (55). The lack of energy of the First Nations and their incapability of challenging the rigid Anglo-European system together put their own children in danger. Marilyn also admits that Native mothers, who, like her, often raise their

children by themselves, do not offer them the attention and love they crave. Many Indigenous mothers are too poor and numb to provide their children with the nurturing environment they need; their contagious apathy governs their lives. The solution for Indigenous mothers and parents, which Marilyn found when she fought for her daughter, is to fight back and challenge the system and love and take care of their children despite the problems they have.

Although Marilyn's life does not change radically at the end of the novel, she takes several steps toward assessing her errors and healing herself. She has a more honest relationship with her daughters; she is more attuned to the natural world; she remembers soothing episodes with her great-grandmother; and she falls in love with a Native man. *Daughters Are Forever* does not necessarily have a happy-ending, but Maracle leaves open the possibility of a better life for Marilyn and her daughters in the future. In the dinner scene with Cat and Lindy, Marilyn has a chance to spend time with her daughters, but their interaction uncovers the tensions between them. Cat's and Lindy's jokes that make fun of their mother's strict rules are criticisms addressed to Marilyn. Cat's question about whether or not the wooden spoon, Marilyn's torture object, was successful points to the scars Marilyn left on her daughters. The breaking of the spoon by Marilyn and Lindy marks the breaking of old habits and the beginning of healing. Their crying, a combination of tears and laughter, alludes to the wounds of the past and the possibility of hope for the present and future.

Knowing that their mother has scars, too, Cat and Lindy recommend that Marilyn see a therapist who can help Marilyn deal with her repressed memories in the way Freudian psychoanalysis suggested. Her grown daughters also come to the realization that "Most of us hurt. Being Indian hurts" (245). Cat believes that many Native women still suffer the effects of colonization and carry the suffering of generations. Cat points out indirectly that, in addition to their cultural and historical wounds, Native women carry a personal suffering inflicted by family members. Marilyn, for instance, carries a double weight coming from her mother's drinking problem and from her own neglect of her children. Cat and Lindy suggest that Dolly, a healer, who advised them when they were teenagers to carry on loving their mother despite bad memories, might help Marilyn as well. Maracle does not detail whether or not the fusing of a Western healing technique like psychotherapy with the Native ways of Dolly, the healer, works, but the

novel ends with this possibility. The last image of Dolly's house suggests that Marilyn could heal, too.

In her study, *I am Woman: A Native Perspective on Sociology and Feminism*, Maracle underscores the significance of children, who can heal Native families and represent the future of First Nations: "Without children, I could not have learned that 'everything is fixable.' Without children I could not have learned that what is revival and renaissance for a Native is death for a colonizer. For both of us there is reconstruction and a future full of passion and compassion."[14] Maracle argues that children stand for the survival and revival of the Indigenous family and culture. That is why Indigenous parents have the responsibility to raise physically healthy and spiritually strong children and inspire in them a sense of ethnic identity. Marilyn tries to recover from her painful past by admitting her mistakes, and her daughters participate in her salvation and healing.

Marilyn's journey to the places of her past is, for the most part, unpleasant and lonely, but the memories of her great-grandmother, Ta'ah, offer her a sense of stability and contribute to her healing. Marilyn's memories of her dead great-grandmother, Ta'ah, although not numerous, rekindle in Marilyn a love for her family, identity, and heritage. Great-grandmother Ta'ah, the stabilizing force of Marilyn's childhood, belongs to the group of loving and influential grandmothers and great-grandmothers such as Tupa in *whispering in shadows*, Bush, Dora-Rouge, and Agnes in *Solar Storms*, and Kui and Keita in *Cousins*. Because her relationships with her mother, stepfather, and siblings trigger painful memories, Marilyn is fortunate that Ta'ah acts like the nurturing mother she has never had, one who inspires Marilyn to believe in herself and in the value of Indigenous culture. Discussing the interaction between humans and animate or inanimate beings in Navajo stories, Susan Berry Brill de Ramírez makes the point that they treat each other as equals and they are involved in substantial relationships that transcend time and space. Brill contends that "not only can human persons come into relationship with animals or plants, but within a conversive framework of interpersonal inclusivity, human persons can also come into interactive and lived relationships with spirit persons (such as relatives who passed on) and other human persons who are not physically

[14] Maracle, *I Am Woman: A Native Perspective on Sociology and Feminism* (Vancouver: Press Gang Publishers, 1996), 10.

present."[15] Brill explains further that "human perceptions and interactions are complex in mysterious ways that a logically bounded and reasoned discourse can never fully explain ... [and so] within conversive relations, these interactions are lived experiences, not merely imagined."[16] Thus, Marilyn's dreams and memories of dead great-grandmother are real and beneficial for Marilyn.

In one of her dreams about her family, Marilyn recreates a bleak image of her house: "She wanted to turn back. Run home ... There was no one at home ... Home was black, empty and soundless" (183). Marilyn reconstructs the image of her home in her dreams, and she evokes the living conditions of her community and family. She is struck by the silence of the village, where the children went to residential schools, those government-funded schools that were supposed to prepare Native children for white society. While the images of her deserted village and home are probably exaggerated in her dream, Marilyn rarely feels safe with her mother and other relatives. Her great-grandmother, Ta'ah, is the only one who provides the stability young and adult Marilyn needs. She remembers the "smell of Ta'ah's, the warmth and the feel of the place. The familiar scent of Ta'ah's wood fire, the scent of food cooking, the aromas curling and playing in the kitchen" (184). Clarence Mondale believes that "in moving, a quintessentially familiar world of touch and smell is abandoned. It is as if the disproportionate details lodged in memory minister to the grief provoked by that emotional rupture."[17] Although Marilyn may have abandoned familiar touches and smells when she left home, she occasionally remembers the comforting memories of her childhood along with more disturbing ones. In her dreams and memories, Marilyn remembers Ta'ah's sound teachings and welcoming home.

While Marilyn's memories of other relatives and places of her childhood are difficult to handle, her memories of her great-grandmother are soothing: "Ta'ah had been dead for forty years and still she felt this everlasting love, this warmth, assurance ... There was never any hint of divorce in her behaviour, her language or her disapproval" (182-83). Ta'ah is loving and

[15] Susan Berry Brill de Ramírez, *Native American Life-History Narratives: Colonial and Postcolonial Navajo Ethnography* (Albuquerque: University of Mexico Press, 2007), 23.

[16] Ibid.

[17] Clarence Mondale, "Place-on-the-Move: Space and Place for the Migrant," in *Mapping American Culture*, ed. Franklin Wayne and Michael Steiner (Iowa: University of Iowa Press, 1992), 54.

patient with young Marilyn, and she encourages adult Marilyn to love nature, her family, and her tribal roots. Ta'ah speaks to Marilyn in her dreams and inspires her to believe in her family because "'We are family. We are and always will be, without beginning or end'" (183). Ta'ah and her decisive influence after her death provide the stability and balance for someone as shaken as Marilyn.

The memory of T.J., the man she meets at the conference in Toronto, also helps Marilyn heal and become more confident. Marilyn falls in love with T.J. because he is a traditional Six Nations and he shares her environmental vision. The powerful winds already know their relationship could be beneficial for Marilyn and arrange their meeting even before the two of them are born. Marilyn even describes him as her Westwind and a reliable partner. T.J. comes from "a long line of grammas who birthed wisdom inside his body" (207). Raised by women and educated to love nature and value Native traditions, T.J. rekindles Marilyn's interest in the wisdom of their ancestors. Marilyn transforms her short romance into a powerful and healing memory, one she can always return to when she needs strength. She "let herself feel the love come up, awaken her body, filter the thoughts and colour the memory of him. She let herself replay the conversation and rehear the smoothness of his voice and let its impact filter through this love" (178). Marilyn heals her body and mind by reliving in her mind the emotions and experiences she felt when T.J. was next to her. Like Marilyn's pleasant memories about being with her daughters or her great-grandmother, the memory of being with T.J. gives her confidence.

Maracle's novel contains neither winners nor losers but only survivors. She portrays the condition of modern-day First Nations women who live on reservations or in cities and struggle to keep their families together. Numb, deserted, alone, and full of remorse, Marilyn feels she has to take responsibility for her past actions. Her mental journeys toward healing and understanding her role and identity as an Indigenous woman and mother take her to inconvenient places, yet the memories of herself as a young mother help Marilyn reconnect with her daughters. Like other Indigenous women, Marilyn also realizes that the relationship with the natural world has not been completely lost and that it can be reestablished. When Native women find the patience for self-reflection, they will hear the winds singing the ancestors' songs.

In *Daughters Are Forever*, places are recreated through memory and become intersections of temporalities and spaces that range from old locations, where tribal communities had lived, to several contemporary households in Canadian cities that embody the realities of Indigenous families. Maracle addresses her protagonist's experiences of places through the memories triggered by her actions in the present. Only after a mature and wiser Marilyn has traveled to the dark places of her life and remembered the repressed memories of her youth, can she deal with her past and improve her future. "To have a sense of one's own past," J. E. Malpas points out "is to have a grasp of one's own present and future in relation to the 'story' of one's embodied activity within particular spaces and with respect to particular objects and persons."[18] Marilyn established this relation among past, present, and future by grounding her story in the places she revisited with her memory.

[18] Malpas, 180.

CHAPTER 5

PAINTING THE INDIGENOUS LANDSCAPE IN GLORIOUSLY DARK COLORS: JEANNETTE ARMSTRONG'S *WHISPERING IN SHADOWS*

Like Lee Maracle, who shows that relationships to places are maintained despite physical distances, Jeannette Armstrong looks at a First Nations woman's connection to her homeland while she lives both on her tribe's reservation and outside it. Armstrong's protagonist is able to reflect on her homeland when she is away from it just as Maracle's Marilyn and Hogan's Angel did. The distance from home triggers Penny's mental images of her homeland, including memories of her beloved great-grandmother and of Tupa's teachings about the Okanagan culture. In addition, Armstrong offers more visual descriptions of spaces than do the other authors under consideration as Penny is a painter whose craft revolves around portraying places around the world to raise awareness of Indigenous people's rights. Through Penny's artistic and mental descriptions of several locations, one realizes that places become imaginative creations that bring together art, craft, and politics.

In her 2000 novel, *whispering in shadows*, Armstrong tells how Penny, who is Okanagan, lives on a reservation and travels from the forests of Western Canada to North America and to the Mayan communities in Mexico. As she tries to make sense of all these places she inhabits and visits, Penny, a single mother of three, great-granddaughter, daughter, and sister, graduates from college, pursues a career in art, becomes engaged in environmental activism, and fights cancer. As a First Nations woman in contemporary Canada, Penny fights for her own social status and that of Indigenous people around the world, advocating their rights, and opposing the destruction of the environment.

Through Penny's dynamic existence, her travels around the world, and her experiences, including her artistic enterprises, her journeys to various locations, and her domestic activities, Armstrong focuses on issues such as Indigenous people's rights, their subjection to poverty, and their campaign against globalization and for a less polluted environment. Penny is exposed to different people and ways of living while she travels, and yet, her journeys make her appreciate her Okanagan home and upbringing even more. This narrative also shows the often chaotic nature of life and demonstrates that

one's experiences are fragmented and not necessarily logically ordered. When Penny finally understands that her homeland contributes to her wellbeing and the harmonious development of her children, she becomes ill and dies of cancer. Penny's illness seems an illogical event which Penny herself does not comprehend, but her cancer, caused by pollution and toxic waste, is a reminder of people's devastating impact on the surrounding environment.

Despite her unfortunate death, Penny lives a full, meaningful life, one in which she preserves and develops her great-grandmother's lessons about the Okanagan land and traditions. Tupa's vision of the Okanagan land calls for one's consideration for natural elements such as flora and fauna and cultural artifacts such as colors, legends, and, songs. When she moves to the city and travels around the world, Penny remembers Tupa's philosophy about the Okanagan land, but she also expands on her great-grandmother's local view of land and nature. Penny's paintings revealing details about Indigenous tribes around the world, place the concerns of Indigenous people in an international context. Although she lives her life respecting her environment and dies because of it, Penny experiences a relationship to place that is neither idealized nor romanticized. She is a painter and an activist who raises awareness of the places inhabited by Indigenous people while she promotes her home's tribal values she acquired at a young age.

The two articles published on Armstrong's *whispering in shadows* address the issue of hybridity in a global context and the influence of her community and the elders on the protagonist. Heike Härting argues that Armstrong investigates "culturally hybrid practices of identity and representation from an indigenous perspective ... [and recognizes] cultural hybridity as a contested space."[1] Jane Haladay looks at how the author underscores the "symbiosis of Okanagan language and land [taught by Tupa], and how ancestral stories are place-specific teachings infused with a feminine presence."[2] While Härting places Armstrong's novel in a larger context, that of postcolonialism, Haladay focuses only on Penny's formative

[1] Heike Härting, "Reading Against Hybridity: Postcolonial Pedagogy and the Global Present in Jeanette Armstrong's *Whispering in Shadows*," in *Home-Work: Postcolonialism, Pedagogy, and Canadian Literature*, ed. Cynthia Sugars (Ottawa: University of Ottawa Press, 2004): 258-59.
[2] Jane Haladay, "The Grandmother Language: Writing Community Process in Jeanette Armstrong's *whispering in shadows*," *SCL/ÉLC* 31, no. 1 (2006): 46.

years and on the role of the community in her life. I plan to expand Haladay's analysis and discuss the influence of place and family members on Penny's life but, more important, I analyze how this influence is put to use by Penny, especially in the global and contemporary environment in which she lives. The protagonist becomes a successful woman, painter, and activist because of her strong connections to the place where she was born and to her great-grandmother's teachings about Okanagan land and traditions. Her unique use of color in her painting imitates the colors of the landscape that Tupa introduced and renders aspects of Indigenous life that Penny witnessed.

Armstrong structures the novel around the old conflict between those individuals who celebrate the natural world and attempt to preserve natural resources and big corporations that destroy the environment, seeking to extract financial gain. Numerous authors and critics present this conflict in terms of a clear-cut binary: Indigenous people respect and preserve the environment while Amer-Europeans destroy it. Such stereotypical conceptions of Indigenous people do a great disservice to them. In the preface to his edited volume, *Defending Mother Earth*, a study which actually calls for environmental justice, Jace Weaver comments that Native Americans, and by extrapolation, all Indigenous people should not be considered the saviors of the environment around the world and the sole possessors of "the mystical, ancient wisdom that alone can save the planet."[3] The fight against environmental devastation, water pollution, construction of dams, the effects of mining, and toxic waste dumps is a far greater challenge, one to which everybody, independent of one's race, citizenship, age, gender, or religion should respond. Lee Schweninger, in *Listening to the Land*, a recent and valuable addition to the scholarship on Native Americans' responses to the environment, argues that Native American writers articulate complicated relationships with the earth "while ... refuting imposed stereotypes of American Indians as nature lovers or as children of the wild who worship a Mother Earth goddess."[4] Both Weaver and Schweninger admit that the rejection of stereotypical images of Indigenous people as earth saviors does not cancel Indigenous people's meaningful relationships with their environments or their contributions to a cleaner and healthier planet.

[3] Jace Weaver, "Preface," in *Defending Mother Earth: Native American Perspectives on Environmental Justice*, ed. Jace Weaver (Maryknoll: Orbis Books, 1996), xvi.
[4] Lee Schweninger, *Listening to the Land: Native American Literary Responses to the Landscape* (Athens: University of Georgia Press, 2008), 2.

Wright, for instance, presents characters who do not try to save the earth but use an often violent natural world to communicate with one another. During her protagonist's mental journey, Maracle lets her be guided by the winds of the city; Marilyn does not fight for environmental justice, but accepts the help of the winds. Hogan writes about five generations of Cree-Inuit women who resist the construction of a dam while helping their youngest offspring to heal from her physical and spiritual wounds and continue their family traditions. Armstrong presents a situation in which an Okanagan woman continues what her great-grandmother taught her about respect for nature, but this does not make all Okanagan women environmental activists. Through her lifestyle and teachings, Tupa reveres nature and offers young Penny lessons about preserving and caring for the surrounding environment. Penny puts these lessons into practice when she dedicates her artistic and activist careers to advocating a healthier and cleaner environment. As her journeys indicate, she is joined in her endeavors by Indigenous and non-Indigenous people around the world.

Tupa's influence on Penny constitutes the foundation for Penny's life philosophy and art. Scholars address the creative potential of memory and imagination that individuals invest in the recreation of history and of scenes from the past. João Luís Jesus Fernandes and Paulo Carvalho argue that "Heritage and memory should not be considered a restraint, but may well be an important part of the reading of the present and, in some cases, one of the supports for the future."[5] Tim Winter posits that people cannot inhabit or view a place and automatically comprehend its history, but they can reinvent the history of that place: "Rather than viewing history as held within the landscape itself, the idea of memory switches attention to the ways places and times are actively constituted and reconstituted in multiple ways on an ongoing basis."[6] Cathrine Degnen believes that the way "the past is

[5] João Luís Jesus Fernandes and Paulo Carvalho, "Military Heritage, Identity, and Development: A Case Study of Elvas, Portugal," in *Heritage, Memory and the Politics of Identity: New Perspectives on the Cultural Landscape*, ed. Niamh M. Moore and Yvonne Whelan (Aldershot: Ashgate, 2007), 130.

[6] Tim Winter, "Landscapes in the Living Memory: New Year Festivities at Angkor, Cambodia," in *Heritage, Memory and the Politics of Identity: New Perspectives on the Cultural Landscape*, ed. Niamh M. Moore and Yvonne Whelan (Aldershot: Ashgate, 2007), 134.

remembered can dramatically affect how the present is perceived."[7] Niamh Moore concurs and adds that the remembrance of the past contributes to the growth of cultural heritage because "memory is critical in the formation of both personal and place identity but it is also crucial in shaping discourses on preservation, development, and how heritage is defined and represented."[8] Both Degnen and Moore point to the past's significance for someone's identity and culture. The worldview and values offered by loving parents, grandparents, and in some cases, great-grandparents shape the manner in which individuals perceive or create their own worlds.

Penny remembers Tupa's positive impact and applies her teachings in her adult life. Penny is raised in the Okanagan tradition by her parents, grandmother, and great-grandmother, and she tries to instill a sense of her Okanagan heritage in her own children. Unlike other Indigenous authors, such as Wright, Hulme, and Pilkington, who write about severed familial links, Armstrong has Penny transmit Tupa's teachings to her own children and reinforces the idea that certain versions of the elders' wisdom and experience are communicated and transmitted to younger generations. While other Indigenous authors depict spiritually mutilated women who lost their sense of self and place along with their family ties and who have to reinvent these ties in order to heal their broken spirits, Armstrong creates a character who is among the fortunate ones because she can continue to enrich her experiences of home and its traditions.

Armstrong explains that the English word *grandmother* "as a human experience is closest in meaning to the term *Tmixuv* in Okanagan, meaning something like loving-ancestor-land-spirit."[9] Tupa embodies the notion of a loving ancestor who teaches her great-granddaughter about the spirit and language of the land and the colors of nature. Arguing for the influence of what she calls "the grandmother language" on Indigenous young people, Haladay also recognizes Tupa's importance: "Because of the impact of Tupa's early teachings, which take place within and are inextricable from

[7] Cathrine Degnen, "Country Space as a Healing Place: Community Healing at Sheshatshiu," in *Aboriginal Autonomy and Development in Northern Quebec and Labrador*, ed. Colin H. Scott (Vancouver: UBC Press, 2001), 370.

[8] Niamh M. Moore, "Valorizing Urban Heritage?: Redevelopment in a Changing City," in *Heritage, Memory and the Politics of Identity: New Perspectives on the Cultural Landscape*, ed. Niamh M. Moore and Yvonne Whelan (Aldershot: Ashgate, 2007), 97.

[9] Jeanette Armstrong, "Land Speaking," in *Speaking for Generations: Native Writers on Writing*, ed. Simon J. Ortiz (Tucson: University of Arizona Press, 1998), 176.

Okanagan language and lands, the maturing Penny is able to deeply cultivate her Okanagan values, knowledge, and relationships as she negotiates her place within a complex, global society."[10] Tupa teaches Penny to love and respect the land, honor traditions, speak the Okanagan language, listen to the elders' stories, and most important, use all these acquired values as guidelines.

In her essay, "Land Speaking," Armstrong discusses her Okanagan identity, the Okanagan language, which her people call N'silxchn, and the connections between land and language. She argues that the land has a language of its own that the Okanagan people learn to speak: "The language spoken by the land, which is interpreted by the Okanagan into words, carries parts of its ongoing reality. The land and language surrounds us completely, just like the physical reality of it surrounds us."[11] Thus, place and location have a significant influence on Okanagan people and their language, identity, and formation. The land is constantly communicating the realities it witnessed, along with stories that generations of Okanagan people grew up with. In *whispering in shadows*, Armstrong draws on the relation between language and land and expands it to include other art forms such as painting and music. Tupa teaches her great-granddaughter about the subtle relationship between land and language and introduces her to Okanagan songs and stories.

The numerous scenes with Tupa that Penny remembers usually occur on the reservation and involve the natural elements of the Okanagan land and environment. An episode which most probably contributes to Penny's identity formation takes place outside by the lake and brings together Tupa's teachings on nature, language, and songs and Penny's affinity for art and color. It also exemplifies the unique connections between land, language, and colors, connections that are familiar to Okanagan women. On a glorious summer day, Tupa and Penny go to the lake to fish and admire the surrounding landscape. They notice that all the natural elements, including the animals and plants close to the lake, seem to coexist in harmony with one another:

> All around, the tall sweet clover was waving and dancing, making shadows on the ground ... Here and there patches of pink and purple ground clover formed feathery

[10] Haladay, 33-34.
[11] Armstrong, "Land Speaking," 178.

flower balls in the sand ... The sand was warm and golden brown, glittering with bits of mica ... She [Penny] could hear bees buzzing and far across the lake in the reeds, the *quack quack* of ducks.[12]

The quack of the ducks is accompanied by the *"splash, splash* of Tupa cleaning fish" (45), and by the songs sung by Tupa and Penny. The sounds that Tupa makes when cleaning the fish and their songs fit rather perfectly with the sounds the animals make. In fact, the omniscient narrator compares Tupa's voice and the Okanagan language with the language of the ducks and bees. This analogy supports the idea that the women of this Okanagan family feel at home within the natural world, where everything and everyone is *in place.*

Young Penny depicts the subtle arrangement of sounds, plants, and animals in a painting which combines several colors and invokes the Okanagan land. Penny, who knows colors before she knows their names, remembers the multitude of hues present in nature and the colors of Tupa's shawl, so she starts to arrange them to create an original painting:

The shawl was a deep, dark blue and the flowers were bright red, yellow and orange ... The silk fringes hung down and waved all around her ... She turned over on her stomach and the sand was suddenly magic. Blue, red, orange, yellow and gold splash over sand. She moved her hands up toward the thin skin and the colours covered her arms and hands. She was all colours and the sand was too. Her heart was beating fast and she sang to the coloured faces in the sand. (45)

The transfer of colors from the shawl to the sand and finally to her body is accomplished through the medium of Penny's art. The inspiration for this new artistic creation comes from natural elements such as the colorful speckles of sand and the nuances of the shawl. In the end, Penny's mental painting includes natural and artificial colors, pieces of the land, parts of the human body, and song lyrics. Under Tupa's nurturing supervision, Penny becomes increasingly confident in her art and knowledgeable about the culture of the land.

Tupa is the first one to notice her great-granddaughter's affinity for colors and encourages her to cultivate it. Her praising Penny's artistic potential and knowledge of colors gives Penny confidence: "You and the

[12] Armstrong, *whispering in shadows* (Penticton: Theytus Books, 2000), 44. Further page references are in the main text.

colours can talk, I see. They tell you things. Listen to them. They never lie"
(46). Tupa tells her that colors, like people and animals, have a language of
their own, one which Penny starts to understand. Tupa has great intuition
because one of the assets of Penny's painting has to do with the manner in
which she combines colors. Penny will use unexpected associations of colors
to paint dramatic scenes from the life and history of the Okanagan and later
from the lives of Indigenous people around the world.

A similar scene with Penny, her father, and Tupa has the little girl
enjoying natural colors again. While Penny's father whistles, Tupa sings a
song about the dancing colors, and invites her great-granddaughter to
appreciate the colors outside. With her acute eye, Penny sees an interesting
image when she catches the warm yellow of the sunshine penetrating the
brown wooden floors in her parents' house. When she goes outside, she is
amazed by the colors of the trees, flowers, and sky and imagines they are
moving and dancing to the rhythms of Tupa's song. This short but insightful
scene shows how Tupa teaches Penny about Okanagan songs while nurturing
her talent for painting.

Another influential episode with Tupa involves the two of them watching
the sunrise and the beginning of a new day, a moment when Tupa reveals the
origin of Penny's name. Her name links Penny to her female ancestors and
reinforces her matrilineal descent. Tupa also teaches Penny to respect each
new day and give thanks for everything that nature offers. This includes the
honoring of their ancestors, whose peace depends on the prayers and
acknowledgement of their descendants. When telling her great-
granddaughter about the origin of her name, which was the name of Tupa's
mother, Tupa, in fact shows Penny how to honor these ancestors: "Paen-aye,
the one whose real name is my mother's, sits with me, to greet the great sun,
who gives us light and life. Give her its warmth to light a path ahead of her"
(18). In thanking the sun for each new day and nature for its nourishing
offerings, Tupa and Penny assure warmth and peace for Tupa's mother and
their other ancestors.

Having been given the name of her great, great-grandmother, Penny is
connected directly to her Okanagan family and culture. Tupa pronounces
Penny's name in the Okanagan language and performs it through songs.
Tupa's "thin gravelly voice was sing song talking. Naming her. 'Paen-aye.'
Saying her English name in the sounds of their language. Speaking it" (69).
By singing and speaking Penny's name in N'silxchn, Tupa links her great-

granddaughter to the place where she was born. As Armstrong states in her essay and exemplifies through Tupa's life philosophy in the novel, the land speaks its own language, which the people learn. When Tupa names Penny in N'silxchn, she places her on the Okanagan land and teaches her to understand and speak the land's language. Or to put it differently, it is ultimately the land which names Penny, while her maternal ancestors function as mediators who are passing the knowledge and language of the land down to her. Penny herself concludes that her name sounds better in Okanagan than in English when it is pronounced *Paen-aye*. When she herself calls Tupa "'My own Tupa, myyyyyy Tupaaaaa.' Claiming her" (69), Penny shows her ardent desire to belong to Tupa and implicitly to the line of women from which she has descended. Despite the explanation of the origins of Penny's name, she does carry an English name. Although Armstrong does not reveal why her protagonist's name is English rather than Okanagan, one could speculate that the reservation where Tupa's family lived is not such an enclosed space and that its population has been assimilated into and influenced by Western society. The blurred borders of the reservation would explain why Penny decides so easily to move to the city and work in a factory where First Nations remained a minority.

Discussing the importance of the question, "Who is your mother?" for the inhabitants of Laguna Pueblo in New Mexico, Paula Gunn Allen expresses the belief that every individual has a place in the world defined by family and clan membership. This particular place in the universe is usually defined by a person's matriarchal lineage:

> In turn, clan membership is dependent on matrilineal descent. Of course, your mother is not only that woman whose womb formed and released you – the term refers in every individual case to an entire generation of women. But naming your own mother (or her equivalent) enables people to place you precisely within the universal web of your life, in each of its dimensions: cultural, spiritual, personal, and historical.[13]

Mothers, grandmothers, great-grandmothers, sisters, and aunts are significant to a person's identity because they are the ones who bring balance to the family, preserve customs and traditions, and transmit them to future generations. Failure to know one's mother or her equivalent leads to estrangement from one's identity, history, and homeland. Following Gunn's

[13] Allen Gunn, *The Sacred Hoop*, 209 (see chap. 1, n. 33).

argument, if an individual does not know her mother, she may not have a place in the world. In *Solar Storms*, for instance, Angel cannot connect with her difficult mother, Hannah, but she benefits from the guidance and care of her great-great-grandmother, great-grandmother, and grandmother. On the other hand, the Koopundi women in Wright's novel, Mata in Grace's *Cousins*, and Katie in Pilkington's *Caprice* grow up without mothers, and they struggle to find out where they belong and with whom.

Penny has a mother, grandmother, great-grandmother, and aunts to teach her about her place in the world and their Okanagan traditions. One of these traditions is the annual digging of roots and picking of berries. Juliana, Penny's mother, notices that none of the women in their family fails to participate in the annual digging and gathering of roots: "'Look at Gramma [Tupa], she's almost ninety and look at you [Penny's grandmother]. You're over sixty. Every year, she has come here and so has her mother and grandmother and so have you, and now me and I'm almost forty" (133). The roots have to be picked by women who have had roots in this homeland for generations and have to be replaced with new roots that will produce new plants. The women respect this tradition not necessarily because the roots and berries constitute their nourishment, but because these activities bring the family and community together. They show respect for their ancestors and their land if they respect these traditions.

Penny, who lives in the city with her three children, understands the importance of maintaining traditions such as the digging of the roots, passing them on to her children. Dissatisfied with the shallow values her children acquired in a busy city, Penny wonders whether or not she alienated her children from old traditions and realizes that the values in her life were conveyed by family and elders; as a result, she decides to move back onto the reservation and take her children to her family's house. The narrator does not specify at what point in her life Penny returns home but describes a family reunion scene. The Okanagan community welcomes Penny and her children, honors them with songs, and supports their decision to return home. She responds: "*Oh my people. You are my medicine. Heal this small family ...I give myself back to this land, our home ... Everything was always right here, waiting for them. Right here at home*" (135). The return to her homeland from the city, the place "*where everything has a price*" (135) is viewed as a healing experience. The Okanagan home, land, and community with their

traditions are benefic and constitute the inspiration for Penny's art and activism.

Penny's art is an interpretation of what she absorbed as a child from Tupa and other family members about the Okanagan land, realities, and tradition. Penny brings together the descriptions of landscape with the harsh realities of industrialization and the everyday issues of Okanagans, First Nations, and other Indigenous populations around the world. More specifically, her preoccupation with "the positioning of warm nature against hard science comes from 'her' Indigenous world-view" (126). As she becomes increasingly aware of the how rapidly and inevitably industry and technology erase traditional lifestyles, she feels the need to react to these dramatic changes, especially when these changes have negative effects on the environment. While Penny does not oppose the advances in technology from which everybody benefits, she fights for environmental justice. In an effort to live in a clean and safe environment and preserve Indigenous culture, she renders the inconveniences of the industrial world in her painting and gets involved in environmental activism. The worldview preached by Tupa, in which plants, animals, colors, and songs fit harmoniously in the same place and in a healthy environment, is disappearing and an industrial world has replaced the environmental comfort of Penny's childhood.

Penny's painting is influenced by Tupa's teachings and, as it develops, it serves to raise awareness about the places and environments in which Indigenous people live. Her original combination of colors depicting Indigenous people in cities, villages, on reservations, and at the conferences she attended has gradually won Penny success as an Indigenous woman painter. However, Penny would rather sacrifice her fame and money than compromise her art and message. When the director of an art gallery persuades Penny to sell her paintings and alter their message so that the tone of the exhibit is not too political and dark, Penny refuses categorically: "Show me in my best light? It's not about me ... I want to shock some sense into people. I want them to see it for what it is. There's a fucking outrage out there, in case you haven't noticed" (203). In her view, the role of painting supersedes the painter's personal interest, and she thinks that her art should address historical, political, and social aspects of Indigenous people, their environment, and culture. Penny's extreme gesture of destroying her own paintings rather than changing the message and political goal of her art reveals her commitment to First Nations and Indigenous people. If she is not

allowed to share her viewpoint, her paintings have no reason to be displayed. Penny believes that her art should shock people and direct their attention toward political messages about the environment and the lives of impoverished Indigenous people in the world. Before she dies, Penny wishes her painting had been bolder and even more direct: *"I should have let the images come out which shouted at me … The story must be told to be understood and changed"* (292). Although she dedicated a considerable part of her life to activism and painting, Penny would have wanted to capture her viewers' attention and elicit a more engaged and active response.

A turning point which determines the subject of Penny's art and her involvement in environmental activism is her participation at an Indian environmentalist gathering held in the wilderness. It is the moment when Penny sees how her education received from Tupa, her painting, and activism can be joined together into one effort. The Indian environmentalist meeting gives Penny an opportunity to contemplate the beautiful scenery and oppose the cutting of the trees in the area. The moment she arrives at the conference, she understands that the forest is threatened by industrialization. It is her visual acuity nurtured since childhood that permits Penny to see the problems of the region and draw images in her mind: "An image … Framed in colour. An image of the camp, first visible only as brilliant bits of colour at the road's end, between the hulking machinery and the dark green line of the trees" (94). The presence of the heavy machinery in the middle of a quiet forest foretells imminent danger.

Penny closes and opens her eyes and sees the beautiful forest as if it were a colorful painting. The ground is imprinted and touched by the warm speckles of the golden sun; the orange flowers, the ferns, and large mushrooms spread over logs; and the needles and branches of trees produce imperceptible creaks like whispers. As she admires the trees and the luscious vegetation beneath them, Penny is overcome with a familiar feeling, *"like homeland … It feels like déjà vu"* (97). This feeling comes from her previous experiences in the natural world, when she created mental paintings out of sand and colors, experiences nurtured by Tupa.

Penny should know and her dialogue with the trees and land underscores her knowledge that the land speaks and transmits messages. The trees whisper to Penny, and the birds talk about their problems:

It's the trees! It's them watching! … Up above, high in the branches she can hear birds warbling soft whistling tunes to each other. Two black ravens are sitting on a

lower limb watching her, too. They're *talking, talking, talking* ... She leans close to the tree ... Her words are barely audible in the still air. The sounds of her language mixing with the soft movement of ferns, the whispering of branches and the sound of birds overhead. (98)

Penny knows that the land, along with everything in and on it, is alive and sensitive to what it is happening around it. She talks back to the land, and their languages mix and become one. Penny engages in a dialogue with the natural world which is uttered in a language of the land that is beyond English. While trees whisper to Penny, she responds and makes herself understood: "She whispers in her language into the shadows. *Beautiful land, keep us safe for the night. Give them your strength in tomorrow's struggle. Move in the hearts of all those who come here as I have been moved*" (111). From her great-grandmother, Penny has learned the language of the land and the ways she can thank the land for its gifts, understand its problems, and ask it for comfort and strength.

The whispers in shadows referred to in the title of the novel are uttered both by the protagonist and the natural world. The whispers the trees, plants, and birds murmur are probably imperceptible to the untrained ear, yet Penny was taught to hear them. Armstrong explains that the Okanagan people learned to survive by listening to the language of the land, which was translated into human words: "It is said in Okanagan that the land constantly speaks. It is constantly communicating ... We survived and thrived by listening intently to its teachings – to its language – and then inventing human words to retell its stories to our succeeding generations."[14] This understanding of the land's language helped generations of Okanagans and First Nations to survive and develop their culture. The particular message which Penny hears in whispers is important because it transmits the dangers Indigenous people and nature constantly face; she realizes now that nature is terrified by the upcoming mutilation of the trees. Penny tries at this gathering and, later on, at the conferences she attends to translate and transmit the whispers of nature to environmentalists and individuals interested in the heritage of Indigenous people. Her efforts to take the whispers out of their shadows and bring the land's message into the light require perseverance. Environmentalists must continue their campaigns despite constant disappointments and defeats.

[14] Armstrong, "Land Speaking," 176.

The presence of heavy machinery, police cars, and helicopters overhead for instance, points to the futile efforts of many Indigenous people who lived in the area and of the environmentalists who attended the gathering. Although people stand in front of the police cars to chant, shout, and prevent the cutting of the trees, they are defeated. The police officers make it clear that the protestors are breaking the law because they are obstructing the legal rights of a company to proceed with its business. The company claims it has a license to log the area. The opposite side, formed of the Natives and environmentalists, argues that the forest is their hereditary territory and that the Supreme Court is still deliberating on this matter. When the loggers rudely order the people to leave – "'Fucking Indians and tree huggers! Go Home!'" – an older Native man responds calmly that he is already home: "'This is my home. It always has been and it always will be, regardless of what you do to it. I'm here for the duration. Get used to it'" (115). For the Natives, home is the place where they were born and where their ancestors had been born and lived, and no one can take it away from them. While the idea that home belongs to its people no matter what happens to the environment sends an optimistic message to Indigenous people everywhere, the protestors cannot successfully oppose the loggers on this particular day and, after several arrests, they give up. The scene ends with a shocked and helpless Penny, who feels an aching in her chest as she looks at the truck packed with trees.

The bold statement of the old man opens up a discussion about place and the survival of Indigenous tribes. The old Indian fights for the clean air of his home and forests, but he does not fear defeat. Having done this before, the old man knows that his place, landscape, and environment change all the time, but his people will always make their presence felt. Several scholars, including Jace Weaver, Robert Warrior, and Craig Womack, remind us that the colonizers are not going anywhere. That they are here to stay is as evident as Indigenous people's survival, resistance, and determination to live on their own land. Because Natives share their homes and environment with settlers, they must learn how to claim it, survive on it, and preserve their traditions. In his well-known study, *Tribal Secrets*, Warrior recognizes that survival and an acceptance of the changes in the environment are important to the present and future fate of Native Americans: "we have survived and can live … Our struggle … is to continue to survive and work toward a time when we can replace the need for being preoccupied with survival within

communities and with the ever-changing landscape that will be our only home."[15] One way of insuring the survival of Indigenous cultures (independent of their tribal diversity) is suggested by Sylvie Poirier, who underscores how traditions could be adapted to present-day contexts. Poirier states: "the members of today's generation have been attempting to develop strategies that will enable them to combine their knowledge and values with a type of economic development that will be capable of safeguarding their autonomy within the contemporary context."[16] This is exactly what Armstrong's protagonist is doing when she applies her great-grandmother's values to a contemporary, global context.

Confident in the survival of Indigenous people around the world but concerned about their poverty and polluted environment, Penny becomes increasingly involved in environmental activism, and she attends numerous conferences both as a speaker and participant. Through her painting and activism, Penny seeks to raise awareness about the places where Indigenous people live. She meets David, who becomes her partner, at a conference on Indigenous people's rights and travels with him throughout the country and to other countries inhabited by Indigenous people. Armstrong reminds readers that colonization in the United States and Canada, Australia, New Zealand, Mexico, South America, and South Africa had some similar effects on Indigenous populations. Penny and David travel to many of these locations and interact with Indigenous people, exchange impressions, support them, give money to those in need, and arrange for customers to buy the Indigenous people's hand-made products. While major differences among Indigenous communities in the same and especially in different countries are evident, issues such as poverty, environmental pollution, isolation of the Indigenous populations, their poor health conditions, and the disposition of their lands prevail in all of their countries, including the United States and Canada. That is why Penny and David conclude that: "The stories mesh and overlap as one story. Ecuador, Bolivia, Peru, Chile, El Salvador, Columbia, Mexico. Millions of brown people, despised, abused, hungry, landless, reduced to slave-labour. Disease and death" (148).

[15] Robert Allen Warrior, *Tribal Secrets: Recovering American Indian Intellectual Traditions* (Minneapolis: University of Minnesota Press, 1995), 126.
[16] Sylvie Poirier, "Territories, Identity, and Modernity among the Atikamekw (Haut St-Maurie, Quebec)," in *Aboriginal Autonomy and Development in Northern Quebec and Labrador*, ed. Colin H. Scott (Vancouver: UBC Press, 2001), 114.

Penny's and David's trip to Mexico is enlightening because it gives them the opportunity to see how some Mayan communities have maintained their ancient traditions despite severe poverty. The Mayan priests, who pray, chant, and give blessings, perform ceremonies for the inhabitants of and visitors to old mountain villages and connect with their ancestors. Although the Mayan rituals differ from the ceremonies her Okanagan relatives performed on the reservation, Penny believes that the priests' language is similar to N'silxchn and follows the sounds of their songs in her own language to pray for her family members, the land, and the people who are suffering. The prayers and songs bring together people of different cultures and religions who transmit their energy to their own communities. These Mayan ceremonies are supposed to unite the participants so they may strive to achieve common goals and respect the different traditions that they preserve in their communities.

Penny and David return to Canada through the United States and, when they compare North America to Mexico, they conclude that there are few differences among these countries in terms of environmental pollution. A city such as Los Angeles smells of urine and fumes and is populated by homeless people, beggars, prostitutes, and people who wander aimlessly. Penny pities the children who have not seen a clear sky, breathed fresh air, and eaten fresh food in years. For Penny, America is *"Utter despair. America, land of the free. Free? What a joke! … a living death … It's no different than what we've seen in Mexico"* (198). Penny reveals herself to be disarmingly naïve when she is surprised that the rich do not help the poor in the United States even if they have the means and power to do so. She fails to realize that rich people are part of the problem because they require larger amounts of energy to sustain their extravagant lifestyles.

More often than not, Penny becomes frustrated at the realization that change takes time and patience and sees her activism as a hopeless endeavor that cannot significantly change the places inhabited by Mayans, Indians, and First Nations. Penny suffers at the sight of the miserable conditions in which Indigenous children in Mexico, Canada, and the United States live. The lack of immediate results has to do with Penny's and David's attempts to help too many Indigenous people living in different areas around the world. Perhaps a more local and focused approach in one particular area or one particular country would have been more successful than a general and comprehensive approach. However, their activism covers such a larger arena because they

want to address and bring together Indigenous voices everywhere and kindle non-Indigenous people's interest in the fate of Indigenous people. In this respect, David is right when he posits that Indigenous and non-Indigenous people around the world should join their cause because "we are millions strong, worldwide ... Cooperation provides a better chance" (188-89). Thus, their effort at "raising awareness" has long-term effects, covers a lot of ground both literally and figuratively, and involves a lot of people.

The author's message about the effects of industrialization and technology on the environment and individuals culminates with the protagonist's illness resulting from exposure to strong toxic pesticides. Penny does not blame her cancer on genetics but on chemical toxins and environmental pollution. She believes that illnesses and diseases spread because people are responsible for the damage done to the environment, animals, the water, and more important, themselves. Härting contends that Penny's cancer "is not merely a symptom of the violated environment written on her body but a physical manifestation of the disintegration and dis-placement of indigenous life, both under the rules of global capital and in a cultural and emotional atmosphere."[17] As Härting herself indicates, Penny's cancer, caused by the environment, calls into question the presumed vital connection between people and their land/place. Yet, Penny's recreations through memories of the Okanagan values instilled by her relatives reinforce the land-individual connection. As long as Indigenous people endure through memory and story, their communities, places, and cultures can persist. Penny's illness could be a symbol of a diseased environment, but it does not necessarily predict the disintegration of all Indigenous life as Härting argues because cancer affects everybody independent of race and ethnicity. In fact, Penny refers to her cancer as the outcome of a roulette game: "When the wheel spins around, the ball falls. Somebody gets struck with cancer" (259). As much as is humanly possible, Penny looks at her situation with a certain amount of serenity, knowing that she has returned to her homeland and will die there. The thought that her children are with her at their ancestral home also brings her peace.

Unlike some other Indigenous protagonists, who complete difficult journeys but eventually find somewhat hopeful messages about their homelands and identities, Penny becomes ill and dies at a relatively young age. Despite Penny's unpredictable and chaotic life, her destiny is part of a

[17] Härting, 276.

larger point the author is making. Armstrong underscores the negative effects of colonization, industrialization, and the exploitation of the environment for profit, effects that strike everybody and especially the Indigenous populations and can be seen at social, economic, political, environmental, and even biological levels.

Seen from a different perspective, however, Penny's life is a success story. After her first marriage falls apart, Penny, a jobless, single mother of three, builds a new life for herself and her children. Penny understands that she has no secure position as a First Nations woman, so she goes to school, graduates from college, continues to paint, and becomes an environmental activist and a successful artist. Applying Tupa's teachings about the land, its colors, language, and traditions, she becomes one of the advocates for Indigenous people around the world and a fighter for a cleaner and safer environment. This is a story of a courageous woman who bettered her life continuously because she remembered what she learned about her Okanagan homeland and translated the knowledge about this place and culture in order to apply it to other regions inhabited by Indigenous people. When the city disappoints her, she returns to the home of her family and makes sure her children are raised by family members and taught Okanagan values and traditions. When she learns that Indigenous people around the world suffer, she tries to alleviate their problems and make these problems known to the world. When people do not understand or join her cause, she shocks them with daunting images. Penny paints because she wants to bring back to the surface her rich heritage and bring to light the realities of Indigenous people, but when she feels that her critics turn her painting into a curiosity which can compromise her artistic calling, she does not allow such injustice. Penny is a brave Okanagan woman who makes room for her ancestral homeland and heritage in her everyday existence.

CHAPTER 6

LAND AS MEDIATOR: VIOLENCE AND HOPE
IN ALEXIS WRIGHT'S *PLAINS OF PROMISE*

One of the challenges that Indigenous people face is the preservation of their tribal traditions in their new environments, which increasingly mirror their assimilated Western worlds. Many Indigenous protagonists adapt their old traditions and, thus, make sure that places reflect these adaptations, or they reconstitute their homelands through memory and consider these memories as soothing and healing experiences. Aboriginal authors such as Alexis Wright and Doris Pilkington tackle other challenges that Indigenous people deal with, which include the violence of the colonial and postcolonial regimes in Australia and the complete separation of parents and their children. Both Wright and Pilkington describe scenes involving family members who are separated forcibly from one another. As a result, the places they inhabit portray the violence that has been done to the protagonists or the isolation and angst that accompanied their separation from their families. Missions, settlements, and boarding schools are such places, and they alienate Aboriginals and estrange them from their traditional cultures. That is why Wright's and Pilkington's protagonists look for ways to reconnect with their family members and homelands or attempt to create safer places, in which they can voice their Aboriginal identity and perform their traditions.

In her debut novel, *Plains of Promise* (1997), Alexis Wright, who is affiliated with the Waanji people of the highlands in the southern Gulf of Carpentaria, describes the estrangement and reunion of several generations of Aboriginal women against a setting which is both healing and violent. Wright deals with issues such as the brutal assimilation of Aboriginal people at St. Dominic's Mission and their struggles to maintain connections with their communities, families, and homelands. Since the settlers separated Aboriginal family members and interfered in their relationships with the land and each other, these relationships had to be reinvented. Aboriginal characters make use of the land and the natural world to communicate with each other and respond to the violence of colonization.

Several critics who write on Australian Aboriginals in general emphasize their connection with place and landscape since pre-colonial times. While they present a romanticized image of Aboriginals, Tuan, Read, and Young offer insightful views on Aboriginal people's relationship to their

environments that point to their intellectual and emotional attachment to their land, homelands, and families. When he discusses this relationship, Yi-Fu Tuan argues that "the Australian aborigines ... have a much stronger sense of history. Events leading to their present world are recorded in features of the landscape, and each time people pass a particular cleft, cave, or pinnacle they are enabled to recall the deed of an ancestor and cultural hero."[1] Because of his/her strong connection to the environment, "the native's identity ... is not in doubt, because the myths that support it are as real as the rocks and waterholes he can see and touch. He finds recorded in his land the ancient story of the lives and deeds of the immortal beings from whom he himself is descended, and whom he reveres. The whole countryside is his family tree."[2] Peter Read also believes that the Aboriginal landscape is inscribed with cultural messages and speaks about the importance of ancestral beings to the Aboriginal landscape and culture: "Land throughout Aboriginal Australia was created by ancestral beings. Each valley, hill, rockhole, waterfall, group of boulders and even prominent rock was likely to have been part of a complex mythology, involving its creation and its relation to the physical and non-physical world."[3] As these critics suggest, Aboriginal people respect the land and the teachings of elders about the ancestral beings who enriched the land with cultural artifacts. Elspeth Young also mentions the ancestral beings who "travelled across the country along clearly defined routes marked by experiences and actions occurring at different points and recorded through song, dance, painting and ceremony."[4] According to these views, many Australians Aboriginals value their connection to landscape and culture, a connection transmitted and enriched by generations of Aboriginal people.

Tuan, Read, and Young offer general views on Aboriginal people's relationships to places that apply only partially to contemporary contexts. Wright situates the action of *Plains of Promise* in a more recent context and complicates the Aboriginal people's relationship with the land. The landscape both records the colonizers' violence toward the Aboriginals and

[1] Yi-Fu Tuan, *Space and Place: The Perspective of Experience* (Minneapolis: University of Minnesota Press, 1977), 189.

[2] Ibid., 157-58.

[3] Peter Read, *Returning to Nothing: The Meaning of Lost Places* (Cambridge: Cambridge University Press, 1996), 67.

[4] Elspeth Young, "Hunter-gatherer Concepts of Land and Its Ownership in Remote Australia and North America," in *Inventing Places: Studies in Cultural Geography*, ed. Kay Anderson and Fay Gale (Melbourne: Longman Cheshire, 1992), 256-57.

promises hope because it mediates difficult relationships among generations of women who lost contact with one another. While the settlers erase their violent actions along with the written documentation of the lives and deaths of several Aboriginal characters in the novel, the landscape records this violent history and renders the tension resulting from the clash of the two cultures, which poses a threat to the apparent unity of colonial space. The landscape ultimately functions as a detached ally of the Aboriginals, one who does not intervene, but helps them along the way.

The landscape becomes a symbolic witness to such violent acts as the rape, beating, and abuse of Aboriginal people at the Mission. No one is present, for instance, when Jipp rapes Ivy on the banana plantation, when Pilot is beaten to death, or when Ivy's mother dies in the cave during the night. All these terrible events are erased from the official documents and historical accounts, but they are integrated into the landscape. The land becomes the only witness to the whites' violence and, from time to time, it responds to these events with a violence of its own, becoming as ungovernable and excessive as the colonizers' abuses. Great storms, thunders, lightning, and quicksand, threaten all the characters' lives. Yet the land remains the only connection the Aboriginal women have with one another after they have lost everything, so in this respect, the land and natural world represent some kind of hope for Aboriginal families.

Though Wright discusses four generations of women who, under colonial oppression, lost contact with one another, the last descendents of these Aboriginal women, Mary and her daughter Jessie, try to reconnect with their relatives. Mary's almost impossible endeavor to find her mother reveals the difficulties faced by contemporary Aboriginals who search for their family members after they have been separated by force from them and from their traditions. Mary's interest in political science and anthropology and her sense of belonging to the Aboriginal community outside St. Dominic's Mission, compel her to begin this search. Although mother and daughter do meet but do not communicate in a conventional manner, they share a connection mediated by nature which takes place outside of the falsified official documents and colonial rules. Thus, nature promises to serve as a space which Aboriginal people can use to their advantage, one which allows a certain degree of healing during and after years of suffering and separation.

The novel opens with a scene of mute violence which takes place at the Mission: a description of a poinciana tree that the missionaries planted to

celebrate their new lives after they had planted themselves on a land that did not belong to them. The "thirsty, greedy foreign" tree grows in front of the black girls' dormitory despite adverse natural conditions and illnesses at St. Dominic's mission.[5] The tree, with strong roots implanted in the ground, symbolizes the domination of the colonizers, who came to stay and impose their rules. Because the foreign tree sucks the energy of the Aboriginal earth, poisons the air, and foreshadows death, the Natives do not welcome its intrusion. The land and the Natives feel the polluting effects of the tree on their environment and themselves: "The Aboriginal inmates thought the tree should not have been allowed to grow there on their ancestral country. It was wrong ... in the middle of the night they woke up gasping for air, thought they were dying" (4). Since they are powerless to oppose the missionaries' colonization and program of acculturation, the Aboriginals at the Mission can only witness the destruction.

A crow sits on the tree's blooming branches and disrupts the sleep of the girls in the dormitory and of the missionaries. In Aboriginal mythology, the crow is valued for its intelligence and special skills. Mudrooroo links the crow's importance to its roles as a moiety ancestor and as a trickster character. Unlike "his more somber moiety counterpart, *Bunjil*, the eaglehawk," the crow can steal fire from guardians by playing all sort of tricks.[6] The crow sitting on the tree planted at the Mission could be a reminder that the Aboriginal people can also play tricks on the missionaries and respond to their intrusion. John Matthew claims that in Aboriginal culture, the crow and the eagle represent two different social classes "which once contested for the possession of Australia" and stand for social division within the Aboriginal communities of the nation.[7] The crow in Wright's novel could suggest an opposition of some sort and send the message that the lifestyle brought by the missionaries is incongruent with the Aboriginals'. On the other hand, the crow in Western culture connotes death and destruction, so the crow could foretell the death of more Aboriginal people.

[5] Alexis Wright, *Plains of Promise* (St. Lucia: University of Queensland Press, 1997), 4. Further page references are in the main text.

[6] Mudrooroo, *Aboriginal Mythology: An A-Z Spanning the History of Aboriginal Mythology from the Earliest Legends to Present Day* (Hammersmith: Thorsons, 1994), 35.

[7] John Matthew, *Eaglehawk and Crow: A Study of the Australian Aborigines Including an Inquiry into Their Origin and a Survey of Australian Languages* (London: David Nutt, 1899), 19.

After the girls in the dormitory listen to the crow's dreadful cries all night, Errol Jipp, the missionary in charge of St. Dominic, delivers to Ivy Koopundi Andrews the sad news that her mother has died. Ivy's mother, who remains unnamed in the novel, was also separated from her own family and made an older playmate for the whites' children. The reason the missionaries were successful in decimating the Aboriginal people was because they separated members of the same family from one another and made it impossible for them to find their relatives again. In this way, Aboriginal children lost contact with their families, language, and culture. Ivy and her mother find themselves in a paradoxical social position as they become outsiders to both cultures. Ivy's mother is rejected by Aboriginals because she had a child with a white man and works for the whites and by the whites because she is not one of them and, thus, is considered inferior.

During the colonial years, Aboriginals were forced to undergo an unnatural *whitification* process meant to erase their historical and cultural heritage and coerce them into embracing Western culture. This process, which was prevalent in colonial New Zealand, Canada, and the United States as well, started with the alteration of Indigenous identity. The Koopundi women's history of hybridity and assimilation includes rape, abuse, separation, and terror. Ivy's Aboriginal mother gives birth to Ivy, whose father is a white man. Ivy is separated from her mother and gives birth to Mary, whose father is also a white man. Colonial history turned the Koopundi women into hybrids, and the clash between settlers and Aboriginal cultures was inscribed on their bodies. On his way to the home of Ivy's mother, Elliot ponders the clash between the two cultures:

> It was like a war, an undeclared war. A war with no name. And the Aboriginal man was put in prison camps, like prisoners in the two world wars. But nobody called it a war, it was simply the situation, that's all. Protection. Assimilation ... different words that amounted to annihilation. The white man wanted to pay alright for taking the lot. But they didn't want to pay for the blackman's culture, the way he thinks. Nor for the blackman's language dying away because it was no longer tied to his traditional country ... The white people wanted everyone to become white, to think white. Skin and all. (74)

Elliot sees the negative effects of assimilation and believes that the colonizers' goal was to eliminate Aboriginal genes by forcing the Aboriginals to live among whites and marry white. For instance, Ivy is a

"half-caste" child at the moment, but in the future, she could marry a white man and "whiten" her genes and the ones of her descendants.

Hoping to "civilize" the Aboriginal people and assimilate them into Western life, the settlers separated many Aboriginal children from their parents and turned them into Christians. Damien Short, who wrote a recent study on reconciliation in colonial and contemporary Australia, reports that "the 1905 Western Australian *Aborigines Act* ... established a system of controls over Aboriginal families and children which regulated marriage, freedom of movement, employment and guardianship of children."[8] Thus, police officers, government officials, and the chief Protector of Aborigines had legal authority to remove children under the age of eight from their families and had the power to detain children until the age of sixteen in institutions.[9] In these institutions, which were similar to American boarding schools, Indigenous children were introduced and converted to Christianity and estranged from their own culture and family as much as possible. Child removals persisted after World War Two and during the 1950s and 1960s.[10]

Wright makes the argument that the settlers' rationale was that their lifestyle, culture, religion, and education were superior and worthy and that the Aboriginal people should have been thankful for these gifts. By spreading and teaching the word of God, the settlers whom Wright portrays think they save the Aboriginals from a dark and inferior world. Beverly, Jipp's wife, is on a mission "to serve God by saving these black souls from themselves, from paganism" (16). People like Beverly and her husband equate *black* with *savage, childish, exotic,* and *primitive* and continue to judge Aboriginals according to the Western standards of the time. Richard Broome posits that "some Europeans were claiming that the Aborigines were not merely savages, but not even men, 'being a species of tail-less monkeys.'"[11] Such characterizations of Aboriginals clearly point to the settlers' disregarding the Aboriginal people's heritage, connection to the land, and the variety of Aboriginal culture.

[8] Damien Short, *Reconciliation and Colonial Power: Indigenous Rights in Australia* (Aldershot: Ashgate, 2008), 88.

[9] Ibid., 88-89.

[10] Ibid., 89-91.

[11] Richard Broome, *Aboriginal Australians: Black Response to White Dominance 1788-2001* (Crows Nest: George Allen & Unwin, 2002), 95.

Beverly's ridiculous cleaning obsession reveals her rejection of everything which is not "clean," white, and pure and suggests indirectly that Aboriginal people are unclean and should conform to Beverly's notions of purity. In linking cleanliness to Victorian advertising, Anne McClintock demonstrates astutely that certain products show the empire as a fixed system of images and attitudes. McClintock posits that soap itself is advertised to offer "the promise of spiritual salvation and regeneration through commodity consumption, a regime of domestic hygiene that could restore the threatened potency of the imperial body politic and race."[12] Thus, cleanliness itself becomes a social construction which is supposed to purify the white body and wash away "the very stigma of racial and class degeneration" from the black skin.[13] In Wright's novel, Beverly, whose only knowledge of Aboriginal people comes from books and magazines, may actually view them through the lens of popular culture and advertising.

Beverly's motherly gestures, including the white dress which she offers Ivy for the funeral, are meaningless to the girls at the Mission, who feel orphaned. The participants at the funeral of Ivy's mother represent a sample of the diversified Australian society at the Mission. Some are church-going Christians, who remain faithful to their rituals but have been converted to Christianity, while the elders, who subvert Christian dogma silently, pose as Christians and practice their own religion. A more sonorous subversion comes from the sky when a storm suddenly breaks out and rain pours over both missionaries and Aboriginals. When the Aboriginal people are silenced by the settlers so that they must carry out their rituals in secret, it is the environment which makes a statement. The storm lashes out violently at the participants as if to punish the way the Christians conduct the funeral of an Aboriginal woman who was separated from her daughter by force, abused, and murdered. Lightening crosses the sky, and thunder shakes the ground under their feet to remind them of the force of nature. The storm is so severe that the Christians interrupt the service and bury the woman quickly, an outcome which can be regarded as a triumph for Aboriginals. Despite its violence, the storm proves benefic to Ivy because she sees "her mother's face smiling at her, a careful, peaceful smile" (18). It is only in the storm, a powerful manifestation of the environment, that Ivy can connect with her

[12] Anne McClintock, *Imperial Leather: Race, Gender, and Sexuality* (New York: Routledge, 1995), 211.
[13] Ibid., 214.

mother, who assures her their relationship is possible when mediated by nature. The violence of the natural world, which becomes a pattern in the novel, reiterates the violence of colonialism, but it also suggests that reconnecting after rupture necessitates violence of some kind. The meeting between Ivy and Mary at the end of the novel takes place during a violent storm as well.

Ivy's struggle to understand who she is and where she belongs is evident when she associates herself with glamorous white girls from magazines but still feels connected to her mother and her culture. Pilkington's Kate feels a similar confusion *vis à vis* her Aboriginal heritage and identity when she attends Western schools and is converted to Christianity. Since she was taken away from her mother when she was little, Ivy does not know who she is and where she comes from, but she senses that her roots and family have nothing to do with the Mission. Ivy receives a lesson from nature and learns to disregard the teasing of the girls in the dormitory. The girls' scary stories about quicksand convince Ivy not to move when she finds herself in another storm. The terrible storm, which gathers "mud, dead branches, trees and dead animals" (35), is nature's attempt to purify itself of the violence and destruction brought to the land. Petrified by fear, Ivy stands with her ankles in the mud instead of finding shelter. It is Maudie, the Aboriginal woman "as old as the land" (11), who endangers her own life to save Ivy from the waters. The scene is important because Ivy is saved by another Aboriginal woman and decides not to listen anymore to the wicked girls from the dormitory. She also learns about the power of the natural world over humans. Nature, as Wendell Berry points, is both helpful and dangerous: "Human nature partakes of nature, participates in it, is dependent on it, and yet is different from it ... Nature is not easy to live with. It is hard to have rain on your cut of hay ... it is hard when nature does not respect our intentions, and she never does exactly respect them."[14] Wright shows the violent along with the empowering potentialities of nature, which functions as a mediator between Ivy and her Aboriginal relatives. Ivy survives this violent storm, an experience that will be helpful when she uses the storm to communicate with her daughter.

Under Maudie's tutelage, Ivy reconnects with her mother and the natural world. Maudie, the old woman respected and feared by both missionaries and Aboriginals, is among the few who helped Ivy's mother, and she saved Ivy's

[14] Berry, *Home Economics*, 141 (see chap. 3, n. 19).

life in the storm, took her fishing, and welcomed her in her home. When Ivy performed poorly at school and did not know whether the savior of the world is called God, Christ, or Jesus, she ran to Maudie's place. There, Ivy sat under the tree her mother had died, remembered the funeral, wondered about her mother, and saw her face. Ivy needed to be outside of the Mission and the indoctrination she was infected with there to receive a different kind of instruction about nature and Aboriginal traditions. When Ivy dug a hole for herself and spoke angrily to the sky, begging for death, Maudie inspected the hole and put the dirt back to send Ivy the message that she must live.

Maudie understands Ivy's importance to her community and senses that the girl comes from an Aboriginal family of healers. However, Maudie does not have time to offer Ivy a more comprehensive education about nature, her family, or the Aboriginal community. In a moment of desperation, Ivy screams: "'Tell me about my mother'," but Maudie has already died (55). Ivy fails to receive the information about the history, heritage, and identity of her mother and has to reconstruct it herself. Unlike the missionaries, Maudie does not give Ivy lectures and written exercises about her history but provides her a comfortable space in which Ivy could feel at home, that is closer to her mother and nature. Maudie lacks the power to intervene in Ivy's history and destiny, especially when the missionaries teach her their own history and hide their crimes against the Aboriginal people. Ivy feels lost because she "does not remember anything about her home and community. Dazed and shocked, she tries to put the puzzle of her life together" (56). The girl's confusion *vis à vis* her identity and culture is shared by other Aboriginals who were separated from their families and communities. Ivy's adult life will revolve around her desperate attempts to put the pieces of her life together; that she is not able to return to her community and family and reunite with her own daughter and granddaughter speaks about the losses suffered by the Aboriginal people.

The missionaries consider Ivy evil and call her "a bad apple" (23) without questioning their own behavior toward women like Ivy and her mother. This label transforms Ivy into a powerless young woman who has to atone for what she is not responsible for: her race and the history of her people. The girls in the dormitory tease her constantly, and Jipp rapes her during the night. After long discussions with God, Jipp justifies his actions by arguing that "God knew he would never reduce himself to their [the Aboriginals'] level," but his assaults are supposed to be beneficial to Ivy

because they take the devil out of her (31). Jipp chooses Ivy because she is silenced, powerless, and vulnerable. While he rapes her in the church, it is Ivy who feels shame for his sins. Powerful men like Jipp use religious rhetoric to their advantage and adhere to a discourse which reduces Aboriginals like Ivy to mere animals and which therefore ironically suits their own bestial actions. Maria Pendersen concurs with this assumption and suggests that "Aboriginal people were considered to be little more than animals who could be bred out of the general population."[15] She stresses further that "Aboriginal women were typically viewed from ethnocentric perspectives and were therefore overlooked and exploited ... used as concubines or sexual partners for the settlers and pioneers."[16]

Another place where Jipp rapes Ivy is on the banana plantation, which also functions as a cemetery. The Aboriginal community knows about Jipp's rapes on the banana plantation, but lacks the power to prevent them or intervene; they are only disgusted by the rustling of dead leaves during the night. Since the Aboriginal people remain silent about the rapes that take place during the night, the land records Jipp's violence and responds to it in turn. Whenever someone dies, Jipp plants a banana tree at the head of the grave to remind everyone that life is more important than death and that no one should die of hunger at St. Dominic's. In Jipp's mind, bananas should represent healthy nourishment and celebrate the life full of opportunities at the Mission. Yet the Aboriginals do not eat the harvest, which they equate with sin, death, disbelief, and lust. Like the poinciana tree in front of the girls' dormitory, the banana trees symbolize an unnatural intrusion on their land, one similar to a rape of the land, which parallels Jipp's intrusion on Ivy's body. Both intrusions are violent and lead to the destruction of the Aboriginals. Many critics, including Andrea Smith, underscore the "connection between the colonization of Native people's bodies – particularly Native women's bodies – and Native lands."[17] Smith adds that the "colonial/patriarchal mind that seeks to control the sexuality of women

[15] Maria J. Pendersen, "Oppression and Indigenous Women: Past, Present, and Future – An Australian Kimberley Aboriginal Perspective," in *Home/Bodies: Geographies of Self, Place, and Space*, ed. Wendy Schissel (Calgary: University of Calgary Press, 2006), 17.

[16] Ibid., 19.

[17] Andrea Smith, *Conquest: Sexual Violence and American Indian Genocide* (Cambridge: South End Press, 2005), 55.

and indigenous peoples also seeks to control nature."[18] While this type of patriarchal control is obvious in *Plans of Promise* as well, Wright also shows how the land responds to the violence against itself and against Ivy. The land does not provide the necessary nutrients, so the missionaries who eat the fruit get rashes all over their bodies. Thus, the land on which Jipp intended to celebrate life is made of layers of rotten bananas and dead roots.

Horrible events such as sudden deaths, illnesses, and suicides continue to plague the Mission. The missionaries find the wrong explanation for these terrible episodes, one which justifies their violent actions. Since they are confident that the Christian faith and their teaching "God's word" bring light into the dark Aboriginal world, the fault must lie with the Aboriginals. When the shaving of Ivy's head proves an insufficient punishment for her supposed sins, one which does not resolve the unexplained events at the Mission, they need further proof to incriminate the girl and her mother. Elliot, a connoisseur of magic, is sent to the homeland of Ivy's mother to ask for help and inquire about the family's sanity.

On his way to the Channel Country of Queensland, located in the remote south-west of Australia, Elliot encounters communities of Aboriginals who preserve their traditions and sees lands barely touched by colonization. He admires a beautiful landscape which is capable of regeneration:

> The land had turned into a brilliant carpet in bright shades of green moments after the rain finally stopped. As far as the eyes could see, soft spikes of grass fluttered in waves. The dead clumps of old grass … lay flattened beneath the abundance of new growth. The land rejoiced. The words of the world whistled by in an endless murmur of repeating rhythms. A mother's songs of quietness after the time of giving birth. (81)

Although there are signs of death in this particular landscape as well, especially during the night, its potential for rebirth suggests hope to the Aboriginal people. Layers of new leaves and grass are born each morning, which makes the landscape comparable to a woman giving birth, to life, and growth. As long as Aboriginal mothers continue to give birth to children on a vigorous and healthy land, then there is hope for the Aboriginal natural and cultural heritage. The land transmits this optimistic message about regeneration through whispers and quiet incantatory sounds and seems to

[18] Ibid.

speak a language of its own, heard and spoken outside of the colonizers' language.

The earth's regeneration is followed by a ceremony which brings together participants of different generations, ancestors who returned from the dead as mosquitoes, elders, and children. The continuity of the relationships among generations of Aboriginals contributes to the proliferation of their ritualistic performances and cultural heritage. Elliot, who, during his journey sang the song of the earth and starved himself not to awaken the spirits of the land with food odors, now sees hundreds of dancers painted in white and wearing pelican feathers and dancing and chanting together. The symbiosis between the Aboriginals and birds demonstrates the people's integration into the landscape. Although Elliot does not participate in the ceremony and remains an outsider to the dancing on the previously prepared branches and cockatoo feathers, he understands that the main goal of the ceremony is to recall the birds to their formerly waterless home, which has turned into an inland sea once again. The sounds of beating hands and feet lead to the transformation of earth into water and to the birds' return to witness the miracle which the Aboriginal people made possible. Now that "the water had resurfaced and covered the grassy landscape," millions of birds fly toward the lake (85).

While the rebirth of the land that Elliot witnessed is indicative of the beneficial influence of the land on the Aboriginal culture, the land also records the settlers' violent actions. Despite the family members' successive attempts to bring Ivy to her community, she remains at the Mission. The elders insist Ivy return home because she may possess the special powers of the old man in their family who healed people and animals with his magic. The old man's death caused disequilibrium within the community of Aboriginals, and they had hoped Ivy could restore order again. Yet, instead of fulfilling her destiny as a healer, Ivy is forced to remain at the Mission and pay for Jipp's mistakes. Shortly after Elliot's return to the Mission, Jipp arranges Elliot's marriage to Ivy, who is pregnant with Jipp's baby. Again, the land reacts visibly to this violent action and lends Ivy a voice when she is muted and powerless. When Dorrie takes a piece of earth in her hand, she realizes she holds a translucent snake. The capture of the snake produces a "chain reaction in the surrounding earth: dozens of the hidden creatures simultaneously surfaced" and attacked one another, mimicking the missionaries' attacks against the Aboriginal people (124). The existence of

snakes and other creatures under thin layers of dust proves that many actions that are carefully hidden need to be acknowledged. Jipp wants to bury his own sin, the impregnation of Ivy, under a false marriage. While Ivy remains silenced, the earth regurgitates the snakes and comments on Jipp's behavior toward Ivy and his violence toward the Aboriginal people.

Although in this particular scene, the snakes could represent violence and sin, in Aboriginal cultures, the snake and especially the rainbow snake are mythic creatures with remarkable powers. Mudrooroo explains that the rainbow snake "is perhaps the most important deity in *Aboriginal* Australia … [and] is also the giver as well as the guardian of the mystic healing rites of the *shamans*."[19] Analyzing the myths of the rainbow snake throughout Australia, Charles Mountford posits that the rainbow serpent is linked to healing, the birth of children, and creation in general. In the Arnhem Land plateau, "the rainbow serpent almost reached the status of a supreme being. He is eternal and indestructible, he is not restricted to any time and place, and he is the creator of the aborigines, of the land on which they live, and of the creatures and plants that provide them with food."[20] Claiming that the rainbow snake appears less powerful in the country of the Murinbata tribe, Mountford believes that it is still considered "the beneficent creator of man and of the whole of creation."[21] Wright does not elaborate on the snake's qualities and strengths in *Plains of Promise*, but the presence of the snakes on the Aboriginal land could be interpreted as hopeful. As long as the snakes continue to resurface, they promise the survival of Aboriginal people.

Ivy survives, but she misses her only chance to return to her homeland when Pilot, whose task was to bring her home, is found dead at the Mission. Pilot wanted to save Ivy and her unborn daughter, prevent her arranged marriage to Elliot, and bring her home. Pilot's body hangs by his broken neck from a branch of a thorny pear tree and is trapped in straggly undergrowth. His open wounds are covered with leaves and dirt, and his whole body is integrated into the landscape: "they broke loose of the prickly foliage and it lay on the ground … Several open gashes had been caused by some sharp object much larger than prickly pear spikes. The black-and-blue

[19] Mudrooroo, *Aboriginal Mythology*, 141.

[20] Charles P. Mountford, "The Rainbow-Serpent Myths of Australia," in *The Rainbow Serpent: A Chromatic Piece*, ed. Ira R. Buchler and Kenneth Maddock (Hague: Mounton Publishers, 1978), 94.

[21] Ibid.

bruises mingled with dirt" (136). Erroll Jipp decides not to investigate this murder for which he is responsible and buries Pilot immediately "without formalities, before the blood dripping out of the torn body even had time to dry" (132). While Jipp erases any record of Pilot's death, just as he eradicated the written documents of the Koopundi women, the landscape records the violence which has been done to Pilot. The signs of his death, such as blood stains and broken branches, will remain imprinted on the landscape. Although the Aboriginals are silenced and even exterminated, the land remembers the missionaries' violence and murder.

Fifteen-year-old Ivy is forced to marry Elliot and spend the rest of her life at St. Dominic's and in a mental institution. After she gives birth to her daughter, Mary, she becomes sick both physically and mentally. History repeats itself when her daughter is taken away from her and grows up without her biological mother. Unlike her mother, who raised Ivy until she turned seven, Ivy loses her daughter from the day she is born. After a series of examinations, the doctors at the mental institution conclude that Ivy had an abortion instead of giving birth to a child and that her inability to communicate must characterize all uncivilized Aboriginals. At the Sycamore Heights institution, the doctors regard Ivy as a typical inmate who struggles to find the missing person: herself. Their treatments do not address the causes of Ivy's condition, such as the abuse, violence, and rapes. Instead, Ivy is labeled as an oddity, that is an Aboriginal out of control due to the peculiarities of her race. Estranged from her family and her newborn daughter, she stares at the landscape and distant hills, ages prematurely, and finally goes insane at the Mission.

The doctors' explanation for Ivy's condition is another instance of racism and a manifestation of pseudo-science. Throughout the novel, Wright exposes the settlers' racist treatment of Aboriginals, who are reduced to animals, savages, children, and peculiar specimens of an inferior race. Broome explains that until the 1850s, the Europeans believed in the Great Chain of Being that ranked Europeans the highest and the Aboriginals the lowest, next to animals.[22] Around the 1840s, the Europeans developed the pseudo-science of phrenology, which "claimed that the shape of the head and its bumps represented the shape and size of the brain within, and the different personality traits of the person."[23] Phrenologists argued that the skulls of

[22] Broome, 94.
[23] Ibid.

Aboriginals revealed deficiencies in the so-called intellectual part of the brain, which was reason enough for Europeans to view Aboriginals as animals. Europeans invented pseudo-scientific theories to justify their actions and created a mindset which allowed and perpetuated discrimination against Aboriginal people. Thus, the Western doctors diagnose Ivy as an oddity because she is an Aboriginal.

By the time Mary, Ivy's daughter, grows up, many of the pseudo-scientific theories are no longer in fashion, although discrimination against Aboriginals continues to this day. Integrated into an urban milieux and disconnected from their families by force, many Aboriginals, like Mary and her daughter Jessie, have lost contact with their communities and relatives, and they are now assimilated within the dominant culture. Historians refer to the Australian Aboriginal people who were separated from their families as the stolen generation, "a common term for possibly the worst injustice perpetuated on Australian soil during the 20th century: the systematic state sanctioned forcible removal from their mothers, families and communities of thousands of Aboriginal babies and children of mixed descent."[24] These historians underline the difficulties Aboriginals encounter when they try to reconnect to their families and cultures. Most of the urban Indigenous people described by Erdrich, Grace, Armstrong, and Maracle left their reservations and villages and feel isolated in big cities. Mary, too, struggles to find her place in a metropolis: "With no family of her own, Mary's life was as solitary as it had been in the city" (240). She dates Aboriginal men who abuse her and tries to associate herself with the Aboriginal community in the city. Mary's reason for working at the Coalition of Aboriginal Governments has to do with her desire "to be Aboriginal" (209) and her hopeless attempts to find information about her family and homeland. Although she is friendly and hardworking, Mary is treated as an outsider by the Aboriginals at the organization: "She perceived a denial by Aboriginal people wherever she worked to accept her Aboriginality. She believed that if her life was to change for the better, she must gain their full acceptance. And this, she was certain, depended on finding her mother so that she could claim family and land affiliations" (240). Mary equates Aboriginality with familial connections, land, community, and acceptance by other Aboriginals and thinks that if she finds her mother, then she will find some comfort and peace and become a much more respected Aboriginal. Applying an idealized and

[24] Short, 5.

unrealistic image to her Aboriginal mother, one which reinforces a fantasy of unconditional maternal love and care, Mary is unable to imagine her mother's degrading situation and the consequences of her tragic life.

Mary travels to her birthplace and spends three months looking for her mother but encounters indifferent people who feed her unreliable stories and incomplete documents. However, Ivy and Mary do meet in a dramatic scene which takes place despite the incomplete historical documents and the reluctance of the missionaries to share information. Since verbal communication is limited and inadequate for a far too complex and complicated relationship between an Aboriginal mother and her daughter, the natural world mediates their encounter and lends them voices once again. During a stormy night at St. Dominic's, Mary feels that something has touched her face and arms; in the flashes of lightening, she sees crazy Ivy, who looks like a "diseased leaf" (294) and an animal whose eyes "claimed all the fear of the earth" (294). Although it is unclear whether the three Koopundi women recognize each other or not, they may be aware of their relationship. Ivy supposedly touches Mary's face because she recognizes her. They communicate in a nonverbal language which speaks of all the violence done to their family, the only type of communication available to them after their tragic lives and separation. Ivy and Jessie start screaming and trembling almost to the point at which they "explode from violent convulsions" (294). When both women calm down, Ivy and Mary exchange several looks that must have some effect on them because when Ivy turns away, Mary feels "a sudden surge of disappointment and depression which she could not explain to herself" (295). The next day, Mary stares at the hut where she had seen her mother and inquires about Ivy. Jessie whispers story after story about Ivy in Mary's ear and claims that the old woman offered her candies. It is possible that Ivy recognizes her granddaughter and has an impact on her since the little girl remembers Ivy's stories.

Mary departs from St. Dominic's on a plane without participating at a conventional family reunion or reestablishing meaningful relations with her mother and birthplace. Whether she is aware of it or not, Mary does meet her mother during a terrible storm which replaces verbal dialogue with a violent and abrupt form of communication, the only form available to the Koopundi women given their tragic history. As Mary and Jessie fly over the beautiful landscape, the pilot asks everybody to admire the sight: "This is pure magic, ladies and gentlemen. What you are witnessing is the water once again

coming to the surface of what we call the 'Disappearing Lake.' It has been dry for at least thirty years. A rare sight, and it is my privilege to show it to you" (302). As the water reappears out of nowhere and forms a lake via pure magic, thousands of waterbirds return to the lake as they did when Elliot visited Ivy's original home. This natural miracle happens again after thirty years only when the three Aboriginal women meet and find themselves together in the same place, so their reunion seems to produce a magical natural phenomenon. While a great storm brought the Koopundi women together and offered them an alternative way of communication, the waters that converge on the dry lake mark the meeting of the three Koopundi women, the only time when they are together in the same place. Seen from this perspective, one reinforced by the hopeful title of the novel, Wright shows a glimpse of optimism for this Aboriginal family. After all, Mary makes sure that she and her daughter, Jessie, will not be separated. Within the Christian tradition at least, one which Mary and Jessie partly adopted and are assimilated into, their names suggest hope and salvation. This detail may also reveal the author's ironical touch since there are few episodes in the novel that suggest salvation and hope.

The novel ends with Mary's and Jessie's departure and recollection of Elliot's story about a magic lake which dries out because of greedy crows so the waterbirds cannot return home. The Koopundi women could symbolize the waterbirds returning to a home, family, and community that are all dry of their resources; this image underscores that the Koopundi women cannot establish meaningful relationships and heal one another from their tragic memories. Some critics posit that Wright's novel sends a rather gloomy message. François Kral argues that the "loss of her baby [Mary] echoes the first loss [experienced by Ivy's mother] and repeats the disjunction epitomized by the severed umbilical chord. Generations of Aboriginal women lead parallel lives without any interaction like separate branches of a generation tree or the pages of a book torn apart."[25] Unlike Kral, I believe that despite their hostile world, women like Ivy's mother, Ivy, Mary, and Jessie find in the natural world a temporary remedy for their physical and mental ailments. The land functions as a mediator between and sometimes an ally to the Koopundi women because it soothes their pain and creates a space in which a dialogue among them is possible. The characters' investment in

[25] François Kral, "Re-Surfacing Through Palimpsests: A (False) Quest for Repossession in the Works of Mudrooroo and Alexis Wright," *Commonwealth* 25, no. 1 (2002): 10.

the land pays off because the environment rekindles connections with their Aboriginal culture and each other. The missionaries and settlers destroyed documents and erased their violent actions, but the natural world records their acts and promises a more optimistic future to Aboriginal people.

CHAPTER 7

GOING PLACES, GOING NATIVE:
DORIS PILKINGTON'S *CAPRICE*

Alexis Wright shows how places reflect the challenges Aboriginal people face such as abuse and separation from their families, and echo the violence that has been done to them. In *Caprice: A Stockman's Daughter* (1991), Doris Pilkington also considers how places become texts that narrate violent scenes of Aboriginal history and describes in detail the settlements and Christian schools that contributed to Aboriginal children's estrangement from their own culture. While Maracle and Armstrong present First Nations women who remember certain places they had inhabited or visited, Pilkington expands on this memory exercise by having her protagonist, Kate, visit the places where her relatives lived and recreate the experiences that happened in these places. As in Marilyn's and Penny's cases, Kate's journey based on memory and recreation is healing and liberating.

While Wright narrates the events of *Plains of Promise* in the third person and devotes several chapters to each of the Koopundi women, in *Caprice*, Pilkington tells her story from the perspective of Kate Muldune-Williamson, who is the granddaughter of an Aboriginal woman and an Irishman. Pilkington brings together the lives of three generations of Mardu women, whose stories are told by one of their last descendants, Kate, who underscores her forced estrangement from her relatives and the lack of relevant information on her family history. What becomes relevant for Kate, a modern-day woman living in the assimilated society of contemporary Australia, is her return to the place of her ancestors and the reinvention of this place and of her family history. The journey to her homeland and her recreation of the history of her people help her develop as an Aboriginal woman, mother, grandmother, and daughter. Although many Aboriginal women like Kate have lost all contact with their families and culture, they eventually understand that their Aboriginality is part of their identities and that a return to their homelands could rekindle their interest in their ancestors' traditions.

Like Mary and Jessie in *Plains of Promise*, Kate grows up without the nurturing love of her mother and grandmother and has to discover by herself how to become an Aboriginal woman and mother. Both Pilkington and Wright deal with Aboriginal protagonists who try to restore the links with

their pasts and with Aboriginal heritage after they have been separated from their family members. Despite their alienation from their families, Aboriginals like Kate enrich their identities by returning to the homeland of their ancestors and making places and the traditions embedded in these places relevant to their lives. Mary experiences a similar nostalgic urge to return to her homeland and find her family, but the outcome of her journey is less favorable because, unlike Kate, she does not benefit from the guidance and additional information received from the community and she lacks Kate's imaginative capacity. Pilkington's and Wright's female protagonists differ from Hogan's heroine, who is denied motherly love but is guided by her grandmother, great-grandmother, and great-great-grandmother in her endeavors to find her roots. Kate's journey also parallels Marilyn's journeys in Maracle's *Daughters Are Forever*. Both Kate and Marilyn are middle-aged, divorced mothers who live in Western environments and find themselves at turning points in their lives when they realize the importance of their Aboriginal identities to their future. Unlike Marilyn, who remembers places and episodes from her past, Kate travels to the actual places where her family members had lived and worked. Kate does not have any memories of her family and relies on her own impressions and other people's accounts. She recreates and imagines her family's history and, consequently, her own history since she cannot remember the brief moments she had spent with her mother and grandmother.

Ashcroft, Griffith, and Tiffin argue that postcolonial literatures focus on "the development or recovery of an effective identifying relationship between self and place."[1] Nadja Zierott concurs and believes that place and land play a major role in Australian Indigenous culture because they are the basis "for the formation of identity."[2] Damien Short makes the case for the significance of land and place in Australian Aboriginal culture and contends that the survival of Australians Aboriginals is strictly related to the ownership of their lands as well as political autonomy: "indigenous peoples' special relationship to their land is such that return of their lands and political autonomy is considered crucial not only to their cultural survival as distinct peoples, but also for their physical and mental well-being and consequently

[1] Bill Ashcroft, Gareth Griffiths, and Helen Tiffin, *The Empire Writes Back*, (New York: Routledge, 2002), 8.

[2] Nadja Zierott, *Aboriginal Women's Narratives: Reclaiming Identities* (Münster: Lit Verlag, 2005), 15.

is a key aspiration."[3] Pilkington's protagonist does not aspire to regain material possessions, such as the family land and house, but she looks for a validation of her Aboriginal identity as a result of her interaction with her family and land. Kate travels to several places, such as her grandparents' hometown, house, workplace, and resting place, the Dunbar Station, the Native Camp, the Moore River Native Settlement, the Roelands Native Mission, and her father's house, places she and her family members inhabited. In retracing her own steps and those of her relatives, Kate puts together her own version of her personal and national history, one based on her impressions and memories and her recovery of traditions. Eager to find out any factual information about her family members and the locations in which they had lived, Kate recreates their homeland and experiences by using her imagination and creativity.

Peter Read argues that "Aboriginal children removed from their parents are exiles in their own land, and when they return to the sites of haunted memory, many of them journey to lay the ghosts of childhood cruelty."[4] Read's statement applies only partially to Kate and what she considers to be the purpose of her journey. Although she may be an exile in her own homeland at first, she is willing to change this condition and be reeducated in the Aboriginal tradition and reintroduced to the places of her childhood. Kate is not so much haunted by her cruel memories as she is inquisitive and eager to redefine herself. The ease with which she absorbs information, visits specific locations, deals with certain memories, and welcomes Aboriginal traditions and communities contributes to the readjustment and redefinition of her identity. Edward Relph recognizes both the identity of places and the people's identities in connection to places and claims that not only is the identity of a place important "but also the identity that a person or group has *with* that place, in particular whether they are experiencing it as an insider or as an outsider."[5] Kate is neither an outsider nor a tourist who visits places, houses, graveyards, and state institutions in Australia, but she is an insider who is involved emotionally and spiritually with Aboriginal land and heritage.

In Book 1, titled "Lucy Muldune 1904-1965," granddaughter Kate returns to her grandparents' home to find out about their life and complete

[3] Short, *Reconciliation*, 5 (see chap. 6, n. 8).
[4] Read, *Returning*, 37 (see chap. 6, n. 3).
[5] Edward Relph, *Place and Placelessness* (London: Pion Limited, 1976), 45.

her own. In the first chapter, "Looking for Lucy," Kate visits some of the locations in which Grandmother Lucy had lived, which means her journey involves reconnecting to places. Peter Read believes that people's "returning to the lost place ... can bring [them] both pleasure and pain."[6] For Kate, the return is quite pleasurable because she has healed already from the loss of her grandparents and mother and she uses her journey as a new learning experience. Her journey starts at dawn, an appropriate time for beginnings, at the cemetery where Lucy and Mick are buried. The oxymoronic imagery of the cemetery at dawn, suggesting both beginnings and endings, has positive connotations for Kate. She considers the visit to her grandparents' resting place to be "a ritualistic performance ... a celebration of a new day; a new beginning."[7] Kate regards visiting the resting place of her dead grandparents not as an end of their lives but as a fresh start, the optimistic beginning for her recreation of places. Kate even admits that "my grandparents' final resting place should be the appropriate location to resume my search to establish my true identity. Because their history is my heritage" (4). Kate's interaction with Lucy's and Mick's home and resting place opens up new possibilities and creates situations in which Kate can connect the past of her relatives with her present and the future of her children; if not for her journey and her decision to recreate this part of family history, her children would not be exposed to the family's Aboriginal heritage. Kate admits that her grandparents' history is the basis of her heritage and reestablishes the link with her past for herself and her children.

Kate starts her journey where her grandparents lived and died, a place which records the history of generations of Aboriginals and contributes to the formation of her Aboriginal identity. Like many Māori, Australian Aboriginals from certain communities value the connections between the living and the dead and their links to the land. Aboriginal people's notion of the Dreaming, a complex feature of their cosmology and epistemology, links living beings with the land.[8] Kevin Frawley explains that Aboriginal

[6] Read, 37.

[7] Doris Pilkington, *Caprice: A Stockman's Daughter* (St. Lucia: University of Queensland Press, 1991), 4. Further page references are in the main text.

[8] Lynne Hume posits that the Dreaming, which in Aboriginal language is called *altjiranga ngambakala*, *djuguba* or *djugurba* (throughout the Great Victoria Desert), *duma* (in the Rawlinson Range), *djumanggani* (in the Balgo area), *ngarunggani* (eastern Kimberley), *tjukurrtjanu* (by the Pintupi), *bugari* (around La Grange and Broome), *ungud* (among the Ungarinjin), and *wongar* (in north-eastern Arnhem Land) has been translated to English as

Australians consider nature and culture as bound together in the Dreaming, a concept which brings together the living, the dead, their experiences and memories, and the land. Frawley argues that "Belief systems associated with the Dreaming link specific places with Dreaming events and give every person, living and dead, a place within a physically and spiritually united world."[9] The authors of *The Empire Writes Back* also talk about Aboriginal land as a text, an encompassing force, a "text of the Dreaming ... that ... is intimately bound up with the life and experience of each individual."[10] Edward Casey claims that places including the Dreaming hold and release the memories of the people who inhabited them: "This kind of keeping [of memories] is especially pertinent to an intensely gathered landscape such as that of aboriginal Australia – a landscape that holds ancestral memories of the Dreaming."[11] Finally, Eva Knudsen claims that the "Dreaming is a reservoir of Aboriginality and the land is the text from which its stories can be read."[12] Although she believes that the notion of "the Dreaming" is not easily defined, Knudsen understands it to be "a synonym for Aboriginal identity."[13]

Lynne Hume, who has written an entire study on the role of the Dreaming and ancestral power for Australian Aboriginals, argues that despite regional variations, it is generally thought that "the land and the Dreaming are one and are linked by spiritual kinship to the extent that one thing cannot be separated from the other: animals, birds, country, human beings and Ancestors."[14] Hume posits that in the creative period, the Ancestors gave shape to the world and "left tangible expressions of their essence in the shape

Dreamtime, eternal Dreamtime, and the Law. *Ancestral Power: The Dreaming, Consciousness, and Aboriginal Australians* (Victoria: Melbourne University Press, 2002), 24-28.

[9] Kevin Frawley, "A 'Green' Vision: The Evolution of Australian Environmentalism," in *Inventing Places: Studies in Cultural Geography*, ed. Kay Anderson and Fay Gale (Melbourne: Longman Cheshire, 1992), 220.

[10] Ashcroft, Griffiths, and Tiffin, 142.

[11] Edward S. Casey, "How to Get from Space to Place in a Fairly Short Stretch of Time: Phenomenological Prolegomena," in *Senses of Place*, ed. Steven Feld and Keith Basso (Santa Fe: School of American Research Press, 1996), 25.

[12] Eva Rask Knudsen, *The Circle & the Spiral: A Study of Australian Aboriginal and New Zealand Māori Literature* (Amsterdam: Rodopi, 2004), 7.

[13] Ibid.

[14] Hume, 29.

of some site or rocky outcrop, tree or waterhole, metamorphosing a part of themselves into some feature of the environment or imprinting themselves on to cave walls or into ritual objects."[15] The ancestors' creation of the world and their involvement in the culture and environment of Aboriginals explains their connection to the land. Hume and the other critics offer general definitions of the Dreaming and acknowledge that Aboriginal people from different regions and communities of Australia create their own variations and definitions of the Dreaming.

Pilkington's vision of the Dreaming underscores the aspect which refers to the laws of the elders that were passed along from one generation to the next. Kate sees the Dreaming, which she calls Dreamtime, as a code of laws, "codes of social behaviour and social conduct, and more importantly, a belief system that was handed down by superior beings of the Dreamtime" (5). These unwritten laws were put together by the elders and respected by Aboriginal communities. Kate, like her Irish grandfather before her, must obey, preserve, and practice the Aboriginal codes of laws and values. Although Kate expected answers and anecdotes about her parents and grandparents from her family members, she received no "special consideration or privileges" (5). Instead, she learns to experience her homeland and culture by herself and to find her own answers. Kate's return to the place of her birth and her travels to locations where her family members had lived are specific to her experiences and interpretations. Because of the capacities of places to tailor themselves to the individual's experiences, Kate is able to put together images and stories about her Aboriginal family and their homeland and heritage. She also weaves her own stories into her experience of the places her family members inhabited. Her recreation of events would not have been possible had she not returned home and visited these places. Kate was enrolled in Western schools and knew very little about her Aboriginal family, places, and community.

Kate's homeland becomes both a collective and personal place where she inserts memories, facts, and fictional accounts about her family members that contribute to the creation of her Aboriginal identity. The stories about her family become an integral part of her own life story and her present. In reshaping her family's history, Kate gathers information about the lives of her grandparents and parents from their neighbors, friends, and acquaintances. Mick's and Lucy's friends, Jack and Phyliss Donaldson,

[15] Ibid., 24-25.

reveal to Kate many memories, "some vivid, others dim" (6), of her grandparents and tell her many stories about them. Exact dates are not very important to Kate, who is content to create her own text out of witnesses' factual and fictional accounts, her interpretations, and her needs and aspirations. David Lowenthal explains that the "past as we know it is partly a product of the present; we continually reshape memory, rewrite history, refashion relics."[16] Mick and Lucy reshape the past when they retell their stories to Kate, who filters them through her imagination. In visiting her family's homes and other places of residence and rewriting her family's stories, Kate becomes more familiar with her Aboriginal heritage. Kate's recreation of her grandparents' past is performed in the locations where they had lived. While she admires the pinkish hues of sunrise, the acacia bushes, and the mulga trees in the cemetery, Kate wonders how the forbidden and almost impossible love and marriage between her grandparents could have worked.

Like Erdrich and Hulme, Pilkington tackles such issues as interracial marriage and relationships between Aboriginals and whites. Lucy, a full-blooded Mandjildjara- speaking Aboriginal girl from the desert region of Western Australia, marries Michael Patrick Joseph Muldune, an Irishman born in the County of Derry. The couple is apparently incompatible because of differences in their appearance, cultural heritage, and historical background. Contrary to opinions, traditions, and the rules of the white and Aboriginal community, Lucy's and Mick's marriage proves a lasting and fulfilling one. Kate sees their marriage as a happy one and admires their efforts to overcome their cultural and ethnic differences.

Kate further ponders the discrepancies between the Irish and the Australian landscape. The contrast between the lush green meadows of Ireland and the arid deserts and remote towns of Western Australia suggests that the environments in which Lucy and Mick had grown up are vastly different. The Irish are not used to a summertime temperature between 35° C and 40°C in the shade, frequent dust storms, and unbearable humidity. Yet Mad Mick Muldune is eager to live under these conditions in the town of Kingsley and to work at the Dunbar station. His ability to confront difficult situations and his ambition to survive in a new environment and culture contribute to his success in Australia. Mick eventually adapts to the Aboriginal style of living and adopts the Australian landscape as his own.

[16] Lowenthal, *The Past*, 26 (see chap. 4, n. 9).

Kate explains that when the newcomers, who arrived at Kingsley, wanted to introduce the flora and fauna of Europe to Western Australia, her grandfather became adamant in his opposition. He told the Europeans that: "'You can't change this country with its rugged, tough landscape and make it into the green fields and meadows of Europe ... You have to learn to adapt and live with it, like I have'" (8). Mick knows from his own experience that people and even animals and plants depend physically on their familiar landscapes and that adaptation to a new environment is difficult. He also understands that a specific location has its own environmental and cultural characteristics. Niamh Moore claims that the "landscape of a particular place will tell us much about the history of the people."[17] In other words, one's attempts at changing the landscape lead to other changes that could affect the economy, social life, and culture of the communities living in the region. A specific example of the incompatibility of the Australian landscape with European animals involves the European rabbit. R.M. Younger relates that a shipment of rabbits arrived in Australia from England in 1859, and they multiplied rapidly once they were released. The European rabbits "caused great damage, particularly in areas where friable soil was ideal for their burrows and the sweet grass provided ample feed."[18] Many of the rabbits had to be killed and their numbers kept down. Mick's commentary about the Australian landscape, which would not be fit for foreign plants, lends itself to a larger point about the Australian Aboriginal people and Europeans. Just as many European plants and animals are not fit for the conditions of the Australian environment, Western standards of living are also incompatible with the Aboriginal people's social and cultural traditions and expectations.

Like the Aboriginals, the Irish were colonized by the British Empire, which dominated their social, political, economic, and cultural existence. The British colonists forced the Irish to "change their lifestyle by destroying their language and culture, then condemning them and persecuting them for being different" (9). Kate says that Mick Muldune inherited his stubbornness and unwillingness to become subordinate and give up his convictions from his Irish ancestors, who had fought the British colonists for centuries. Lucy and Mick fought the same battles and shared similar experiences as they grew up under colonial domination, which explains their successful relationship and

[17] Niamh M. Moore, "Valorizing Urban Heritage?," 97 (see chap. 5, n. 8).
[18] R. M. Younger, *Australia and the Australians: A New Concise History* (New York: Humanities Press, 1970), 334-35.

marriage. Although the historical and social milieu of the Aboriginals and the Irish under the Empire might be seen as comparable, their customs and traditions vary significantly. The cultural differences between the two peoples are evident in the episodes preceding the marriage of Lucy and Mick. Mick falls in love with Lucy, a young full-blooded Mardu woman who works for the white owners of a big ranch at the "Native Cam," and decides to marry her. Following European tradition, Mick approaches her family and asks for Lucy's hand but is told he must attend a meeting of the elders, who decide the fates and social behavior of their community members. The elders plan marriages and assure that all Aboriginals follow the rites and rituals and respect the Law.

The meeting of the elders is awkward for Mick, who feels "hundreds of pairs of dark eyes staring silently, boring into his soul" (13). This is a rather unique moment in Aboriginal history when a large group of Aboriginal men scrutinize a male European to decide his fate and future. Mick is kept under surveillance and judged according to Aboriginal laws and values instead of Western traditions. More than that, the elders subject Mick to a kinship system of moral codes, rules for socialization, and laws for marriage and place him in the Burungu group based on the color of his skin. According to custom, individuals are born into certain skin categories that determine the way they should behave toward other members of the community.

The existence of the skin groups points to a racialized and unequal Aboriginal society. It is unclear whether the skin groups were put in practice by the settlers or by Aboriginals. Narrator Kate links the existence of the skin groups to the Mardu traditions and says that the "Dreamtime beings handed down the belief system referred to as the 'Law'" (14) and this belief system led to the division of people into skin groups.

Pilkington does not offer many explanations of the classification of Aboriginal Australians according to the color of their skin. Richard Broome elaborates on the caste system and claims that it created two worlds – one white, one black. Europeans came to control the Aboriginals "less through institutionalisation and more through a caste barrier of colour prejudice and discrimination, which separated dark-skinned Australians from light-skinned Australians and made Aborigines outcasts in their own land."[19] In this system "people are assigned or denied opportunities depending on factors outside

[19] Broome, *Aboriginal Australians*, 143 (see ch. 6, n. 11).

their control and regardless of their abilities."[20] Unlike her daughter and granddaughter, Lucy thinks that the whiter one's skin is, the higher one's social status.

Maria Pendersen discusses the Aboriginal marriage system and concludes that the Australian government controlled the marriages of Aboriginals at the beginning of the twentieth century: "it was the *Aborigines Act* (1905) that gave the government complete control over the lives of Aboriginal people, including whom they were allowed to marry, whether they were allowed to raise their children, and where they were allowed to live."[21] Whether the pressures came indirectly from the government or from the Aboriginal communities, the marriage between Lucy and Mick is out of their control and has to be approved. Robert Tonkinson claims that for the Mardu, "marriage is never solely the concern of the couple, but brings two family groups in closer alliance."[22] In Lucy's and Mick's case, the elders agree to the alliance of two people of different ethnicities and races and from different countries.

The Aboriginal people's traditions and Mick's views on marriage show that both Aboriginal and Irish societies are patriarchal. Whether it is the man who was supposed to marry Lucy but rejected her or Mick whose marriage to Lucy is decided by the elders and the Dreamtime ancestors, the wife does not have a say in her future. Aboriginal society oppresses women in that it limits their choices *vis à vis* marriage. Tonkinson argues that "it should be clear that status differences exist between Mardu men and women, and definitely favor the former, as in other Aboriginal societies ... Women have far fewer marital rights than men."[23] Mick's explanations for his infatuation reveal that he, too, is a supporter of patriarchal traditions. Lucy is a perfect wife because she "doesn't yell or shout and let her tongue run away of control ... She's a good cook, a good housekeeper. She's not a demanding, domineering woman" (22-23). Mick admits rather proudly that no man, white or Aboriginal "will covet my wife" (22). The Irishman falls in love with her because Lucy conforms to the traditional portrait of the submissive wife who is dedicated to her house and family. Mick even says that he chose her

[20] Ibid., 144.
[21] Pendersen, "Oppression," 19 (see ch. 6, n. 15).
[22] Robert Tonkinson, *The Mardu Aborigines: Living the Dream in Australia's Desert* (Fort Worth: Holt, Rinehart and Winston, 1991), 98.
[23] Ibid., 100.

because she resembles his Irish mother, "a saint, who struggled all her life without complaining" (23).

Although Mick's choices and Lucy's submissiveness speak of the patriarchal period in which both of them lived, Kate does not criticize her grandparents' marriage or expose it as out of the ordinary. Lucy's and Mick's marriage, arranged by the elders, is not different from many other marriage arrangements in Aboriginal Australia and Europe at beginning of the twentieth century. Instead, Kate, whose own marriage does not last, praises her grandparents, who set an example of devotion, tolerance, and love for the future generations of the Muldune family. That Mick is now made a Burungu, who can marry only a Milangga woman like Lucy, marks his own Aboriginal rebirth; Mick becomes an Aboriginal by marriage. Kate comments on how both her grandparents kept their traditions and showed deference toward each other's cultural heritage. Lucy attended the annual race meetings, honored her tribal culture, and became involved in ceremonials rites and rituals. Mick remained faithful to the Catholic religion and did not tolerate any blasphemy against the Pope and the Catholic Church. He expressed his emotions through music and sang Irish songs that would transport him to his birthplace in Ireland. Thus, their interracial and intercultural relationship is based on mutual respect and the understanding and acceptance of each other's differences.

Lucy's and Mick's lives in Kingsley have a great impact on their granddaughter, who considers them role models and imagines how they had spent their time together. Kate recreates in her mind an episode with her grandparents watching the sunset and imagines how "they must have sat in the shady bough shed ... watching the vivid sunsets every evening" (19). By observing her grandparents watching a fictional sunset outside of their home, Kate thinks of them with a certain degree of nostalgia and longing for a time which she considers better. Lowenthal explains that nostalgia implies hope and possibility: "What pleases the nostalgist is not just the relic but his own recognition of it, not so much the past itself as its supposed aspirations, less the memory of what actually was than of what was once thought possible."[24] Kate puts together a portrait of her grandparents that emanates optimism and a hopeful image of Kingsley. Her experiences at Dunbar Station, however, like those of her grandmother and mother, are neither optimistic nor hopeful.

[24] Lowenthal, 8.

Book 2 focuses on the life of Kate's mother and on the family's life in Kingsley and Dunbar Station. The difficult conditions in which they live at different government institutions point to racial injustice and a significant social gap between Aboriginal people and white Australians. The second part of the novel begins with a description of a thunderstorm which unleashes its force on the day Margaret Brigid Muldune (Peggy) is born. Peggy's arrival into the world is celebrated by flashes of lightning and laughter because the rain finally nourishes the arid, thirsty earth. The locals welcome this wonderful sight by shouting and dancing in the streets, which suggests that thunderstorms are rare moments of happiness for Aboriginals. That Peggy's birth is associated with a thunderstorm is appropriate because her life is also tempestuous and adventurous. Mick is proud of his beautiful daughter, whom he considers the greatest gift in the world, but he will not have the chance to see her reach maturity because he dies in a terrible railway accident when Peggy turns fourteen.

Kate finds out that her young mother attended a state school to which other Aboriginal children were denied access. Due to her white lineage, Peggy receives what her parents consider is a more rigorous education. Unlike Peggy, who eventually will reject her Western education and Christian religion and who goes against her mother's will and marries a full-blood Aboriginal, Lucy regards Western education as superior. Mick and Lucy clearly think that their daughter will be more successful if she associates with white people, so Peggy has white godparents, aunts, and playmates. Despite her mixed parentage and blood, the pretty girl with black hair and green eyes is not discriminated against by white children, which means that the whites see Peggy as one of their own. Broome discusses the negative impact of segregation, a discriminatory system directed against Aboriginal people which had social, economic, and psychological repercussions, saying, "at the deepest level it [segregation] gnawed away at the Aboriginal psyche ... [and made Aboriginal people realize that] they were rejected by the rest of the society."[25] Broome also posits that whenever Aboriginals approached Europeans, they faced "that look, that coolness, that unease, or even that overt sneer that spelled white rejection."[26] The existence of schools which only white Australians or light-skinned Aboriginals attended perpetuated the racial discrimination against Aboriginal people.

[25] Broome, 149.
[26] Ibid.

After Mick's tragic death, the social and economic status of the family changes. Although they are poor, Lucy and Peggy move to the Dunbar Station and live close to its white owners and not in the Native Camp where hundreds of Aboriginals live. The situation of these two places next to each another alludes to the segregation of white Australians and Aboriginals and among full-blood and half-caste Aboriginals. The living conditions of Aboriginals at the Native Camp are deplorable; they lack running water and suffer from malnutrition. White Australians first isolated the Aboriginals, who were considered primitive and inferior; then, they separated Aboriginal children from their parents and educated them in Western boarding schools. Winchester, Kong, and Dunn describe the changes in the housing landscape brought about by the Australian colonial government, which "attempted to address the conflicts by creating and maintaining reserves in which Aborigines were segregated."[27] They elaborate on the poor living conditions of Aboriginals and their low quality housing that "reflected the integral role of the landscape in reinforcing government perceptions of and attitudes towards Aboriginal people, perceptions and attitudes which favoured their segregation and subordination."[28] The Native Camp described by Pilkington in her novel reflects these poor housing conditions.

The segregation policies in Australia are similar to those implemented in the United States, while the placement of Aboriginal children in Western schools had the same effects as the creation of boarding schools for Native Americans. Margaret D. Jacobs produced a comparative study of the Indigenous children forced into boarding schools in the United Stated and Australia in which she concludes that in the late nineteenth and early twentieth centuries, state officials in the aforementioned countries systematically carried out policies of indigenous child removal for similar reasons. She argues that:

> in Australia, authorities claimed that removing children of part-Aboriginal descent from their families and communities would lead to their gradual absorption into white Australia. In the United States, officials promoted assimilation for Indian

[27] Hilary P. M. Winchester, Lily Kong, and Kevin Dunn *Landscapes: Ways of Imagining the World* (Harlow: Pearson, 2003), 86.

[28] Ibid.

children through separating them from their communities and educating them at distant boarding schools.[29]

Although both sides of the Pacific had similar policies for the boarding schools and implemented similar techniques, such as the cutting and shaving of the Indigenous children's hair, there is little evidence of any direct influence. The governments of both nations wanted the Indigenous families to cooperate toward the achievements of their colonial goals. Tsianina Lomawaima discusses the Indian boarding schools and claims that United States government officials established boarding schools to "mold a 'successful' student – obedient, hardworking, Christian, punctual, clean, and neatly groomed – who would become a 'successful' citizen with the same characteristics."[30]

The low social status of Aboriginals prompts Lucy to disassociate herself and Peggy from the inhabitants of Native Camp and to make sure that Peggy's friends and future husband are white. Lucy expresses her contempt for full-blooded Aboriginals when she confesses: "I don't want a Mardu (fullblood) boy to marry with my daughter … I want Muda, Muda (half-caste) boy – same as my girl – you know, one read and write, or a good Wudgebellam (white man) – not Mardu" (39). This statement, which shows Lucy's political affiliations, is similar to other declarations voiced by white Australians. Lucy claims she respects the code of laws of the elders, but in reality, she voices what the white Australians want: the purification of the Aboriginal people who are viewed by white Australians as primitive and inferior. Both Wright and Pilkington allude to the extermination of the Aboriginal gene. The authors show that by forcing Aboriginals to marry whites or individuals of lighter skin, white Australians believed that they would eventually destroy the Aboriginal race and culture. Lucy associates lighter skin and whiteness with racial superiority, education, and a more dignified social status. Her rationale for marrying Peggy to a white man is not surprising since Lucy was married to an Irishman and embraced his culture.

[29] Margaret D. Jacobs, "Indian Boarding Schools in Comparative Perspective: The Removal of Indigenous Children in the United States and Australia, 1880-1940," in *Boarding School Blues: Revisiting American Indian Educational Experiences*, ed. Clifford E. Trafzer et al. (Lincoln: University of Nebraska Press, 2006), 203.

[30] Tsianina Lomawaima, "Hm! White Boy! You Got No Business Here!" in *American Indians*, ed. Nancy Shoemaker (Malden: Blackwell, 2001), 209.

Not even her Europeanized upbringing and schooling can prevent free-natured Peggy from falling in love with Danny Dinnywarra Atkinson, a full-blood Burungu, the black helper of a white overseer at the station. Unlike her mother, Peggy is obviously not prejudiced toward Aboriginal people. By engaging in a carnal relationship with Danny, Peggy disregards her mother's wishes that she marry a light-skinned or white individual and offends the whole white community. True to her convictions, Lucy is willing to estrange her own daughter from herself and her Aboriginal heritage. Lucy's reaction is ironic because her husband confronted skeptical friends, who found an Aboriginal woman unsuitable to marry a European, and overcame all racial barriers for the sake of love. Yet Lucy, an Aboriginal, finds a full-blood Aboriginal unsuitable for her half-caste daughter, and she is not willing to sacrifice her social position within the white community for the sake of her daughter. Lucy and her white friends decide to send Peggy to the Moore River Native Settlement, "where all the half-caste children and young people were trained and educated in skills that would be useful to them" (42). Mother and daughter settle at the Moore River, where Peggy gives birth to a healthy six pound girl with black hair and dark brown eyes who clearly looks like an Aboriginal.

A second tragedy strikes the Muldune family when Peggy dies of a broken heart one day after she gives birth to Kate. The only time the three Muldune women are together in the same place is for a short period of twenty four hours. The Koopundi women in Wright's novel share a similar tragic destiny when they spend a few hours together and communicate in a bizarre nonverbal dialogue mediated by the natural world. In Hogan's *Solar Storms*, Angel tries desperately to find her mother, who had abandoned her, and when she finally sees her before Hannah's death, their dialogue does not bring Angel the closure and healing she needs. Ironically, some of the Indigenous women described by Pilkington, Wright, and Hogan spend much time and energy trying to reconnect with their mothers, but when they find them, they cannot connect. Nor can they express their love and consideration or engage in meaningful dialogues. In addressing this subtle issue, the writers conclude that the tragic colonial history, with all its implications prevents these women from direct communication with one another and from more fruitful relationships. Wright discusses the violence of colonization, which destroyed the lives of numerous Aboriginal women and estranged them from their families and heritage. Pilkington tackles an equally significant issue,

namely the indoctrination of Aboriginal people who were forced to think that the Westerners' culture, tradition, and ultimately race are superior to theirs.

Narrator Kate does not elaborate on the reasons why Lucy decides to leave her at the Moore River Native Camp and return to Kingsley. One can only speculate that she was too devastated to raise Danny's daughter. Her neighbors and friends remember that she became the epitome of "sadness and despair ... sorrow and grief" (44). Like Ivy in *Plains of Promise*, who loses her sanity and stares at the landscape, Lucy gives up living after her daughter's death and spends her remaining days staring silently at the hills. Kate acknowledges the tragedies in her family and mourns her relatives, but she also achieves her goal, which involves her visitation of the places in which her family members had lived and died and her reintroduction to her Aboriginal family and their culture. The places, landscapes, towns, buildings, and government institutions Kate visits, provide her with a useful cultural and historical context of her Aboriginal family and people.

The last part of the novel, entitled Book 3 "Kate Muldune-Williamson 1940," is narrated both by an omniscient and a first-person narrator. It centers on Kate, who grows up at Moore River and becomes a strong Aboriginal woman. The hyphen left after the year of Kate's birth suggests the continuance of her evolution. The omniscient narrator covers Kate's childhood years at the Moore River, while the first-person narrator takes over when Kate is capable of distinguishing between the indoctrination she was subjected to over the years and her Aboriginal identity, which she reveres. Book 3 starts with a description of the Moore River Native Settlement, a real place from which Doris Pilkington and her family escaped. In a more recent novel, Pilkington complains about the standard of living at the Settlement, which was "so degrading and inhumane ... that a staff member ... pronounced that anyone living there, children or staff, were doomed."[31] Julie Goodspeed-Chadwick concurs when she reports that "the conditions of Moore River were appalling. By carefully detailing the conditions of the living arrangements, Pilkington successfully paints a picture of an inhospitable, even cruel, abode."[32] Moore River was a government institution

[31] Pilkington, *Follow the Rabbit-Proof Fence* (St. Lucia: University of Queensland Press, 2002), 76.

[32] Julie Goodspeed-Chadwick, "Postcolonial Responses to White Australia: Traumatic Representations of Persons of Native and Mixed Blood in Australian Contemporary Literature (especially Women's Writing)," *Atlantic Literary Review* 4, no. 4 (2003): 208.

where part-Aboriginal and half-caste children were confined against their will after they had left their relatives behind; many mothers never saw their children again after they had been brought to the Settlement. White Australians thought they finally had found the solution to the Aboriginal *problem*, which was plaguing the country, when they "protected" Aboriginals from themselves and erased their connections to their heritage. The control over the marriages of the inmates, who were forced to seek only whiter partners, would eventually eradicate the Aboriginal gene. The Westerners forbade the speaking of any Native tongue and the practice of Aboriginal rituals. The new product resulting from Moore River was "the Settlement child," an individual with no past who lived in the present of Western culture.

The colonizers were successful at maintaining an environment which permitted and even urged Aboriginal people to discriminate against each other. For instance, Lucy refused so categorically to allow her own daughter to marry a full-blood Aboriginal that she contributed to her daughter's death and alienated herself from her granddaughter. Other light-skinned Aboriginals considered that they were superior to their full-blooded family members and were ashamed of their heritage. Twentieth-century Aboriginal society was one which kept "mothers, grandmothers and other blood relations behind an invisible wall of silence and obscurity, [and thus,] all traces of their [Aboriginal] existence vanished. All links to their traditional, cultural and historical past were severed forever" (51). Kate's journey to the places in which her family members lived is significant because she is willing to show that Aboriginal people's links with their culture and traditions have not been severed; with her recreations of traditions, she breaks the wall of silence and obscurity that plagued Aboriginal families and communities.

Critics agree that what contributed to the Aboriginal people's loss of traditions was the loss of place and land. The *terra nullius* concept, which entailed that no one owned the land in Australia, and the Mabo 1 Act, which denied Aboriginals any access to land in the Murray Islands, contributed to the extinction of any native land rights in Australia. Fay Gale argues that "the dreadful social destruction" resulted "from the loss of place and the power of the cultural forces and the security attached to it."[33] Gale explains

[33] Fay Gale, "The Endurance of Aboriginal Women in Australia," in *Habitus: A Sense of Place*, ed. Jean Hillier and Emma Rooksby (Aldershot: Ashgate, 2002), 342.

how the dispossession of the land produced a chain reaction of further cultural losses: "With the loss of land came the loss of religion so closely embedded in the land ... With the loss of land came the loss of traditional foods and medicines. We have seen all too well the resulting decline in Aboriginal health ... To Aboriginal people their very being is tied to their land."[34] After the colonizers confiscated the land, they placed Aboriginals in camps, stations, settlements, and missions, separated the children from their families, and educated Aboriginal children in Western schools. Pilkington deals with the consequences of the land dispossession and other destructive actions of the colonizers when the Aboriginal communities are already segregated.

Kate also revisits the state institutions she attended so that she can compare the two educational systems. As a child growing up at Moore River Native Settlement, Kate was indoctrinated into thinking that Western education is appropriate and superior to Aboriginal learning and thought. Kate liked European heroes such as Robin Hood and William Tell and books with colorful pictures of fairies, witches, elves, and goblins. European-oriented education was more attractive and convenient for these children, who forgot quickly about their oral Aboriginal culture, which was taught and transmitted from generation to generation by family members. Lured into accepting a European-based education, the Settlement children acted in European plays and danced to European songs. The standard education for the half-caste children resembled that of government schools in Western Australia.

To add a spiritual dimension to this education and erase their connection to the text of the Dreaming, Settlement children were introduced to the Christian religion. Kate was moved to Roelands Native Mission Farm, where she was reborn as a "true" Christian. This rebirth began with a bodily cleansing which consisted of the shaving of the girls' heads and disinfection with kerosene. Kate's depiction of the disinfection process the Aboriginal girls had to go through is similar to the ritualistic punishments of young women in the Bronze Age. Irish poet Seamus Heaney imagines how the bog people responded to adultery and writes a scene of tribal revenge in which the adulterous woman is killed: "her shaved head/like a stubble of black

[34] Ibid., 342-43.

corn/ her blindfold a soiled bandage/ her noose a ring."[35] The missionaries in Australia were also violent and wanted to make sure that the former Aboriginals and new-born Christians became a uniform mass with no sings of their old culture left. This cleansing was followed by several years of fundamentalist Christian indoctrination and the teaching of Christian virtues and behavior. At the end of their religious education, the Settlement children became Mission children who were integrated more easily into Australian society.

The Western Australians believed that assimilation into Australian society was the right solution for the "primitive" Aboriginal people. Mudrooroo argues that behind the assimilation policy was the Western Australians' fear that Aboriginals could turn into an angry and underprivileged majority. Assimilation "was a policy of division, of seeking to alienate individual Indigenous people from their communities and pushing them into European society."[36] As Aboriginal children "were forcibly removed from their parents and placed in institutions which became the only homes they ever knew," they also became estranged from their heritage and were integrated and assimilated into a Western lifestyle.[37] Kate's life follows this pattern because she was educated in Western schools, turned into a Christian, and prepared to become the wife of a handsome Westerner and the mother to Western Australian children. Mudrooroo admits that the children raised at missions and Western schools "look back with fondness on these institutions" because these schools constitute the only reality they knew and contributed to their formative years.[38] Yet the Aboriginal and Western thought and educational systems are not mutually exclusive. Kate cannot erase or undo her Western education and she probably does not even desire to do so, but she can learn and let herself be instructed in Aboriginal culture.

After Kate and her four children have visited Ross Station and met Kate's father, Danny Atkinson, Kate exclaims triumphantly that she is an Aboriginal woman:

> How could I despise my own flesh and blood, and how could I not love this warm, caring man who calls me 'my gel' and who proudly introduces me to his friends and

[35] Seamus Heaney, *Opened Ground: Selected Poems 1966-1996* (New York: Farrar, Straus and Giroux, 1998), 112.

[36] Mudrooroo, *The Indigenous Literature of Australia* (Melbourne: Hyland House, 1997), 14.

[37] Ibid.

[38] Ibid.

acquaintances as 'my daughter' ... I realise now that I have a past, a history that I
have become extremely proud of. I even have a genuine skin name. I am Milangga,
the same skin section as my grandmother Lucy Muldune. This is my birthright and
no one can take this away from me. (71)

Kate's exclamation marks the conclusion of her journey and reinforces her
desire to alleviate the pain resulted from the tragedies of her family and to
build bridges across generations, cultures, and ethnicities. Kate identifies
with the skin color of her Aboriginal grandmother and accepts the guidance
of her full-blood father. Unlike the other female protagonists who are guided
by mothers, grandmothers, and great-grandmothers in their journeys, Kate
accepts the guidance of her father, Danny, who contributes to his daughter's
Aboriginal education and teaches her Mardu. This detail is significant
because most of the novels written by Aboriginal women writers describe
Western and Aboriginal husbands and fathers as violent and careless.
Although Pilkington creates several portraits of caring, intelligent, and loyal
men in *Caprice*, the end of the novel does not reinforce or impose a
patriarchal order. Kate believes her grandmother's influence to be equally
important.

Pendersen underscores the importance of education to Aboriginal
women, who should reclaim their past and identity: "As Aboriginal women,
we are now saying that we have a history, we are not invisible, we have a
voice, and we are reclaiming our humanity. Our future must embrace change
and this change can only happen through education."[39] After decades of a
European-oriented education, Kate recognizes the importance of her roots,
land, culture, skin color, blood, and family. Kate, a middle-aged, divorced
woman, becomes increasingly committed to rediscovering her Aboriginal
heritage and is ready to unlearn everything she was taught in Western
schools. She starts to remember Aboriginal words and songs she had
forgotten. Mardu words for objects that had the power to heal had remained
imprinted on her mind although she had not used them in years. Kate's
Aboriginal horizon expands as she learns to communicate in Mardu and
listens to stories she can share with her family. Most of all, her journey into
the past of her family helps her understand her heritage and mission in life.
She becomes an Aboriginal Bridging Course student at the Western
Australian Institute of Technology and graduates in 1981. Knowledge of

[39] Pendersen, 25-26.

Aboriginal history and culture and a rigorous education would give Aboriginal women a voice and more power to fight for their rights. At forty-one, Kate is a mother of four grown-up children, a grandmother to five grandchildren, a college graduate, the lover of a decent man, and an Aboriginal woman who knows how to make sense of her past and return to her origins.

Despite the tragic deaths of her Irish grandfather and her beloved mother, the estrangement from her grandmother, the long separation from her father, her European-oriented education, and her Christian indoctrination, Kate finally understands that her Aboriginal home and heritage are important to her and her family. In his study on Australian Aboriginals, Read posits that "Belonging ultimately is personal ... belonging means sharing and ... sharing demands equal partnership."[40] Kate realizes she belongs to the home and family of her Aboriginal father, and she is ready to educate herself and her children in his home. Her journey to all the places she has visited allows her to put together a text about Aboriginal families, culture, and heritage; the social and political situation of Aboriginal people; and the injustices they have suffered. Kate reinvents her own version of the Dreaming place made of memories, facts, stories, and hopes. In recreating this place and text of the Dreaming, she creates her own past, present, and future and shares her experiences with her Aboriginal children. At the end of Pilkington's novel, Kate urges other Aboriginal people who grew up away from their families, to embark on journeys similar to hers and travel to the cultural sites and to the locations in which their Aboriginal families had lived. The author suggests that there is hope that the Aboriginal tradition may be recreated and reinvented.

[40] Read, *Belonging: Australians, Place and Aboriginal Ownership* (Cambridge: Cambridge University Press, 2000), 223.

CHAPTER 8

THREE MĀORI RESPONSES TO ONE PLACE
IN PATRICIA GRACE'S *COUSINS*

Places are often defined by their inhabitants' social and cultural practices. Indigenous people from tribes around the world construct places and imprint them with their personal experiences and aspirations, whether these places are reservations, remote villages, missions, boarding schools, or homes. While Doris Pilkington's Kate recreates her homeland and the Aboriginal home of her family members during her journey, Patricia Grace's protagonists in *Cousins* (1992) create their own interpretations of their Māori home. *Cousins*, a novel which deserves a lot more critical attention than it has received, focuses on three Māori first cousins from the same family and place who were educated differently, followed different paths as adults, and fought similar battles in different ways. All of them embark on distinctive journeys that ultimately lead them to the same place: their Māori home and the land of their ancestors. As the focus of the cousins' journeys shifts from solitary to more open and communal experiences, so do their outcomes and goals; that each cousin starts by looking for a personal voice, purpose, and place and finds them in the midst of her community, speaks of their interest in their Māori land and its traditions. When they return to their home, the cousins each contributes or has contributed to the preservation and enrichment of Māori culture in some fashion.

An omniscient narrator opens the novel and relates the facts about Mata's childhood and early adulthood years; in the second part, Makareta's mother, Polly, and Makareta, through her letters to Polly, are the narrators; and the third part is narrated by Missy's dead twin brother, who renders Missy's actions closely. The shift from a third-person narrative, which deals mostly with the girls' childhood and youth, to the first person marks the end of their formative years and the beginning of their adult lives. As they become older, more experienced, and recognizable by their individual personalities, the cousins have more confidence in their voices and actions and tell their stories themselves. The last three sections are narrated in the first person by Makareta, Missy, and Mata, who discuss their marriages, careers, and the outcomes of their journeys. Grace's narrative technique makes room for numerous Māori voices from the same family and place that all tell parts of the family story and interact with one another. These Māori

narratorial voices that transcend time, space, and even the realm of the living and dead, render the diverse choices, education, and lifestyle of members from the same Indigenous family. This diversity that characterizes such a narrow part of Māori life foregrounds a richer and more complex one which informs the other Māori families and communities throughout the country. Grace explores this diversity and sets up challenging antitheses around the issue of land between Māori conservative worldviews and less rigid ones.

Grandparents Keita and Wi acquire the family land and teach their children and grandchildren about its value. Although several critics present Keita's and Wi's outlook in a theoretical frame that points to the importance of land in Māori culture and to all Māori, their philosophy does not apply to all Māori. In *Cousins*, Grace shows that not all Māori want to own and acquire land or remain home to cultivate it. Hong-Key Yoon argues that Māori culture and mentality focus on issues related to land: "From the land, people acquire the sustenance of life, both materially and spiritually. From the ancestral land, people find their places to stand (turangawaewae). Deepest affection for it is only natural to them."[1] Patrick D. Morrow explains that "To the Māori, land is sacred and becomes a resting place for the bodies of one's ancestors."[2] According to these scholars, Māori people understand that the land has material and spiritual value and represents their life essence. Yet these ideas are not ideals for all Māori, some of whom, as Grace shows, decide or are forced to leave their places of birth, live in cities, and even undergo a Western education. Thus, their natural affection for the sacredness of land, as Yoon describes it, is more problematic. Grace writes about three cousins from the same family who relate to Māori land, culture, and traditions in different ways, and she points out that the Māori's responses to place vary with each individual. What becomes important, then, is the manner in which the cousins translate their knowledge about their Māori home and education into their new places or how they reinvent their acquired knowledge and apply it to new places and contexts.

Other critics, such as Carola Simon, G.J. Ashworth, and Brian Graham, who address the diversity which characterizes both places and individuals, more clearly put into perspective the actions of Grace's protagonists. Carola

[1] Hong-Key Yoon, *Māori Mind, Māori Land: Essays on the Cultural Geography of the Māori People from an Outsider's Perspective* (Berne: Peter Lang, 1986), 24.

[2] Patrick D. Morrow, "Disappearance Through Integration: Three Māori Writers Retaliate," *Journal of Commonwealth and Postcolonial Studies* 1 (1993): 94.

Simon, in an article on regional identities, insists on the plural form of the noun *identity* in reference to specific regions because: "different identities might be allocated to the same region at the same point in time and for that reason, we should not speak of 'the' identity of a region, but of identities in the plural."[3] G.J. Ashworth and Brian Graham argue that the polysemy of places results from the multiple identities that individuals assign to places: "if individuals create place identities, then obviously different people, at different times, for different reasons, create different narratives of belonging. Place images are thus user determined, polysemic and unstable through time."[4] Individuals who inhabit or encounter certain places assign them several identities that are likely to change over time. Grace's protagonists interpret and experience the same place in different fashions and assign different meanings and bring various experiences to places such as their Māori home and land or the city. The family's older generations perpetuate a more conservative lifestyle which gravitates around respect for one's elders and the acquisition of land. The younger Māori challenge these traditional views and opt not to acquire land but to honor and enrich the Māori culture wherever they are. Several parents and children in Grace's novel do not respect their grandparents' and great-grandparents' views regarding the land. Makareta, a national representative of the Māori, uses the knowledge and education acquired in her Māori home as bases for her future activism; Missy respects her grandparents' traditional teachings, continues their conservative view, and becomes the leader of the family's home and community; and Mata reunites with her family and finds at home the happiness and safety she craved.

Grandparents Keita and Wi preside over the family, control the family's access to land and fortune, and try to impose their rules on their younger relatives. Keita allows her son, Pere, to marry Polly, who comes from an old family, but comments that Polly's family has no land: "We know your family. It's a very good family, from a strong line, a family strong in the

[3] Carola Simon, "Commodification of Regional Identities: The 'Selling' of Waterland," in *Senses of Place: Senses of Time*, ed. G.J. Ashworth and Brian Graham (Aldershot: Ashgate, 2005), 31.

[4] G.J. Ashworth and Brian Graham, "Senses of Place, Senses of Time and Heritage," in *Senses of Place: Senses of Time*, ed. G.J. Ashworth and Brian Graham (Aldershot: Ashgate, 2005), 3.

customs, but, Polly, they've got no land."[5] Makareta's father, who died in the
World War I, married Polly, whom Keita tries to remarry to her other son,
Aperahama, to save the prestige of the family and keep their land. The family
does not approve of Anihera's marriage with Albert, an Englishman with no
family and no land, who mistreats her and wants to get her fortune. Keita and
Wi also disapprove of the marriage of Missy's parents, Gloria and Bobby,
because Bobby has no land. For this reason, they let Gloria and her children
live in poverty, and they concentrate all their energies on Makareta's
education and marriage prospects. Keita and Wi, whose marriage was
arranged for the benefit of the people and the acquisition of additional land,
arrange the marriage of their favorite granddaughter, Makareta, with
Hamuera, who comes from a rich family of farmers, because they want their
family to acquire more land. The marriage eventually takes place, and the
families unite their fortunes, although Makareta will not be the bride.[6]

Keita and Wi sustain an aggressive challenge to colonial domination
through their response to place and their ownership of land. Their
preservation and acquisition of land, which become powerful tools against
the settlers' expansive policies, also bring prosperity and maintain the lines
of genealogies. Their land also has spiritual value because it is a historical
and a social place where their ancestors are buried and where Māori customs
and rituals take place. Peter Adams claims that land has "emotional and
societal values" for the Māori because it confers "dignity and rank, providing
the means for hospitality … the resting place for the dead, and the heritage of
future generations."[7] Part of Keita's and Wi's love and respect for their land

[5] Patricia Grace, *Cousins* (Honolulu: University of Hawai'i Press, 1998), 102. Further page
references are in the main text.
[6] Grace emphasizes the difficulties of marriages in general and of interracial marriages in
particular. Makareta's marriage does not last because her husband does not respect her Māori
identity and activism. Albert marries Anihera for her money and land and abandons his
daughter after his wife's death. Mata's friend, Jean, who seemed to fit into Mata's
romanticized version of happy families, goes through two divorces. Keita's and Wi's and
Missy's and Hamuera's arranged marriages work out not because the spouses love one
another but because they value the ownership of land. Mata's marriage with Sonny fails
because of her naïveté and inexperience. Yet Mata considers Sonny a reliable friend on whom
she can depend. Despite Keita's and Wi's disapproval and the young couple's financial
difficulties, Gloria and Bobby have a happy marriage based on mutual trust.
[7] Peter Adams, *Fatal Necessity: British Intervention in New Zealand 1830-1847* (Auckland:
Auckland University Press, 1977), 177.

comes from their respect for their ancestors. By working the land, they pay homage to past generations and believe they build a future for younger generations, assuming these generations share the same outlook.

Grace does not mention the manner in which Keita and Wi acquired their land, but it is evident that they are its rightful owners. In New Zealand the discussion about land sovereignty revolves around the Treaty of Waitangi (1840), which was signed first by fifty chiefs and later by five hundred chiefs and representatives of the British Crown and recognized Māori ownership of their lands and other properties. The second article of the Treaty of Waitangi guarantees protection for Māori lands and gives the New Zealand government the right to buy those lands:

> The Queen of England acknowledges and guarantees to the Chiefs, the Tribes, and all the people of New Zealand, the entire supremacy of their lands, of their settlements, and of all their personal property. But the Chiefs of the Assembly, and all other Chiefs, make over to the Queen the purchasing of such lands, which the man who possesses the land is willing to sell, according to prices agreed upon by him, and the purchaser appointed by the Queen to purchase for her.[8]

Historians report that the variant translations of the document in English and Māori led to disagreements and multiple interpretations of the Treaty of Waitangi. To the Māori, the treaty "stood as a potent symbol for Māori of their rightful constitutional place."[9] Adams argues that the Māori did not know that "successive Secretaries of State at the Colonial Office would either fail to understand or else begrudge the extent of Māori land ownership, believing instead that the treaty guaranteed them little more than their potato patches, *pa*, and sacred places."[10] Despite the controversies surrounding the Treaty of Waitangi and its claims about land possession, it is possible that it provided people like Keita and Wi access to land.

Keita and Wi own their land, but they are incapable of obtaining the rights to raise Mata. After her Māori mother's death, her father, Albert, had robbed Mata of the love and care of her Māori family and sent her to a Home where she was indoctrinated with Christian religion and taught a Western curriculum. Mata's aunt, Gloria, comments on her sister's marriage to a

[8] Philippa Mein Smith, *A Concise History of New Zealand* (Cambridge: Cambridge University Press, 2005), 48.

[9] Ibid., 50.

[10] Adams, 176.

white man who considers both his wife and child to be inferior to him: "'And bloody Albert putting you in that place. Bad to my sister, Albert, only want her for a slave for him that's all. Didn't want any brown baby, too'" (39). His disregard for Māori suggests that Albert's behavior matches that of a colonizer in that he treats his wife and Mata like the colonized. Although he does not go through the trouble of raising his daughter, he wants her to be educated according to Western standards.

Until the end of the novel, when Mata's search for her place and home ends, there are numerous scenes in which Mata is so disoriented, reserved, and numb that most of people regard her as mentally challenged. Arguably, Mata's life is the most tragic compared to those of her two cousins; without parents to offer her love and guidance, separated from her home and relatives, and surrounded by strangers, she feels lost and alone. Mata's relationship to certain places and streets in the city is devoid of meaning. Grace insists on fixing Mata's spatial coordinates, gives many details about the direction of her walks, and underlines the fact that Mata's journey lacks both purpose and destination. In fact, most of her life, Mata Pairama is walking without going anywhere: "'Nowhere' 'No Reason' 'Nothing' No One'" (14). The author uses enumerations of the shops, objects, and street signs Mata encounters to render her aimless journeys: "Cross, Wait, Switch Go Slow, Keep Clear, King Bun, Red Hot Specials, Neon Tops, Book Exchange … Past hairdressers, photographers, jewelers, preachers, singers, sniffers and paper sellers. Hot bread, Chicken Spot, fruit and vegetables, fish and chips" (11-12). Mata records everything she encounters, from smells, objects, and sounds to sights, to avoid answering more disturbing questions about herself and her life. The more she sees, the less she is willing to attach meaning, desires, and emotions to what she sees or walks by, and she wants "nothing, and just to walk, foot in front of blistery foot" (26). Compared to those of her two cousins, Mata's journey is probably the most dramatic one because she goes from being a nobody who goes nowhere to being a Māori woman who returns to her community and learns how to become its member.

When the teachers from the boarding school allow Mata to spend one vacation with her Māori family, the girl compares the activities at the Home with the rituals of her Māori home. Mata's romanticized vision of a nuclear family with "mothers, fathers, tables, cups and dishes in cupboards, curtains with flowers on them" (17) matches neither Western nor Māori realities. Aunty Gloria's and Uncle Bobby's house, with a wooden door, lights

hanging by cords, and no proper bathroom, reflects the financial situation of the family, but it is welcoming and cozy for shy Mata. Jovial Bobby sings and tells jokes while the children help lay the table. Mata remarks on the difference between their eating habits and hers and on the peculiarity of the food. Gloria cooks eel and allows her husband and children to eat it with their fingers and wipe their hands on the newspaper tablecloth. Although they eat with their hands and urinate on the lawn, Gloria, Bobby, and their children live a more healthy and considerate life than their Māori relatives or Westerners. Makareta chooses to live by Western standards and achieves professional success, but she is unhappily married and divorces her husband. Keita and Wi also improve their financial situation with their arranged marriage but impose certain rules that their family members choose not to follow.

Mata's exposure to a Western education reinforces her Western values and makes her cling to what she is most familiar with. When she claims her name is May Parker, a name given to her at the Home, Gloria is more complainant than Keita and calls her May for a short while, but grandmother Keita does not tolerate such inaccuracy and reinstates her Māori identity and name. Keita explains that Māori names function as bridges between generations and tells Mata that she is named after her Māori great-grandmother. After she spends time with her family, Mata realizes she is Mata Pairama, daughter of Anihera Keita Pairama, and esteems her name as one of her most valuable possessions.

Grace subtly evokes the family reunion scene and the gathering of the community and family members at which Mata meets her grandparents, cousins, and all her relatives, with a spatial metaphor which she renders through shy Mata's eyes. Mata notices how her family members are getting close to one another: "Uncle Bobby with a lamp, *them* with their torches. Him getting closer to *them*, *them* getting closer to him. All getting closer to each other" (43). Their structured physical closeness means they are familiar with each other and they care for one another and, at the same time, it shows their predetermined places and responsibilities within the family dynamics. Children and women set the table, while men provide the illumination for the dinner party. When all the elders gather together, they want to see Mata, embrace her, and enjoy her return. Although she feels awkward about attending the dinner and kissing her grandparents and all her relatives, Mata notices she has changed into someone else, someone who forgets to read the

scriptures, say her prayers and constantly think of her boarding school. Mata transforms slowly from the pious girl who is afraid of the devil and its temptations, into a young girl who is curious about her Māori relatives and their language, food, and customs. She becomes aware that her mother's background is her own, and she gathers avidly more information about her mother.

The family reunion scene on the marae shows how the family and community can stand united, but their unity does not mean that they share the same thinking. While they respect rituals and ranks, these Māori value their options and their own decisions. Mata's discovery of the miraculous marble, an event that is retold by Makareta and Missy in their accounts, also alludes to a degree of uniformity and similarity in the three cousins' lives. However, this uniformity does not necessarily completely characterize these three Māori destinies as each of the cousins chooses a different path and journey. Although the cousins share the same marble, home, and family, their financial situations, education, and places of residence could not be more different. Thus, their worldviews, opportunities, choices, and interpretations of the same place and culture differ as well. Mata, Makareta, and Missy are three different Māori women who carry on their own versions of Māori culture in the new places they inhabit.

The marble episode brings the three cousins together on Māori land for the first and last time, lets them share a magical childhood moment, and ties together their lives without them even realizing it. Only Makareta's death will bring them together again at their Māori homeland at the end of the novel. The "big glass marble with blue, yellow, red and green ribbons swirling inside it" (48) symbolizes beauty and hope to those who find it. Makareta tells the other cousins that Mata found the marble on the site of the family's old house where Keita was born, which explains why the earth offers gifts to the family members: "Things come up out of the ground there – green or blue glass, medicine bottles, bits of crockery, broken combs" (130). This offering, which supposedly comes from the ancestors, should strengthen the girls' relationships to each other and to their Māori land.

One would expect that Mata would be permitted to stay with her Māori family, but she is sent back to the Home and then thrown into a big city, where she regresses into a lonely and reserved person. Ironically, after she has bonded with her cousins and found her place among her family members, she is uprooted again and thrown among strangers. As indicated before,

Mata's alienation in a big city is manifested in her recurrent, aimless journeys. Unlike Makareta, who nurtures her Māori identity in the city, Mata cannot grow as a Māori woman in the same city, which does not provide her a safe home. She walks "following her feet, wanting nothing and going nowhere" (95). Nothing and no one interests Mata, who cannot find her place and continues to go nowhere. Not even her friendship with a Māori woman, Ada, helps her because Ada eventually dies; her marriage with a Māori man does not last because Sonny leaves her. A pattern in Mata's behavior is obvious: she tries to associate herself with Māori people when she is away from her home. It becomes increasingly evident that Mata feels most at home where her Māori family lives. That is why the only two things Mata values are her Māori name and the photo of her mother that Grandmother Keita gave her. In fact, Mata repeats her name and looks at her mother's photo all the time, and these acts function as defense mechanisms against the isolation, loneliness, and numbness she feels in the city.

The second part of the novel, narrated by Polly and by Makareta through the letters she sends to her mother, covers Makareta's story, which differs from Mata's gloomy account. Makareta benefits from all the advantages of the firstborn grandchild of the family and from a Māori education. Her grandparents spoil her, offer her a good education in English and Māori, and prepare her to become an outspoken, sensible, and caring head of the family. The elders teach Makareta to serve her family and community and preserve the family's fortune and land. Despite her happy and secure childhood and adolescence, Makareta feels she has no control over her own life, which has already been planned for her. Makareta, an advocate of personal freedom, becomes the first one to reject her grandparents' preordained plans that tie her to the family land and to an arranged marriage which promises more land. She eventually uses her upbringing and education to promote Māori culture and help Māori communities all over the country.

After Pere's death in Egypt during World War I, Keita, Wi, and Hui are adamant about Makareta's staying at the ancestral homeland despite Polly's desire to take her to Wellington. Makareta goes back and forth between her mother and her grandparents and tries to reconcile her mother's will to live in the city with her paternal grandparents' desire to remain home where the family land is. While Polly, a young Māori widow, has a successful existence in the city, the Māori elders, along with Makareta's grandparents, stand for a traditional way of life, one closer to home, nature, the community, and the

family land. As a child, Makareta looks forward to returning home and spending time with the elders and her cousins, but when she grows older, she decides to leave her overprotective home and take control of her life. Luckily, Makareta finds her own way to reconcile these two worldviews when she offers her knowledge of Māori language, culture, and rituals to Māori communities throughout the country.

Keita's and Wi's secret marriage arrangement between Makareta and a young man from a rich Māori family is supposed to bring prosperity and financial security to both families, but it reveals the controlling and stifling mindset of conservative Māori. Polly, who was exposed to this traditional mindset, recognizes the advantages of arranged marriages: "'Makareta, I'm not saying it's wrong if it's what you want. Having someone chosen isn't a bad thing. Keita, Wi, and the old ones, would've thought carefully, prepared carefully'" (149). Makareta's determination and individualism win out over family tradition and her relatives' shame in front of the whole community. Part Two of the novel ends ambiguously with Makareta's troublesome departure under the agonized eyes of Gloria and Missy, who cannot stop her and worry that they will be blamed for Makareta's sudden departure.

At the end of Part Three, a section narrated by Missy's deceased twin brother, readers find out that the family honor is saved by Missy, who decides to sacrifice herself for the family and take Makareta's place as a bride. Her decision is surprising because based on Missy's personality and education she might be expected to follow her desire to live in the city and not to sacrifice her dreams so that the family preserves its land and acquires more land. Missy is exposed to Māori rituals, but the elders and her grandparents do not pay too much attention to Gloria's children because they considered Bobby too poor. Keita even punishes her daughter for her unfortunate marriage choice by letting Gloria's family live in poverty. Missy's gesture changes her fate, along with the social and financial situation of her entire family.

The third part of the novel is unexpected because of both the shift in narrative and of Missy's sudden decision. The narration of the story by a dead Māori attests to the involvement of ancestors and dead relatives in the decision making of the living Māori, which shows that the boundary between the realm of the living and that of the dead is blurred. Dead family members, who participate in certain events and actions of the living Māori, strengthen their connections to the ancestral home. Mata, for instance, has to respect

Māori custom and take Makareta's body home so that she is buried in the place where she and her ancestors had been born and lived. The Māori respect the dead, consult them, and obey their rules because the dead carry an intense energy and good will that they transmit to their living relatives. Missy's deceased twin brother give her additional insight into her life, gives her strength, and reveals unknown details about her birth. Her brother comments that he enriches Missy's spiritual life and brings her closer to her Māori heritage: "But there's a spiritish trace of me that has curled itself in to you" (159). Some of Missy's most important choices, including her decision to get married and take Makareta's place, may be influenced by her twin brother, who is an invisible but strong presence in her life.

Missy's twin brother, who shares a part of his family history unknown to his family members, reveals details about his parents' love affair, one they carried on despite Keita's disapproval, about his father's combat experiences in the war, and about his mother's physical condition on the day of Missy's birth. After she analyzes the placenta (whenua), Great-aunt Kui realizes that Gloria carried twins, but she does not want to cause further grief to Gloria and Bobby, who had lost other children. The brother watches how his father respects Māori ritual and buries the placenta, the only evidence of the brother's existence. Paul Tapsell explains that the word *whenua* means "land – ancestral estate which nourishes a kin group; afterbirth, placenta."[11] The linguistic connection between land and birth points to other connections among the land, birth, family, and generations of Māori. Like a womb, the land shelters and nourishes fresh Māori blood; at the same time, the land welcomes the family members who die.

Missy's choice to take Makareta's place as a bride is unexpected because her early dreams predicted that Missy would conform to Western models. Unlike Mata, who is coerced into a Western education and lifestyle, Missy prefers them because of the glamorous possibilities they promise. As a schoolgirl, Missy wishes to become a star; fantasizes about Western films with cowboys, sailors, pirates, tap dancers and singers; and imagines building a life in Wellington. Ironically, all three cousins, who eventually return home, live or want to live in the city, a place where Māori people and

[11] Paul Tapsell, "*Taonga, marae, whenua* – negotiating custodianship: a Maori tribal response to Te Papa: the Museum of New Zealand," in *Rethinking Settler Colonialism: History and Memory in Australia, Canada, Aotearoa New Zealand and South Africa*, ed. Annie E. Coombes (Manchester: Manchester University Press, 2006), 98.

traditions are assimilated into mainstream culture. With her unexpected choice to take Makareta's place, Missy ends the family's turmoil and becomes the chosen daughter and, later on, the head of the family. Despite her hasty decision, Missy gives up her fantasies, which most probably would have never materialized, and makes a practical choice which is favorable to the entire family.

Missy's brief first-person narration in Part Five focuses on her new role in the family, a role which reinforces the traditional values upheld by her grandparents. Her decision changes her life and pleases the elders, who believe that she had saved the family from public shame and brought financial security to the community. Missy learns Māori and teaches her children and her other relatives to speak Māori as well; she follows Māori customs closely and respects the elders; and she learns how to cultivate the land. As the future head of the family, Missy has new responsibilities that revolve around bridging gaps between generations and preserving traditions the same way her grandparents envisioned. The mother of three children, Missy becomes the link between past and future generations because she takes care of her parents and grandparents, whom she eventually buries, and welcomes all her Māori relatives home. She takes Michael, Makareta's son, under her wing and introduces him to the Māori language and Māori customs. Missy's acceptance of her arranged marriage also allows Makareta to follow her destiny in the city and become an avid defender of Māori rights around the country.

While Missy becomes successful because she perpatuates the traditional views of her grandparents in a place where people resist change, Makareta is successful wherever she goes because she welcomes changes and applies the knowledge she has acquired to different locales and contexts. If she had stayed home, Makareta easily could have become a great leader of the Māori community, a role which Missy embraces and even excells at. As an educated Māori woman representing the Māori minority in contemporary New Zealand, Makareta helps larger Māori communities. Like Penny in Jeanette Armstrong's *whispering in shadows*, who represents the unheard voices of First Nations and other Indigenous people, Makareta becomes an activist who promotes Māori culture and fights for the rights of Māori all over the country. Penny's and Makareta's involvement presupposes a deeper understanding of Indigenous people's problems and a pragmatic thinking which assures some solutions to these problems. Thus, Makareta's decision

to leave her restrictive home in favor of the city serves a greater purpose because she becomes a representative of Māori culture and language and an active participant in the Māori renaissance.

After a failed marriage to a man who does not know his wife can speak Māori, Makareta renews her interest in her cultural heritage and invests her time in defending Māori's rights to equality, land ownership, and health care. She realizes that although she had left home years ago, her birthplace and the education she received there can have an impact the lives of other Māori in a significant fashion. Makareta remembers her great-aunt's positive and influential teachings: "I was lucky that I had Kui Hinemate beside me, or inside me, or wherever it is that she speaks to me from" (204). Makareta's knowledge benefits numerous uprooted Māori who had lost their connections to their own families, language, and culture and need guidance in their process to regain them. Morrow attributes these losses to assimilation and argues that "one aspect about the Māori that virtually everyone agrees upon is that they have been uncommonly successful at getting themselves assimilated."[12] While assimilation of the Māori into Western life is a common, inescapable, and even positive aspect of Māori history, it has not led to a complete loss of Māori language and culture. Rather, Māori experience these losses because they are marginalized and discriminated against.

Some of the social and political pressures of the Western system on the Māori communities and individuals involve linguistic and cultural restrictions. Grace addresses the controversy surrounding the use of Māori through a conversation among Kui, Missy, and Makareta and insists on their different reactions to these imposed restrictions. Since Māori children are taught English and forbidden to speak Māori in schools, Missy and Makareta ask Kui to refrain from speaking Māori on the school's perimeters. Kui responds that the Māori language is a part of her identity which no one can deny: "'Maybe that's right for you, Daughter, but this old woman speaks her very own language wherever she is, wherever she goes. Otherwise who is she?'" (179). Ironically, these women from the same Māori family, in which respect for Māori culture prevails, offer different responses to using their language. Missy and Makareta will choose Māori language and culture as foci of their existence later on, but the Māori whom Makareta meets and helps have not benefited from an early exposure to the Māori language.

[12] Morrow, 92.

Makareta's activism, which deals with "issues of land, language, health and welfare, work, education, customs and culture" (208-09), involves not only the state assimilated Māori, but also those Māori like Mata, who were forced to leave their homes and receive an exclusively Western education. That is why Makareta travels around the country to promote and teach Māori to those who were not exposed to Māori culture. Makareta believes that she defends the people who live in places "where nothing substantial was inbuilt ... where there was no memory, where the void has been defiled by an inrushing of anger and weeping" (208). By filling in certain gaps in the lives of some Māori and defending their rights, Makareta becomes both an educator and a political activist who criticizes the poverty, bad health, unemployment, discrimination, and criminality that at least in part characterize contemporary Māori life.

Makareta's enthusiasm and commitment to Māori people win her national recognition, and they speak both of her altruism and her willingness to put into practice Keita's and Hui's teachings on community leadership and the Māori language. The last sentences of her account are directed toward someone other than herself, namely her cousin, Mata: "I [Makareta] don't want her [Mata] to walk away from here to walk forever ... It must be her turn to, again, to hold the coloured marble" (218). Makareta remembers that Mata shared the marble with her on that day and realizes that Mata's future and well-being depend on her return home. In fact, Makareta's death is the only event that can bring stubborn and numb Mata home. Had Makareta not died, Mata would have remained in the city and never returned home, that is toward a place where Mata can walk with a purpose. While Missy's decision allows Makareta to follow her destiny, Makerata's death allows Mata to return home and end her meaningless walking.

While for Makareta and Missy the connection to their homeland does not raise significant identity crises, for Mata, the return home is difficult. Mata is so disoriented after her long and tiresome wanderings that she needs a guide to set her on the right track. When Makareta meets her on the streets of Wellington, she has to show Mata the way: "'This way ... My house is this way ... It's quicker this way ... This is where I live all alone'" (241-42). Not even Makareta's impressive house, her tasty dinners, her welcoming gestures, and her revelation that Mata owns land at home convince Mata to return home with Makareta. Makareta's death, which forces Mata to respect her people's funeral rituals and take her cousin home, is the turning point of

Mata's life and the moment in which Mata's journey becomes meaningful. Instead of leaving her dead cousin and fleeing like she wanted to, Mata organizes Makareta's funeral, takes her home, and returns home herself.

The presence of the dead relatives in Makareta's house attests to the blurry line between the living and dead Māori. The dead come to Makareta's room to participate in the mourning rituals, accompany her home, and uphold the Māori funeral rituals. In fact, Mata first discovers that Makareta had died when she sees their dead relatives in her cousin's room and house: "I recognised the old lady [Kui] who looked after Makareta when she was little ... Then I noticed the other people. The room was full of them. They were shadowy. They were old" (247). Scholars discuss the intricate connection between death and place in Indigenous cultures and agree that the place where the ancestors are buried brings Indigenous people home and strengthens the ties between generations. Tony Swain argues that in many Aboriginal cultures, death is "a return of place-being to place ... In Aboriginal belief there is no room for judgments or retributions which might alter a spirit's course ... It is enough that a spirit is restored to its place."[13] Deborah Bird Rose concurs and claims that death is linked to nationality and place: "Just as birth is about place and metamorphosis, so too is death. At death the person is believed to become partitioned: the bones go back to the person's country, and some form of the person also returns to and travels in the person's country."[14] Swain, Rose, and others posit that specific locations, where individuals from the same family are buried, mediate the Indigenous people's relationships to their ancestors.

Māori customarily bury their dead in the land of their families and communities. With the help of her husband, Sonny, and her dead relatives, who guide Mata through the funeral process, Mata makes the necessary arrangements for Makareta's funeral to take place on their homeland. Mata, who does not know Māori customs well enough, is confused at first about the location of the funeral until it becomes clear to her that she is returning to the place where her Māori family lives. Upon her arrival home, Mata meets both the relatives she has not seen since childhood and the dead relatives she has seldom or never seen. When she recognizes her mother among the dead

[13] Swain, *A Place for Strangers*, 45 (see chap. 1, n. 1).

[14] Deborah Bird Rose, "Dance of the Ephemeral: Australian Aboriginal Religion of Place," in *Experiences of Place*, ed. Mary N. MacDonald (Cambridge: Harvard University Press, 2003), 174.

relatives, Mata completes her journey home and her search for her mother: "And then I saw a woman standing forward of the others, looking only at me. It was Anihera ... my mother had come to me" (254). The novel ends with the image of the Missy and Mata, who stand on each side of Makareta and preside over the family and community.

Although the last scene of the novel brings Mata, Missy, and Makareta together in the same place, the cousins spend most of their lives apart and interpret their homeland in different fashions. While Missy remains home and agrees with the conservative views of her grandparents, who value land ownership and acquisition, Makareta rejects these outlooks and opts for personal freedom and political activism. Mata is disoriented and moves from place to place until she finally settles for the family home. Grace writes an engaging novel in which the various threads are pulled together and divergent paths move toward common goals and thus the gaps between past and present, rural and urban, and old and new become narrower. The author brings together three Māori protagonists with different personalities, upbringing, and life choices who share the same family and home. The bright and honest Makareta, the shy and altruistic Mata, and the resilient and hard-working Missy share the wonderful marble as children and their destinies as adults. Missy takes Makareta's place and lives her cousin's chosen life; Makareta fights for the rights of Māori and dies so that her cousin Mata can return home; and Mata finally joins her estranged family and continues Missy's and Makareta's work. During their journeys, the cousins have learned to integrate their personal dreams into higher aspirations that include their home, family, community, and each other.

CHAPTER 9

NATION AS AN INTERSECTION OF CULTURES AND ETHNICITIES: KERI HULME'S *THE BONE PEOPLE*

Many Indigenous authors tackle the violent effects of colonization on Indigenous people's places and describe the strategies their characters employ to reconstruct or hold on to their homelands. In *Cousins* by Grace, the three protagonists imagine their homeland from three different locations, while Maracle's Marilyn remembers violent scenes of her childhood and youth from her home in the city. Having lost contact with their families, the descendants of the Aboriginals from Wright's and Pilkington's novels return home to rediscover their heritage. Angel, the heroine in Hogan's *Solar Storms*, also returns home to piece her life together, and she opposes the construction of a dam in the area. Erdrich's protagonists learn how to deal with the loss of their land and with the changes that occur on their reservation. While many Indigenous authors examine the effects of colonialism on Indigenous people, fewer analyze Indigenous people's relationships to Europeans after colonization. In *The Bone People* (1983, 1985), Keri Hulme focuses on how her Māori and European characters create places and literally build new sites where they can coexist. Simon is English, perhaps even Scottish nobility; Kerewin is half-European, half-Māori; and Joe is almost a full-blood Māori. While Simon is supposed to represent a version of the European colonizer, he is the one who brings and keeps the Māori characters together and facilitates their relationships. Simon is willing to turn his past, young age, vulnerability, and disability into assets that will serve his Māori friends.

The fictional setting of *The Bone People* is Whangaroa on the South Island of New Zealand. Hulme did not write a novel about nature and its impact on the characters' lives and Māori identities, but rather, she focused on the creation of new places in which Māori and Pakeha cultures meet, clash, and inform one another. Like the other Indigenous writers I look at, Hulme puts together characters whose creations of and relationships to places are unique and transformative. Away from their original homes and their blood family members, Hulme's protagonists share an unusual friendship which crosses ethnic, racial, and cultural boundaries and develops in places that shelter their creative synergy. Kerewin's tower, the house owned by her family, and the beach are provisional places where the three of

them feel comfortable, learn how to communicate, share their stories, and
heal their wounds. Joe and Kerewin find, create, and invent new places in
which dialogues, physical and mental health, and acceptance of each other's
differences prevail. The future of postcolonial New Zealand depends on the
relationships among people of different ethnicities and backgrounds and
among citizens who will interact with one another in a way that would make
the nation a good place to live.

Although Hulme delivers a somewhat optimistic message, this does not
necessary mean that she finds solutions to all her characters' problems. Her
protagonists are uprooted from their homelands and families and bear some
physical and spiritual wounds. Joe lost his wife and has no children of his
own; Kerewin had an argument with her Māori family, lives alone, and
becomes ill; and Simon is a disabled orphan who was shipwrecked on New
Zealand and lost any ties to his family and any memories of his past. Despite
their differences in age, class, gender, culture, ethnicity, and personal
experience, the three of them learn to communicate, interact, and heal each
other. While recovering from these wounds, they reestablish connections
with their families and cultures and integrate people of different ethnicities
into their communities, proving that healing is an inclusive process. Such
connections and interactions help them piece their lives together and
reintroduce them to their old Māori customs. Hulme's protagonists represent
the future of a nation whose people have to come to terms with colonization
and their own ethnic and cultural differences while they struggle to honor
their traditions and heritage.

The three protagonists form an unusual trio which functions at some
point as a family, although the protagonists are not related by blood or by
law. Estranged from or deprived of their own families, the three of them
search for a family substitute or a union which resembles a possible family
and for places where this union can grow. Marita Wenzel argues that these
different and complicated people, who represent the future of New Zealand,
have to find a way to coexist: "the different cultures in New Zealand,
represented by Joe, Kerewin and Simon have to arrive at a solution for a
future family and nation which, as the title implies, has to be constructed
from the very bones of the people; or it could also refer to the skeletons of

the past to be used as a basis."[1] The solutions that the characters find lead to love, healing, understanding, and sharing, but their means of communicating these feelings and actions are unusual. Because of Simon's disability, the three characters' interaction, which sometimes takes place beyond language and ordinary forms of communication, also involves physical violence and suffering in addition to their pain, disillusionment, and disappointment. Kerewin's and Joe's violence, isolation, strange forms of communication, drinking problems, and health conditions are only a few of hardships that exemplify the personal and national problems faced by the citizens of postcolonial New Zealand. Yet their relationships, while unorthodox to the common eye, eventually work for Kerewin, Joe, and Simon. Their strange symbiosis teaches the nation about the connections that will have to be made among other family members who will be confronted with similar problems. The three of them represent a version (not necessarily perfect) of the future New Zealand family, which will shelter family members of different cultures with difficult sets of problems and wounds.

Kerewin moves from solitude, physical suffering, and rejection of both Māori and European customs, toward community, family, healing, dialogue, and reconciliation of the two cultures. Her estrangement from her family and her illness which, presumably, is stomach cancer, led to her avoidance of any human contact in her newly built home. Kerewin's tower by the sea with a view of the stars, a wonderful location which draws Simon and Joe to her home, becomes the focal place of their friendship. That she has built this bizarre construction on her own and away from her Māori family speaks of her desire to reinvent her life and herself in a different place: "She had debated ... whether to build a hole or a tower ... the idea of a tower became increasingly exciting; a star-gazing platform on top."[2] These two choices reinforce Kerewin's androgynous nature, an issue which comes up throughout the novel. A virgin who rejects sexual contact and intimacy, Kerewin, smokes cigars, drinks, fights better than most men, and discovers her maternal instincts. Continuing to reinvent herself and her homes, Kerewin eventually reconciles with her Māori family, becomes part of a new

[1] Marita Wenzel, "Liminal Spaces and Imaginary Places in *The Bone People* by Keri Hulme and *The Folly* by Ivan Vladislavic," in *Beyond the Threshold: Explorations of Liminality in Literature*, ed. Hein Viljoen and Chris Van der Merwe (New York: Literator, 2007), 57.

[2] Keri Hulme, *The Bone People* (Baton Rouge: Louisiana State University Press, 1983), 7. Further page references are in the main text.

type of family with Joe and Simon, and tears down the tower to rebuild a spiral-shaped construction. Jacqueline Buckman believes that "by attempting to integrate Māori and Pakeha values, Kerewin has finally managed to realize the goals of Aikido [a martial arts technique she masters] … by unifying the body and spirit."[3] Kerewin's journey involves her bridging of gaps, finding places that accommodate her mixed identity, and reconnecting to other people, her Māori roots, and her newly-formed family, her art, and her body.

Kerewin describes Joe as a "confused mixture of the congenial and the unpleasant. Gentle with his son, and brutal. Drunken boor and sober wit" (250). Despite the beatings, Simon believes that Joe is the best father he can have, and he warms up only to him and Kerewin. Joe characterizes himself as somewhat of a failure because he gave up many of his dreams. He dropped out of college to support his wife and thinks of himself as a wheel in the system, a "typical hori after all, made to work on the chain, or be a factory hand, not try for high places" (230). Joe wasted his potential and fell into the stereotypical role of a working-class Māori who occasionally gets drunk and beats his son. He also has to deal with the painful loss of his young wife, Hana, whom he loved deeply, and to accept a life with no offspring (besides Simon, who is not Hana's and Joe's flesh and blood) and no close family members. Simon represents hope in Joe's empty life, although Joe often fails to be a good father to his son and almost beats him to death.

Finally, eleven-years-old Simon, the charming, generous, and moody boy is the glue of this newly-formed family. Joe and Kerewin see each other in a bar, where both drink quite heavily, but it is not until Simon shows up at Kerewin's tower that the three of them befriend one another. Simon's past remains a mystery, especially because he does not remember details about his family and life in Europe. Judging by the objects he has on him after the shipwreck, a rosary and a ring featuring a phoenix coat of arms, Joe and Kerewin suspect he is of Scottish descent. Kerewin conducts her own research to find out that Simon may possibly have Irish blood and be connected to His Lordship the Earl of Conderry, yet this information remains unreliable. The first time Kerewin sees Simon, she is impressed by Simon's golden aura; he looks like a "weird saint in a stained gold window" (16).

[3] Jacqueline Buckman, "Challenging the Conventions of the Kunstlerroman: Keri Hulme's *The Bone People*," *WLWE* 52, no. 2 (1996): 61.

Simon also has the gift of seeing other people's auras. Considered by many critics to be a Christ-like figure, Simon has a great capacity for self-sacrifice, and he contributes to Joe's and Kerewin's healing and salvation.

Joe and Kerewin go through personal crises that are amplified by the lack of welcoming homes where parents and siblings get along; for this reason, they create their own places that function as provisional homes. The characters' disconnection from their Māori families is not the result of separations effected by the government, as we have seen in many novels by Indigenous writers, but of the characters' personal choices. Like Grace, Hulme addresses the tensions between generations of Māori and records rebellions against more traditional views. Hulme's protagonists finally find and create alternative places and homes where they can feel comfortable with themselves and the world around them. Yet these places are difficult to discover, create, or build after these people have experienced so many losses. Simon has no home after the shipwreck until Joe and Hana take him in. Joe tries to maintain a domestic environment for his foster child, but his drinking and abusiveness stand in the way of good parenting and a safe home. Kerewin builds a mysterious tower, where Joe and Simon feel welcome, but she destroys it after her relationship with Simon and Joe takes a turn for the worse. Because the characters do not possess stable and secure places, they are constantly looking for replacements.

The bonding among Kerewin, Simon, and Joe starts immediately after Simon's uninvited appearance at Kerewin's tower. From then on, the three of them take walks together, cook, talk, and share their stories about troubled relationships with family members. Their unconventional friendship develops in unconventional places and away from more traditional locations, such as the maraes and the homes of their families. As Joe and Kerewin learn how to deal with Simon's disability and communicate with him, they find spaces where dialogues can take place. They spend many days on the beach close to the sea, where Simon likes to show them his artistic creations made of shells, debris, feathers, and plants found on the beach, creations that help him communicate with Joe and Kerewin. Simon's attraction for the New Zealand shore, beach, and sea is contagious for Kerewin and Joe, who are reintroduced to the littoral landscape and to new forms of communication, understanding, love, and sacrifice.

To strengthen their relationships, Kerewin invites Joe and Simon to her family's house on the beach at Moerangi, a rustic house with no electricity

and running water. Steve Matthewman explains that the "beach is a relational concept; it only makes sense in connection to other places (and spaces)."[4] The beach brings together the natural and the civilized worlds and encourages people's living close to nature. At the Moerangi house, the three of them drink rainwater, walk bare-footed on the beach, fish, cook, and talk. Kerewin's feelings for the sea encompass awe and attachment; she is "drinking the beach in, absorbing sea and spindrift, breathing it into her dusty memory" (163). Kerewin's happiness at being home and close to the sea is transmitted to Simon and Joe, who respond accordingly. Their gesture of closeness, manifested through the knitting together of their arms, speaks of the bond among them and their transformation into one organism: a family of some sort. Kerewin feels "their heart beats echo and shake through her" (163), and Simon is happy to run in between them and has an urgent "need to be with them" (163).

Despite being the only survivor from a shipwreck, Simon does not fear the sea, but remains fascinated by it. The shore symbolizes an oxymoronic combination of life and death, and it is a place where Simon finds the tools for communication and artistic recognition. Patricia Grace also describes the shore as a place where completeness and nothingness, growth and stagnation, and creativity and sterility reside at the same time:

> The shore is a place without seed, without nourishment, a scavenged death place. It is a wasteland, too salt for growth, where the sea puts up its dead. Shored seaweed does not take root but dries and piles, its pods splitting in the sun, while bleached plants crack and turn to bone.
> Yet because if being a nothing, a neutral place – not land, not sea – there is freedom on the shore, and rest.
> There is freedom to search the nothing, the weed pile, the old wood, the empty shell, the fish, searching for the speck, the beginning – or the end that is the beginning.
> Hope and desire can rest there, thoughts and feelings can shift with sand grains being sifted by the water and the wind.[5]

As in Hulme's novel, the seashore contains debris and putrid remains, but it also promises new beginnings and the hope that these relics might become usable again. Simon, for example, uses bits and pieces he finds on the shore

[4] Steve Matthewman, "More than Sand: Theorising the Beach," in *Cultural Studies in Aotearoa New Zealand: Identity, Space, and Place*, ed. Claudia Bell and Steve Matthewman (Melbourne: Oxford University Press, 2004), 49.

[5] Patricia Grace, *Potiki* (Auckland: Longman, 1986), 18.

to make instruments through which he can have a voice to speak with his friends. The metaphor of the seashore, with its usable and lifeless remains, epitomizes the relationship between the three protagonists that miraculously works despite their problems and suffering.

Because of his disability, Simon has more trouble making himself understood, but he still functions as a facilitator of conversation. Although Susie O'Brien demonstrates that "Simon is reinscribed with Kerewin's voice, and is finally incorporated into her enlightened vision," Simon also contributes to the creation of the characters' visions, worldviews, and conversations.[6] Many times, he even interrupts their discourse and puts forth his own. The process is difficult because he is always spoken for: "the words … had been spoken across his head before, but never to him" (73). Yet Simon finds his own creative contribution to their verbal communication by adding his own non-verbal signs to it: "the sounds and patterns of words from the past that he had fitted to his own web of music. They often broke apart, but he could always make them new. So he lay prone on the floor, and listened to them, and made Kerewin [and Joe] part of them, part of his heart" (73-74). What Simon communicates through his gestures, writing, and actions consists in part of Kerewin's and Joe's words, to which Simon has added his feelings and individuality.

Simon learns to communicate and create his own language by using the objects he finds in the environment. Quoting the research done by C. J. Dunst and L. W. Lowe, Linda Lang and Eileen Uptmor analyze how people with severe disabilities communicate by advancing from attending the environment to responding to the environment. Lang and Uptmor suggest that a disabled person can engage in an effective form of communication by "manipulating the environment in order to obtain and sustain the attention of the individual, determining the stimulus events that are maintaining the individual's attention, and developing the individual's behavioral topography through the use of successive approximations."[7] Simon manipulates the objects he finds on the beach to grab Kerewin's and Joe's attention and start

[6] Susie O'Brien, "Raising Silent Voices: The Role of the Silent Child in *An Imaginary Life* and *The Bone People*," *SPAN* 30 (1990): 80.

[7] Linda Lang and Eileen Uptmor, "Intervention Models to Develop Nonlinguistic Communication," in *Functional Communication: Analyzing the Nonlinguistic Skills of Individuals with Severe or Profound Handicaps*, ed. Les Sternberg (New York: Springer-Verlag, 1991), 51.

a dialogue with them. Matthewman defines the beach as "a littoral zone, a sandy shore between sea and land. The beach is also a **liminal** zone, a coast between nature and culture, located at the threshold of space and place."[8] Using the beach as a link between nature and culture, Simon employs the sea and the objects on the beach to communicate and inspire conversations with Joe and Kerewin.

An artistic construction made by Simon from the debris found on shore functions as his innovative means of communication and becomes a conversation opener for the three characters. Kerewin and Joe talk about Simon's creations either with the boy or between themselves because they are intrigued by them. While the creation made of the debris on the shore is Simon's, the naming of the parts of the construction is done by Kerewin. Kerewin offers the linguistic signs for the objects Simon brings from the shore and gives him explanations about them: "Gull's feather ... That's a fragment of sea biscuit ... It's an echinoderm ... lamanaria of some kind ... Lessonia variegate for your information ... electric light bulb ... These are seeds of a tree" (125). Despite Kerewin's linguistic contribution, the assemblage and the artistic touch belong to Simon. What results from the remains Simon finds on the shore is "an odd little temple, a pivot for sounds to swing around" (127). Even Kerewin concludes that his little temple makes music and contends that he may have "discovered how to use a new kind of soundwaves" (127). Simon's creation is connected to sounds, music, and communication especially because of Simon's reaction to it and his use of it. He lies down, listens to his construction, closes his eyes, and opens his mouth. In trying to imitate the sounds that come out of his marine construction, Simon speaks with the voice of nature, to which he adds his own twist and contribution. On the other hand, it may be that Simon gives nature a voice by putting together the objects he has found on the shore in a particular order. In any event, his discourse is linked to nature and to the place where he set foot on New Zealand shore for the first time.

Simon creates another, similar discourse which also functions as a form of communication and resembles the voice of nature. He often interrupts Kerewin's and Joe's speech to present his own creation and speak his own mind in his own voice. Both Joe and Kerewin witness how Simon makes music hutches, "spiralling construction[s] of marramgrass and shells and driftchips and seaweed" (102). When Kerewin listens to the music hutches,

[8] Matthewman, 36.

she hears how "the pulse of her blood and the surge of the surf and the thin rustle of wind round the beaches were combining to make something like music" (102). The land and the sea give Simon a voice and a part in Kerewin's and Joe's conversations. Simon makes a natural creation, which has artistic and linguistic connotations, out of the New Zealand natural resources he found on the shore – a detail which links Simon to the land of New Zealand. In this way, he uses natural resources to contribute to the preservation and renewal of the Māori landscape and to the invention of a new form of communication. Simon is Māori by instinct and by association with Joe and Kerewin; he is attached to the New Zealand environment, and he likes exploring the land and looking at the sea.[9]

Simon's creations and means of communication strengthen his conversation and relationship with Kerewin and Joe. As the three of them spend more time together and get to know each other better, their connection becomes stronger. Together, they create a space where they can be honest with one another and heal their wounds. During the course of their friendship, all three characters evolve. More specifically, since they try to deal with their own suffering, they learn how to reach out and accept each other's help. Whether they are at Kerewin's tower, at her house on the beach, or on the shore, the three of them create a space where they transform themselves.

Kerewin changes from a person who "hasn't ever had anything to do with children" to a woman who exhibits maternal instincts (21). When she meets Simon for the first time, she feeds him, tucks him in, and watches him sleep. Although Kerewin cautions herself not to fall under Simon's charm – "I might end up liking you, brat, if I'm not careful" (54) – she becomes more and more involved in the child's life, and she gradually lets him into hers. After Hana's death, Joe finds in Simon his only reason to live. He understands Simon, treats him with tenderness but sometimes projects his own insecurity and suffering onto the child. Simon is content to be around Joe and Kerewin and to contribute to their happiness and healing. He is "hugging himself for joy" (68) when Kerewin finally accepts his gift, which consists of his only possessions recovered from the shipwreck. Simon's

[9] Discussing Simon's vision of a Māori ancestor, Gay Wilentz claims astutely that "one's relation to one's culture is not necessarily biologically based." Simon grows up within Māori culture, which he feels it is part of his heritage. "Instruments of Change: Healing Cultural Disease in Keri Hulme's *the bone people,*" *Literature and Medicine* 14, no. 1 (1995): 139.

gesture of giving Kerewin his most valuable things – his rosary and the ring with the coat of arms engraved on it – underscores his kind and altruistic nature. Knudsen contends that Simon acquires "such a full social authority within the narrative that he comes across not only as the most convincingly portrayed character, but as the character with the most distinctive personal integrity."[10]

Simon demonstrates his integrity when he endures beatings from his foster father and even from Kerewin and forgives his assaulters. Joe's last severe beating, which follows Kerewin's surprising beating of Simon, breaks their relationship and sends Simon to the hospital and Joe and Kerewin on an exile of sorts. The physical violence that includes Joe beating Simon (most frequently), Kerewin beating Simon (once), and Kerewin fighting with Joe (once) is either an unusual form of communication or a negotiation of power. Appalled by the manner in which Joe treats his son, Kerewin, a connoisseur of Aikido, beats Joe. Before fighting Joe on the beach, Kerewin sees Simon's scars and wounds and criticizes Joe: "I wouldn't bash a dog in the fashion you've hurt your son" (148). At her family's house, Kerewin does not permit gratuitous violence and forbids Joe to beat Simon. Their argument results in a fight between the two adults that Kerewin wins to Joe's surprise. In trying to impose her power, Kerewin also sends Joe a message about peace, understanding, and good parenting.

What Kerewin does not understand, however, is that Simon incites Joe's beatings because he wants to smooth out things in his father's life. For instance, feeling the tension between Kerewin and Joe, Simon provokes his dad into beating him: "[he should] start a fight and stop the illwill between his father and Kerewin. Get rid of the anger, round the woman, stop the rift with blows, with pain, then pity, then repair, then good humour again" (192). At other times, Joe beats him because Simon "becomes both more diffident and more unruly" (175). With each beating, Simon's body heals, and he loves Joe more. Stephen Fox claims that Simon's "violence is his way of 'speaking' and of allowing others also to 'speak' through their violence toward him. His 'disability' becomes a bridge between the two adults and between the two cultures."[11] While violence in general is a form of communication for Simon, it is, as I have shown earlier, not the only one.

[10] Knudsen, *The Circle*, 166 (see chap. 7, n. 12).

[11] Stephen Fox, "Barbara Kingsolver and Keri Hulme: Disability, Family, and Culture," *Critique* 45, no. 4 (2004): 414.

Fox is correct when he says that the boy's disability is a bridge between people and cultures, yet this bridge stays solid only for a short period of time. The beatings expose Joe's vulnerability, and he shows regret after his abusiveness. His violence releases Joe's daily tensions and improves his relationships with everyone else, including Simon. Their communication through violence solidifies Joe's relationship with his son and restores the unity and peace to their familial trio. Kerewin's response to the beatings and to violence reveals both her agreement and disgust. When Kerewin opposes the beatings, she tries to protect Simon from the violence of his foster father and shows her maternal side. On the other hand, Kerewin imitates Joe's behavior once and beats Simon, an act followed by Joe's cruelest beating of Simon for taking Kerewin's possessions that leads to their separation.

The protagonists' separation brought about by extreme violence is indicative of their personal problems, which are also national problems. Hulme makes the point that these people of different ethnicities found a temporary model of coexistence but have yet to find a definitive way of living together as a family or as friends. That violence breaks out in the places such as the beach, the tower, or Joe's house, in which their friendship flourishes, points to the provisional nature of these places. That is why, after their individual journeys, they return to their ancestral Māori homes and welcome Simon into their extended communities. The meeting at the *whare tipua* (ancestral home) of Kerewin's family suggests that Kerewin, Joe, and Simon have found a more lasting place to live in, one to which Simon also belongs. Hulme suggests that some generations did not grasp fully the concept of ethnic diversity and must be sacrificed so that the next generations can be born out of their bones and ashes and experience a better future.

Before their reunion at the end of the novel, Joe, Simon, and Kerewin follow a path of suffering which absolves them of their sins and the gratuitous violence inflicted on each other and eventually saves them. Responsible only for minor childish wrongdoings, Simon does not pay for his sins, but for his friends'. Hulme's solution for the three of them involves individual journeys of personal redemption to different places. Simon recuperates in the hospital after Joe's severe last beating; Kerewin confronts cancer; and Joe recovers after jumping off a cliff. At the end of their journeys that presuppose cleansing through suffering and pain and reinforce the need for healing, community, and wholeness, they come to the conclusion that

they need companionship and understanding from those around them. After she destroys her tower and prepares to leave, Kerewin makes a sculpture from clay representing Joe, Simon, and herself, a symbol of hope that their friendship will eventually prevail.

The first journey is Joe's, followed by Simon's and Kerewin's. Joe is imprisoned in jail for the broken bones and wounds given to Simon, and he has a chance to reflect on the damages he done to his family and friends. When Joe is released from jail, he takes a journey to the house of his Māori grandmother, an important location for Joe's identity formation. Living in a household in which family members often turned against each other, Joe grew up confused about his family and identity. Joe's father died young, and his mother sent him to live with his grandmother while she spent six years in a mental institution. Joe's grandfather, a stern man who went to church and avoided the marae, was embarrassed by his wife's Māori identity. Joe's religion and upbringing confused him because he was raised a Catholic but he feels Māori and marries a Māori woman. Nana was the only one in his family who channeled his education toward Māori culture. She embraced her Māori identity and customs and valued traditional healing, which she considered superior to Pakeha medicine. Using her traditional treatment, Nana cured her grandson's polio and saved his life. Joe's return to his grandmother's house underscores the value he places on his Māori roots and heritage in difficult times.

Joe undergoes a mythic experience when he meets the Kaumatua, a wise man who reminds Joe of his responsibility to his Māori land and culture. The Kaumatua warns that Joe is a broken man who needs healing to become whole again. He also needs to understand his destiny and path in life, which has everything to do with his Māori heritage and with the rebuilding of his new family. The Kaumatua has dedicated sixty years of his life to fulfilling his grandmother's prophesy, guarding the mauriora, and waiting for three people: the broken man, the stranger, and the digger. These easily recognizable people are Joe, Simon, and Kerewin, who, according to the grandmother's prophesy, should be given the mauriora, "the heart of this country", because they represent the future of the country (364). The Kaumatua guards the stone which arrived on a canoe together with the little god, a deity no one worships anymore; the "mauri is distinct and great beyond the little god" (363). As Joe accepts gradually the prophesy and the

symbolic powers of the mauriora, he begins to heal, grow, and become whole again.

The old man also cautions against the dangerous effects of colonization on the Māori people and the land and underscores the significance of the miraculous force of the mauriora. He believes that the Māori people lived in harmony with the land and themselves until the colonizers arrived:

> it was the old people's belief that this country and our people, are different and special ... But we changed. We ceased to nurture the land. We fought among ourselves. We were overcome by those white people in their hordes. We were broken and diminished. We forgot what we could have been, that Aotearoa was the shining land. Maybe it will be again ... be that as it will, that thing [the mauriora] which allied itself to us is still here. (364)

A return to the precolonial status that the old man describes is both impossible and undesirable for the protagonists, who must find a solution which is applicable to the present. The hopeful future of Aotearoa, which is also promised by the mauriora, can be realized in a contemporary setting. Chadwick Allen argues that Kerewin and Joe become the new ancestors of the nation after colonization "not by trading their Māori identities for Pakeha ones but rather by continuously reforging their Māori identities to fit contemporary situations."[12]

After he buries the old man and performs the funeral ceremony, Joe takes to his new home the mauriora, which looks "very black or very green, and from the piercing, the hole in the centre, [emits] light like a glow-worm, aboriginal light" (384). Influenced by the old man's stories and his healing abilities, and confident in the powers and promises of the mauriora, Joe returns home and hopes he can reunite with Simon and Kerewin. This reunion takes place at the home of Kerewin's family, where Joe had brought the mauriora. Knudsen remarks that Joe has learned to appreciate the mauriora in the context of the Māori community: "by experiencing the spirituality of place Joe realizes that sacred matters die if they are reduced to artefacts and placed in a museum, just as the Kaumatua realizes that other people must bring the spirituality of this solitary place back into a

[12] Chadwick Allen, *Blood Narrative: Indigenous Identity in American Indian and Maori Literary and Activist Texts* (Durham: Duke University Press, 2002): 154.

community context."[13] The powers of the mauriora work only when it serves people.

Simon's story, strategically placed in between Joe's and Kerewin's, is meant to bridge the gap and tie the stories together. Simon becomes aware of the need for human contact, friendship, and a family and understands that his home is where Joe and Kerewin are: "And home is Joe, Joe of the hard hands but sweet Joe ... And home has become Kerewin the distant who is so close ... And if he can't go home he might as well not be. They might as well not be, because they only make sense together" (395). While both Kerewin's and Joe's journeys involve a return to the home of their Māori ancestors and an integration of the Māori customs in their new lives, for Simon, home is connected to two Māori people. Again, Simon represents the bridge between the Pakeha and Māori cultures and the Māori family Hulme describes.

Kerewin's journey emphasizes physical and spiritual healing and the rebuilding of relationships and homes. Disappointed by modern medicine and its "queer state of ignorance" (416), Kerewin decides not to have surgery for her stomach cancer. The graphic images of the decomposition of her body are indicative of the imanence of her death. However, Kerewin is miraculously cured and saved by visions and appearances of Māori ancestors. After she sees visions containing Simon, Joe, and her family members that suggest quite overtly the direction her life needs to take from then on, Kerewin is visited by a Māori ancestor "of indeterminate age. Of indeterminate sex. Of indeterminate race" (424) who cures her with a potion. Kerewin, who struggled with her androgyny and her mixed heritage, understands that she should reconsider the boundaries *vis à vis* gender, race, and ethnicity.

Although Kerewin's and Joe's Māori family members make sporadic appearances in the novel, punctuated by the protagonists' reluctance to bring them into their conversations, their Māori ancestors, relatives, and elders play a more important role toward the end of the novel, when it becomes more clear that the futures of Kerewin's multiethnic family and of the nation depend on a combination of the old and the new. The absorption of young people such as Simon into an ancient Māori family and community should help make possible the building of the foundation for the new nation. Kerewin's story, like Joe's and Simon's, reinforces an increasing need for community, friendship, and openness toward cultural and ethnic differences.

[13] Knudsen, 179.

Kerewin's rebuilding of the marae (the old cultural meeting house) at Moerangi is also part of Kerewin's healing process and of her realization that Māori traditions and holistic medicine saved her and restored her physical and mental balance. Her reconstruction of the building is, thus, a gist to the Māori community: "*I started rebuilding the Māori hall because it seemed, in my spiral fashion, the straight-forward thing to do ...I was recognised, saluted, and they shrugged when they found it was my time and money being given free*" (431). By building the marae and her new spiral-shaped home, Kerewin proves she is the digger, as the kaumatua predicted. Kerewin's journey is similar to Joe's in that it redirects her needs toward the community, family, and wholeness. The spiral, the shape Kerewin chose for her new home, symbolizes continuity and the possibility of new beginnings.

Together and individually, Kerewin, Joe, and Simon rediscover the Māori traditions and their places within the Māori communities. The last image, with Joe and Simon listening to Kerewin's music, speaks about their renewed relationship, which is going to work and last. The inclusion of the stranger, Simon, within the Māori family, community, and ultimately nation suggests that the Māori and Pakeha cultures are compatible and that the foundation of a new nation and place presupposes this fusion. Nicholas Entrikin underscores the importance of diversity for a nation and of difference for both nations and communities: "Both the nation and the community derived strength and unity through diversity. The community was held together by the loyalty of independent individuals to a common purpose rather than through a fusion of many minds into a single way of thinking."[14]

Referring to the colonization of Native Americans, Craig Womack explains that assimilation goes in both directions: "When cultural contact between Native Americans and Europeans has occurred throughout history, I am assuming that it is just as likely that things European are Indianized rather than the anthropological assumption that things Indian are always swallowed up by European culture."[15] Womack and other scholars emphasize the cultural exchange which takes place among people of different ethnicities within the same nation. Unlike other contemporary

[14] Nicholas J. Entrikin, "Place, Region, and Modernity," in *The Power of Place: Bringing Together Geographical and Sociological Imaginations*, eds. John A. Agnew and James S. Duncan (Boston: Unwin Hyman, 1989), 35.

[15] Womack, *Red on Red*, 12 (see chap. 1, n. 10).

Indigenous authors, who portray Indigenous characters involved in destructive or, at best, tangential relationships with Europeans, Hulme tackles close relationships among settlers, Māori, and Māori of mixed descent and sends the message that open and substantial interactions among individuals of various ethnicities and cultures should constitute the foundation of new nations. Throughout their journeys, Kerewin, Joe, and Simon understand that, ironically, Europeans are not necessarily the cause of the problem to the present suffering of Māori, but the solution; it is the Māori who have to find answers to their identity crises and include individuals like Simon into their families and communities. Simon is more than willing to adopt a new identity, culture and tradition and Kerewin and Joe learn that they have to do the same.

The microcosm of *The Bone People* and the relationships among the three protagonists reflect some of the main issues of the macrocosmic nation. Hulme proposes some alternatives to the effects of colonization, such as love, acceptance, understanding, and healing, instead of hatred, discrimination, and illness. Hulme's protagonists discover that they can develop and learn to accept their differences in new places or in newly created places outside of their traditional homes. The multiethnic trio formed of Kerewin, Simon, and Joe discovers its synergetic potential in untraditional places, such as a tower, a spiral-like house, a beach house, and a beach and, then, they learn how to transfer their knowledge and adapt their relationship to a larger Māori community.

CHAPTER 10

CONCLUDING REMARKS

Identity in Place: Contemporary Indigenous Fiction by Women Writers in the United States, Canada, Australia, and New Zealand emphasizes contemporary Indigenous people's responses to place in the fiction of eight Indigenous women writers. Having looked at the kinds of places contemporary Indigenous people inhabit or imagine, I have argued that places are social and cultural constructions that regenerate themselves as a result the impact of their permanent and temporary inhabitants. Individuals shape the physical and cultural aspects of places, and in this process, they also regenerate their ethnic identities. Places as meeting points for histories, cultures, races, and ethnicities leave room for individual transformations, and in these novels the Indigenous people living in various places in the United States, Canada, Australia, and New Zealand adapt to their changing worlds and in doing so, change the social and cultural features of their homelands and new homes. It is through the characters' return to real or imagined places and homes that they change, reinterpret their personal and national histories, and establish links with the past, ones which are significant to their presents and futures.

In their fiction, these Indigenous authors present women with physical and psychological wounds who search for healing and a recognition of their ethnic identities and tribal cultures in places in which the ethnic identities and cultures of settlers dominate. Several critics maintain that colonialism prevented Indigenous people from connecting with their own places and homes, and yet there are numerous narratives about Indigenous people who find places to heal and prosper. Many Indigenous people have come to terms with the effects of colonization in their countries, and they also have found ways to rediscover and adapt their tribal cultures to more recent contexts. I show how Indigenous people struggle to find their own places and homes in a postcolonial world, in cities, and contemporary communities, but their struggles do not implicitly suggest defeat. Descriptions of contemporary Indigenous people's places need to be reconsidered and viewed in a fresher context, which should include the Indigenous people's efforts to recreate their homes.

My analysis underscores the ways in which Indigenous people cope with violent colonization, physical wounds, loss of land, and estrangement from

their families. Some of their coping mechanisms and healing practices include travels to their ancestral homelands, the recreation of homelands through the process of memory, or the building and establishing of new homes. Each Indigenous character's relationship to place carries with it the tribal traditions of a particular place and this relationship is transformative for Indigenous people. I have concluded that the works I have analyzed assert that Indigenous people can survive in postcolonial nations, adapt to a global world, and contribute to the preservation and the flourishing of their cultures by creating new homes or places.

I have underlined the fact that Indigenous women's journeys to places are different for each character and each tribal culture. Yet I have found similar threads and paths that Indigenous people in each country follow. The Native American characters I have analyzed find out where they belong, and they cross the boundaries of their reservations and villages, return to their homes, and travel to cities. Their mobility informs their communities, whose cultures are more prone toward rewriting old traditions and adapting them to new contexts. The First Nations characters leave the homes of their families and recreate their home through memory by remembering scenes in which their family members influenced their existences. In their new homes in the city, these First Nations women are involved in political activism. Arguably, the Aboriginal protagonists in the works covered feel most severely the effects of colonization because they were violently separated from their families and educated in Western schools; some of the Aboriginal characters are physically and mentally mutilated, while others revisit the homes of their family members and try to reestablish the connections to their ancestral cultures. Finally, the Māori characters create new spaces in which they feel at home, spaces that accommodate and shelter their increasingly multiethnic communities. The Indigenous characters' journeys to old and new places point to their efforts to rebuild old homes or build new homes in new spaces, find safe places, and adapt their traditions to a changing world.

I have focused on the impact places have on Indigenous people's ethnic identities and how Indigenous people affect places, but I have not written anything like the final word on the complex relationships between Indigenous people and their locations. I only have opened a general discussion on Indigenous identity and theories about place to show the connections between them and argue that the creation of new places and traditions resuscitates and helps the development of tribal cultures. I believe

that numerous areas would benefit from further critical consideration as there is an increasing need for more critical studies on contemporary Indigenous people around the world. For instance, scholars could produce more in-depth studies on places and Indigenous identity in each of the postcolonial countries I looked at. Other critics could analyze specific places, such as boarding schools and draw conclusions about the educational systems in colonial and postcolonial nations. As the city becomes the new location for many contemporary Indigenous people, urban areas populated by communities of Indigenous people, Indigenous families, or solitary Indigenous individuals also deserve more attention.

Although several of the Indigenous writers whose work I have analyzed do not mention the controversial issue of land sovereignty, it is definitely a subject which should be addressed further because it frames the whole discussion about Indigenous people's land. Indigenous people from the United States and Canada were forced to sign treaties which reinforced the assumption that their autonomy was limited. In Australia, the irrational concept of *terra nullius* ("land belonging to no one") held that all land belonged to the Crown upon the English settling in Australia in 1788. In 1992, the High Court found that Eddie Mabo and the people of Mer in the Torres Strait had retained ownership of their lands. The Waitangi Treaty signed in New Zealand, which supposedly guaranteed Māori ownership of their lands, was translated and interpreted in several ways, so the Māori were eventually disadvantaged. The treaties and acts signed in the four postcolonial countries establish contexts for the historical evolution of Indigenous people's relationships to land and place.

The issue of ethnic identity in connection to national identity should also be given further consideration. Critics should also discuss in depth the status of Indigenous people within their multiethnic and multicultural nations. Some scholars argue that multiculturalism started out by promising cultural diversity but ended up doing exactly the opposite. Despite its unrealistic optimism, Nanda Shrestha's and Wilbur Smith's quilt metaphor, used to describe multicultural America, promises a solution to the problem faced by Indigenous people in postcolonial nations:

> Think of a quilt for a moment spread across the vast land of America. Look at all those colorful patches as a panoramic landscape, representing a multitude of ethnic groups with their own stories to tell about the geographical imageries of ethnic/racial experiences. When threaded together, all those imageries become one, united into a

powerful quilt, sharing one common experience … Yet the whole does not diminish
the beauty and individuality of all those patches. Their beauty is actually enhanced.
Their power is reinforced.[1]

Indigenous people want to live in nations in which their ethnic identities and
cultures are celebrated so that they can contribute to the cultural heritage of
postcolonial nations. Yet, in many cases, the tensions among ethnic groups
or between the dominant culture and ethnic groups indicate that a
multicultural quilt made of colorful patches is still in the making.

Turning away from the theories of multiculturalism to the actual
integration of Indigenous people within the dominant society and culture,
Andrys Onsman offers more focused examples to suggest the diversity of
Indigenous people's locations. In his study on Indigenous identity in the
twenty-first century, Onsman enumerates the diverse locations inhabited by
Indigenous people around the world: "Not all Native Americans live on
reservations, not all Aborigines live tribally, not all Yanamano live
communally in the Brazilian forest … An Aborigine in a suit driving a BMW
in Sydney is still an indigene; a Native American Abstract Expressionist
exhibiting in New York is still an indigene; a Sami without reindeer in
Helsinki is still an indigene."[2] Onsman is arguing against stereotypical
descriptions of Indigenous people and for an integration of Indigenous
people into a multiethnic and global world. This integration presupposes the
affirmation within the dominant culture of tribal and cultural differences.

Indigenous people's expression of their tribal identities and of the
differences among the tribes within postcolonial nations around the world
remains crucial to their survival. Within the literary field, the expression of
Indigenous people's identities is greatly encouraged and allowed much
freedom. At the end of his chapter from the study *American Indian Literary
Nationalism* entitled "Splitting the Earth," Jace Weaver quotes Craig
Womack, who, when was asked about his expectations for future Native
American literature, answered: "'More and funkier.'"[3] In fact, Womack, in
the novel, *Drowning in Fire*, offered his version of "more and funkier," that

[1] Nanda R. Shrestha and Wilbur I. Smith, "Geographical Imageries and Race Matters," in
Geographical Identities of Ethnic America: Race, Space, and Place, ed. Kate A. Berry and
Martha L. Henderson (Reno: University of Nebraska Press, 2002): 290-91.

[2] Onsman, *Defining Indigeneity*, 118 (see chap. 1, n. 35).

[3] Weaver, "Splitting," 74 (see chap. 1, n. 8).

is "a story of a place, family, Creek history, Christianity, and jazz."[4] Indigenous writers will probably continue to take risks and tackle even "more funky" stories about places and Indigenous families, both assuring the endurance of Indigenous people and enriching the genre of Indigenous literature. Thus, the writers' creativity and experiments within the literary field could hopefully lead to more sonorous accomplishments in the social and political arenas. *He iti wai köwhao waka e tahuri te waka* ("It may be a small storm, yet a successful outcome is imminent" in Māori).

[4] Ibid.

REFERENCES

Adams, Peter. *Fatal Necessity: British Intervention in New Zealand 1830-1847*. Auckland: Auckland University Press, 1977.

Akiwenzie-Damm, Kateri, and Josie Douglas, eds. *Skins: Contemporary Indigenous Writing*. Wiarton: Kegedonce Press, 2000.

Allen, Chadwick. *Blood Narrative: Indigenous Identity in American Indian and Maori Literary and Activist Texts*. Durham: Duke University Press, 2002.

Allen, Paula Gunn. *Off the Reservation: Reflections on Boundary-Busting, Border Crossing, Loose Canons*. Boston: Beacon Press, 1998.

———. *The Sacred Hoop: Recovering the Feminine in American Indian Traditions*. Boston: Beacon Press, 1992.

Armstrong, Jeannette. "Land Speaking." In *Speaking for the Generations: Native Writers on Writing*, edited by Simon J. Ortiz, 174-94. Tucson: University of Arizona Press, 1998.

———. *whispering in shadows*. Penticton: Theytus Books, 2000.

Arnold, Ellen L. "Beginnings Are Everything: The Quest for Origins in Linda Hogan's *Solar Storms*." In *Things of the Spirit: Women Writers Constructing Spirituality*, edited by Kristina K. Groover, 284-303. Notre Dame: University of Notre Dame Press, 2004.

Ashcroft, Bill, Gareth Griffiths, and Helen Tiffin. *The Empire Writes Back: Theory and Practice in Post-colonial Literatures*. New York: Routledge, 2002.

———. *Key Concepts in Post-Colonial Studies*. London: Routledge, 1998.

Ashworth, G. J., and Brian Graham. "Senses of Place, Senses of Time and Heritage." In *Senses of Place: Senses of Time*, edited by G. J. Ashworth and Brian Graham, 3-12. Aldershot: Ashgate, 2005.

Basso, Keith H. *Wisdom Sits in Places: Landscape and Language Among the Western Apache*. Albuquerque: University of Mexico Press, 1996.

———. "Wisdom Sits in Places: Notes on a Western Apache Landscape." In *Senses of Place*, edited by Steven Feld and Keith H. Basso, 53-90. Santa Fe: School of American Research Press, 1996.

Berry, Wendell. *Home Economics*. New York: North Point Press, 1987.

Brill de Ramírez, Susan B. *Native American Life-History Narratives: Colonial and Postcolonial Navajo Ethnography*. Albuquerque: University of New Mexico Press, 2007.

Broome, Richard. *Aboriginal Australians: Black Response to White Dominance 1788-2001*. Crows Nest: George Allen & Unwin, 2002.

Brown, Joseph Epes. *Animals of the Soul: Sacred Animals of the Oglala Sioux*. Rockport: Element, 1992.

Bruchac, Joseph. *Roots of Survival. Native American Storytelling and the Sacred*. Golden: Fulcrum Publishing, 1996.

Brückner, Martin. *The Geographic Revolution in Early America: Maps, Literacy, and National Identity*. Williamsburg: University of North Carolina Press, 2006.

Buckman, Jacqueline. "Challenging the Conventions of the Kunstlerroman: Keri Hulme's *The Bone People*." *WLWE* 52, no. 2 (1996): 49-63.

Casey, Edward S. "Body, Self, and Landscape: A Geophilosophical Inquiry into the Place-World." In *Textures of Place: Exploring Humanist Geographies*, edited by Paul C. Adams, Steven Hoelscher, and Karen E. Till, 403-25. Minneapolis: University of Minnesota Press, 2001.

———. *Getting Back into Place: Toward a Renewed Understanding of the Place-World*. Bloomington: Indiana University Press, 1993.

———. "How to Get from Space to Place in a Fairly Short Stretch of Time: Phenomenological Prolegomena." In *Senses of Place*, edited by Steven Feld and Keith H. Basso, 13-52. Santa Fe: School of American Research Press, 1996.

Cattelino, Jessica R. "Casino Roots: The Cultural Production of Twentieth-Century Seminole Economic Development." In *Native Pathways: American Indian Culture and Economic Development in the Twentieth Century*, edited by Brian Hosmer and Colleen O'Neill, 66-90. Boulder: University Press of Colorado, 2004.

Chavkin, Allan. "Vision and Revision in Louise Erdrich's *Love Medicine*." In *The Chippewa Landscape of Louise Erdrich*, edited by Allan Chavkin, 84-116. Tuscaloosa: University of Alabama Press, 1999.

Claval, Paul. "Changing Conceptions of Heritage and Landscape." In *Heritage, Memory and the Politics of Identity: New Perspectives on the Cultural Landscape*, edited by Niamh Moore and Yvonne Whelan, 85-93. Aldershot: Ashgate, 2007.

Cook, Barbara J. "Hogan's Historical Narratives: Bringing to Visibility the Interrelationship of Humanity and the Natural World." In *From the Center of Tradition: Critical Perspectives on Linda Hogan*, edited

by Barbara J. Cook, 35-52. Boulder: University Press of Colorado, 2003.

Degnen, Cathrine. "Country Space as a Healing Place: Community Healing at Sheshatshiu." In *Aboriginal Autonomy and Development in Northern Quebec and Labrador*, edited by Colin H. Scott, 357-78. Vancouver: UBC Press, 2001.

Entrikin, J. Nicholas. "Place, Region, and Modernity." In *The Power of Place: Bringing Together Geographical and Sociological Imaginations*, edited by John A. Agnew and James S. Duncan, 30-43. Boston: Unwin Hyman, 1989.

Erdrich, Louise. *Love Medicine*. New York: Henry Holt, 1993.

———. *The Bingo Palace*. New York: Harper, 1994.

———. *Tracks*. New York: Perennial, 1988.

Fernandes, João Luís Jesus and Paulo Carvalho, "Military Heritage, Identity and Development: A Case Study of Elvas, Portugal." In *Heritage, Memory and the Politics of Identity: New Perspectives on the Cultural Landscape*, edited by Niamh Moore and Yvonne Whelan, 121-32. Aldershot: Ashgate, 2007.

Fife, Connie, ed. *The Colour of Resistance: A Contemporary Collection of Writing by Aboriginal Women*. Toronto: Sister Vision, 1993.

Fleras, Augie and Jean Leonard Elliott. *The Nations Within: Aboriginal-State Relations in Canada, the United States, and New Zealand*. Toronto: Oxford University Press, 1992.

Fox, Stephen. "Barbara Kingsolver and Keri Hulme: Disability, Family, and Culture." *Critique* 45, no. 4 (2004): 405-20.

Frawley, Kevin. "A 'Green' Vision: The Evolution of Australian Environmentalism." In *Inventing Places: Studies in Cultural Geography*, edited by Kay Anderson and Fay Gale, 215-34. Melbourne: Longman Cheshire, 1992.

Freud, Sigmund. *A General Introduction to Psycho-analysis."* Translated by Joan Riviere. New York: Clarion Book, 1969.

Gale, Fay. "The Endurance of Aboriginal Women in Australia." In *Habitus: A Sense of Place*, edited by Jean Hillier and Emma Rooksby, 339-51. Aldershot: Ashgate, 2002.

Gish, Robert. "Life into Death, Death into Life: Hunting as Metaphor and Motive in *Love Medicine*." In *The Chippewa Landscape of Louise*

Erdrich, edited by Allan Chavkin, 67-83. Tuscaloosa: University of Alabama Press, 1999.

Goodspeed-Chadwick, Julie. "Postcolonial Responses to White Australia: Traumatic Representations of Persons of Native and Mixed Blood in Australian Contemporary Literature (especially Women's Writing)." *Atlantic Literary Review* 4, no. 4 (2003): 199-218.

Grace, Patricia. *Cousins*. Honolulu: University of Hawai'i Press, 1998.

———. *Potiki*. Auckland: Longman, 1986.

Grewe-Volpp, Christa. "The Ecological Indian vs. Spiritually Corrupt White Man: The Functions of Ethnocentric Notions in Linda Hogan's *Solar Storms*." *Amerikastudien/American Studies* 47, no. 2 (2002): 269-83.

Haladay, Jane. "The Grandmother Language: Writing Community Process in Jeannette Armstrong's *whispering in shadows*." *SCL/ÉLC* 31, no. 1 (2006): 32-48.

Hans, Birgit. "Water and Ice: Restoring Balance to the World in Linda Hogan's *Solar Storms*." *The North Dakota Quarterly* 70, no. 3 (2003): 93-104.

Hathaway, Nancy. *The Friendly Guide to Mythology: A Mortal's Companion to the Fantastical Realm of Gods, Goddesses, Monsters, and Heroes*. New York: Viking, 2001.

Härting, Heike. "Reading Against Hybridity: Postcolonial Pedagogy and the Global Present in Jeannette Armstrong's *Whispering in Shadows*." In *Home-Work: Postcolonialism, Pedagogy, and Canadian Literature*, edited by Cynthia Sugars, 257-84. Ottawa: University of Ottawa Press, 2004.

Heaney, Seamus. *Opened Ground: Selected Poems 1966-1996*. New York: Farrar, Straus and Giroux, 1998.

Hill, Barbara Helen. "Home: Urban and Reservation." In *Genocide of the Mind: New Native American Writing*, edited by MariJo Moore, 21-28. New York: Thunder's Mouth Press, 2003.

Hogan, Linda. *Solar Storms*. New York: Simon & Schuster, 1995.

Hulme, Keri. *The Bone People*. Baton Rouge: Louisiana State University Press, 1983.

Hume, Lynne. *Ancestral Power: The Dreaming, Consciousness, and Aboriginal Australians*. Victoria: Melbourne University Press, 2002.

Jacobs, Margaret D. "Indian Boarding Schools in Comparative Perspective: The Removal of Indigenous Children in the United States and

Australia, 1880-1940." In *Boarding School Blues: Revisiting American Indian Educational Experiences*, edited by Clifford E. Trafzer, Jean A. Keller, and Lorene Sisquoc, 202-31. Lincoln: University of Nebraska Press, 2006.

Jaskoski, Helen. "From the Time Immemorial: Native American Traditions in Contemporary Short Fiction." In *Louise Erdrich's Love Medicine: A Casebook*, edited by Hertha D. Sweet Wong, 27-34. New York: Oxford University Press, 2000.

Karl, François. "Re-Surfacing Through Palimpsests: A (False) Quest for Repossession in the Works of Mudrooroo and Alexis Wright." *Commonwealth* 25, no. 1 (2002): 7-14.

Katanski, Amelia V. "Tracking Fleur: The Ojibwe Roots of Erdrich's Novels." In *Approaches to Teaching the Works of Louise Erdrich*, edited by Greg Sarris, Connie A. Jacobs, and James R. Giles, 66-76. New York: Modern Language Association of America, 2004.

Knudsen, Eva Rask. *The Circle & the Spiral: A Study of Australian Aboriginal and New Zealand Māori Literature*. Amsterdam: Rodopi, 2004.

Kroeber, Karl. "To the Reader." In *Native American Storytelling: A Reader of Myths and Legends*, edited by Karl Kroeber, 1-13. Malden: Blackwell Publishing, 2004.

Lang, Linda, and Eileen Uptmor. "Intervention Models to Develop Nonlinguistic Communication." In *Functional Communication: Analyzing the Nonlinguistic Skills of Individuals with Severe or Profound Handicaps*, edited by Les Sternberg, 38-56. New York: Springer-Verlag, 1991.

Littig, Beate. *Feminist Perspectives on Environment and Society*. Harlow: Prentice Hall, 2001.

Lomawaima, Tsianina. "Hm! White Boy! You Got No Business Here!" In *American Indians*, edited by Nancy Shoemaker, 209-35. Malden: Blackwell, 2001.

Lowenthal, David. *The Past Is a Foreign Country*. Cambridge: Cambridge University Press, 1985.

Malpas, J.E. *Place and Experience: A Philosophical Topography*. Cambridge: Cambridge University Press, 1999.

Maracle, Lee. *Daughters Are Forever*. Vancouver: Polestar, 2002.

————. *I Am Woman: A Native Perspective on Sociology and Feminism.* Vancouver: Press Gang Publishers, 1996.

Maristuen-Rodakowski, Julie. "The Turtle Mountain Reservation in North Dakota: Its History as Depicted in Louise Erdrich's *Love Medicine* and *The Beet Queen*." In *Louise Erdrich's Love Medicine: A Casebook*, edited by Hertha D. Sweet Wong, 13-26. New York: Oxford University Press, 2000.

Massey, Doreen. *Space, Place, and Gender.* Minneapolis: University of Minnesota Press, 1994.

Matthew, John. *Eaglehawk and Crow: A Study of the Australian Aborigines Including an Inquiry into Their Origin and a Survey of Australian Languages.* London: David Nutt, 1899.

Matthewman, Steve. "More than Sand: Theorising the Beach." In *Cultural Studies in Aotearoa New Zealand: Identity, Space and Place*, edited by Claudia Bell and Steve Matthewman, 36-53. Melbourne: Oxford University Press, 2004.

Mazey, Mary Ellen, and David R. Lee. *Her Space, Her Place: A Geography for Women.* Washington: Resource Publications in Geography, 1983.

McClintock, Anne. *Imperial Leather: Race, Gender, and Sexuality.* New York: Routledge, 1995.

Mihesuah, Devon A. "Commonality of Difference: American Indian Women and History." In *American Indians in American History, 1870-2001: A Companion Reader*, edited by Sterling Evans, 167-76. Westport: Praeger, 2002.

Mohanram, Radhika. *Black Body: Women, Colonialism, and Space.* Minneapolis: University of Minnesota Press, 1999.

Mondale, Clarence, "Place-on-the-Move: Space and Place for the Migrant." In *Mapping American Culture*, edited by Franklin Wayne and Michael Steiner, 53-88. Iowa: University of Iowa Press, 1992.

Monk, Janice. "Gender in the Landscape: Expressions of Power and Meaning." In *Inventing Places: Studies in Cultural Geography*, edited by Kay Anderson and Fay Gale, 123-38. Melbourne: Longman Cheshire, 1992.

Moore, Niamh M. "Valorizing Urban Heritage?: Redevelopment in a Changing City." In *Heritage, Memory and the Politics of Identity: New Perspectives on the Cultural Landscape*, edited by Niamh M. Moore and Yvonne Whelan, 95-108. Aldershot: Ashgate, 2007.

Morrow, Patrick D. "Disappearance Through Integration: Three Maori Writers Retaliate." *Journal of Commonwealth and Postcolonial Studies* 1 (1993): 92-94.

Mountford, Charles P. "The Rainbow-Serpent Myths of Australia." In *The Rainbow Serpent: A Chromatic Piece*, edited by Ira R. Buchler and Kenneth Maddock, 23-97. Hague: Mounton Publishers, 1978.

Mudrooroo. *Aboriginal Mythology: An A-Z Spanning the History of Aboriginal Mythology from the Earliest Legends to Present Day.* Hammersmith: Thorsons, 1994.

————. *The Indigenous Literature of Australia.* Melbourne: Hyland House, 1997.

O'Brien, Susie. "Raising Silent Voices: The Role of the Silent Child in *An Imaginary Life* and *The Bone People.*" *SPAN* 30 (1990): 79-91.

O'Keeffe, Tadhg. "Landscape and Memory: Historiography, Theory, Methodology." In *Heritage, Memory and the Politics of Identity: New Perspectives on the Cultural Landscape*, edited by Niamh M. Moore and Yvonne Whelan, 3-18. Aldershot: Ashgate, 2007.

Onsman, Andrys. *Defining Indigeneity in the Twenty-First Century: A Case Study of the Free Frisians.* New York: Edwin Mellen Press, 2004.

Ortiz, Simon J. "Introduction: Wah Nuhtyuh Dyu Neetah Tyahstih (Now It Is My Turn to Stand)." In *Speaking for the Generations*, edited by Simon J. Ortiz, xi-xix. Tucson: University of Arizona Press, 1998.

Pendersen, Maria J. "Oppression and Indigenous Women: Past, Present, and Future – An Australian Kimberley Aboriginal Perspective." In *Home/Bodies: Geographies of Self, Place, and Space*, edited by Wendy Schissel, 15-26. Calgary: University of Calgary Press, 2006.

Peterson, Nancy Mayborn. *Walking in Two Worlds: Mixed-Blood Indian Women Seeking Their Path.* Caldwell: Caxton Press, 2006.

Pilkington, Doris. *Caprice: A Stockman's Daughter.* St. Lucia: University of Queensland Press, 1991.

————. *Follow the Rabbit-Proof Fence.* St. Lucia: University of Queensland Press, 2002.

Poirier, Sylvie. "Territories, Identity, and Modernity among the Atikamekw (Haut St-Maurie, Quebec)." In *Aboriginal Autonomy and Development in Northern Quebec and Labrador*, edited by Colin H. Scott, 98-116. Vancouver: UBC Press, 2001.

Purdy, John. "Against All Odds: Games of Chance in the Novels of Louise Erdrich." In *The Chippewa Landscape of Louise Erdrich*, edited by Allan Chavkin, 8-35. Tuscaloosa: University of Alabama Press, 1999.

———. "Building Bridges: Crossing the Waters to a *Love Medicine*." In *Teaching American Ethnic Literatures: Nineteen Essays*, edited by John R. Maitino and David R. Peck, 83-100. Albuquerque: University of Mexico Press, 1996.

Ramirez, Renya K. *Native Hubs: Culture, Community, and Belonging in Silocon Valley and Beyond*. Durham: Duke University Press, 2007.

Read, Peter. *Belonging: Australians, Place and Aboriginal Ownership*. Cambridge: Cambridge University Press, 2000.

———. *Returning to Nothing: The Meaning of Lost Places*. Cambridge: Cambridge University Press, 1996.

Relph, Edward. *Place and Placelessness*. London: Pion Limited, 1976.

Richardson, Miles. "Place and Culture: Two Disciplines, Two Concepts, Two Images of Christ and a Single Goal." In *The Power of Place: Bringing Together Geographical and Sociological Imaginations*, edited by John A. Agnew and James S. Duncan, 140-56. Boston: Unwin Hyman, 1989.

Rose, Deborah Bird. "Dance of the Ephemeral: Australian Aboriginal Religion of Place." In *Experiences of Place*, edited by Mary N. MacDonald, 163-86. Cambridge: Harvard University Press, 2003.

Rosenthal, Nicolas G. "The Dawn of a New Day?: Notes on Indian Gaming in Southern California." In *Native Pathways: American Indian Culture and Economic Development in the Twentieth Century*, edited by Brian Hosmer and Colleen O'Neill, 91-111. Boulder: University Press of Colorado, 2004.

Sack, Robert D. "Place, Power, and the Good." In *Textures of Place: Exploring Humanist Geographies*, edited by Paul C. Adams, Steven Hoelscher, and Karen E. Till, 232-45. Minneapolis: University of Minnesota Press, 2001.

Scholtmeijer, Marian. "The Power of Otherness: Animals in Women's Fiction." In *Animals and Women: Feminist Theoretical Explorations*, edited by Carol J. Adams and Josephine Donovan, 231-62. Durham: Duke University Press, 1995.

Schouls, Tim. *Shifting Boundaries: Aboriginal identity, Pluralist Theory, and the Politics of Self-Government.* Vancouver: UBC Press, 2003.

Schultermandl, Silvia. "Fighting for the Mother/Land: An Ecofeminist Reading of Linda Hogan's *Solar Storms.*" *Studies in American Indian Literatures* 17, no. 3 (2005): 67-84.

Schweninger, Lee. *Listening to the Land: Native American Literary Responses to the Landscape.* Athens: University of Georgia Press, 2008.

Short, Damien. *Reconciliation and Colonial Power: Indigenous Rights in Australia.* Aldershot: Ashgate, 2008.

Shrestha, Nanda R. and Wilbur I. Smith. "Geographical Imageries and Race Matters." In *Geographical Identities of Ethnic America: Race, Space, and Place*, edited by Kate A. Berry and Martha L. Henderson, 279-94. Reno: University of Nebraska Press, 2002.

Simon, Carola. "Commodification of Regional Identities: The 'Selling' of Waterland." In *Senses of Place: Senses of Time*, edited by G. J. Ashworth and Brian Graham, 31-45. Aldershot: Ashgate, 2005.

Smith, Andrea. *Conquest: Sexual Violence and American Indian Genocide.* Cambridge: South End Press, 2005.

Smith, Jonathan M. "The Place of Value." In *American Space/American Place: Geographies of the Contemporary United States*, edited by John A. Agnew and Jonathan M. Smith, 52-75. New York: Routledge, 2002.

Smith, Linda Tuhiwai. *Decolonizing Methodologies: Research and Indigenous Peoples.* Dunedin: University of Otago Press, 1999.

Smith, Philippa Mein. *A Concise History of New Zealand.* Cambridge: Cambridge University Press, 2005.

Stewart, Kathleen C. "An Occupied Place." In *Senses of Place*, edited by Steven Feld and Keith H. Basso, 137-65. Santa Fe: School of American Research Press, 1996.

Stookey, Lorena L. *Louise Erdrich: A Critical Companion.* Westport: Greenwood Press, 1999.

Sturm, Circe. *Blood Politics: Race, Culture, and Identity in the Cherokee Nation of Oklahoma.* Berkeley: University of California Press, 2002.

Swain, Tony. *A Place for Strangers: Towards a History of Australian Aboriginal Being.* New York: Cambridge University Press, 1993.

Tapsell, Paul. "*Taonga, marae, whenua* – negotiating custodianship: a Maori tribal response to Te Papa: the Museum of New Zealand." In *Rethinking Settler Colonialism: History and Memory in Australia, Canada, Aotearoa New Zealand and South Africa,*" edited by Annie E. Coombes, 86-99. Manchester: Manchester University Press, 2006.

Tarter, Jim. "'Dreams of Earth:' Place, Multiethnicity, and Environmental Justice in Linda Hogan's *Solar Storms.*" In *Reading under the Sign of Nature: New Essays in Ecocriticism*, edited by John Tallmadge and Henry Harrington, 128-47. Salt Lake City: University of Utah Press, 2000.

Tonkinson, Robert. *The Mardu Aborigines: Living the Dream in Australia's Desert.* Fort Worth: Holt, Rinehart and Winston, 1991.

Tuan, Yi-Fu. *Space and Place: The Perspective of Experience.* Minneapolis: University of Minnesota Press, 1977.

van Dam, K.I.M. "A Place Called Nunavut: Building on Inuit Past." In *Senses of Place: Senses of Time*, edited by G. J. Ashworth and Brian Graham, 105-17. Aldershot: Ashgate, 2005.

Warrior, Robert Allen. *Tribal Secrets: Recovering American Indian Intellectual Traditions.* Minneapolis: University of Minnesota Press, 1995.

Waters, Joel. "Indians in the Attic." In *Genocide of the Mind: New Native American Writing*, edited by MariJo Moore, 85-92. New York: Thunder's Mouth Press, 2003.

Weaver, Jace. "Preface." In *Defending Mother Earth: Native American Perspectives on Environmental Justice*, edited by Jace Weaver, xv-xvii. Maryknoll: Orbis Books, 1996.

———. *Other Words: American Indian Literature, Law, and Culture.* Norman: University of Oklahoma Press, 2001.

———. "Splitting the Earth: First Utterances and Pluralist Separatism." In *American Indian Literary Nationalism*, edited by Jace Weaver, Craig S. Womack, and Robert Warrior, 1-89. Albuquerque: University of New Mexico Press, 2005.

Wenzel, Marita. "Liminal Spaces and Imaginary Places in *The Bone People* by Keri Hulme and *The Folly* by Ivan Vladislavic." In *Beyond the Threshold: Explorations of Liminality in Literature*, edited by Hein Viljoen and Chris Van der Merwe, 45-60. New York: Literator, 2007.

Wilentz, Gay. "Instruments of Change: Healing Cultural Disease in Keri Hulme's *the bone people*." *Literature and Medicine* 14, no. 1 (1995): 127-45.

Wilson, Michael D. *Writing Home: Indigenous Narratives of Resistance.* East Lansing: Michigan State University Press, 2008.

Winchester, Hilary. "The Construction and Deconstruction of Women's Roles in the Urban Landscape." In *Inventing Places: Studies in Cultural Geography*, edited by Kay Anderson and Fay Gale, 139-56. Melbourne: Longman Cheshire, 1992.

Winchester, Hilary P.M., Lily Kong, and Kevin Dunn. *Landscapes: Ways of Imagining the World.* Harlow: Pearson, 2003.

Winter, Tim. "Landscapes in the Living Memory: New Year Festivities at Angkor, Cambodia." In *Heritage, Memory and the Politics of Identity: New Perspectives on the Cultural Landscape*, edited by Niamh M. Moore and Yvonne Whelan, 133-47. Aldershot: Ashgate, 2007.

Womack, Craig S. *Red on Red: Native American Literary Separatism.* Minneapolis: University of Minnesota Press, 1999.

Wright, Alexis. *Plains of Promise.* St. Lucia: University of Queensland Press, 1997.

Yoon, Hong-Key. *Maori Mind, Maori Land: Essays on the Cultural Geography of the Maori People from an Outsider's Perspective.* Berne: Peter Lang, 1986.

Young, Elspeth. "Hunter-gatherer Concepts of Land and Its Ownership in Remote Australia and North America." In *Inventing Places: Studies in Cultural Geography*, edited by Kay Anderson and Fay Gale, 255-72. Melbourne: Longman Cheshire, 1992.

Younger, R. M. *Australia and the Australians: A New Concise History.* New York: Humanities Press, 1970.

Zierott, Nadja. *Aboriginal Women's Narratives: Reclaiming Identities.* Münster: Lit Verlag, 2005.

INDEX

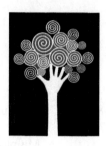

POSTCOLONIAL STUDIES

Maria C. Zamora, *General Editor*

The recent global reality of both forced and voluntary migrations, massive transfers of population, and traveling and transplanted cultures is seen as part and parcel of the postindustrial, postmodern, postcolonial experience. The Postcolonial Studies series will explore the enormous variety and richness in postcolonial culture and transnational literatures.

The series aims to publish work which explores various facets of the legacy of colonialism including: imperialism, nationalism, representation and resistance, neocolonialism, diaspora, displacement and migratory identities, cultural hybridity, transculturation, translation, exile, geographical and metaphorical borderlands, transnational writing. This series does not define its attentions to any single place, region, or disciplinary approach, and we are interested in books informed by a variety of theoretical perspectives. While seeking the highest standards of scholarship, the Postcolonial Studies series is thus a broad forum for the interrogation of textual, cultural and political postcolonialisms.

The Postcolonial Studies series is committed to interdisciplinary and cross cultural scholarship. The series' scope is primarily in the Humanities and Social Sciences. For example, topics in history, literature, culture, philosophy, religion, visual arts, performing arts, language & linguistics, gender studies, ethnic studies, etc. would be suitable. The series welcomes both individually authored and collaboratively authored books and monographs as well as edited collections of essays. The series will publish manuscripts primarily in English (although secondary references in other languages are certainly acceptable). Page count should be one hundred and twenty pages minimum to two hundred and fifty pages maximum. Proposals from both emerging and established scholars are welcome.

For additional information about this series or for the submission of manuscripts, please contact:

Maria C. Zamora
c/o Acquisitions Department
Peter Lang Publishing
29 Broadway, 18th floor
New York, New York 10006

To order other books in this series, please contact our Customer Service Department:

(800) 770-LANG (within the U.S.)
(212) 647-7706 (outside the U.S.)
(212) 647-7707 FAX

Or browse online by series:
www.peterlang.com